Praise for *The Measure of Man*

"*The Measure of Man* offers us the Florentine Renaissance as at once a political suspense thriller, a riveting intellectual adventure tale, a study in the character and complex motives of key Florentine personalities, and a lyrical reverie on the psychological and political meaning—as well as the tantalizing radiance and essential mystery—of the city's astonishing works of art. In a remarkable achievement, Rothfield has combined all these riches into a brief, vivid, and unified story. Through his eyes, we see the Florentine Renaissance as most fundamentally a struggle over the nature and possibilities of liberty: a long tragic arc from the cultural pinnacle of republican idealism in the early fifteenth century, through the aesthetic flowering and civic vicissitudes of the age of the Medici and Savonarola, to the brooding meditations of Machiavelli and Michelangelo over the fate of the dying republic."

—Ric Burns, documentary filmmaker

"Larry Rothfield is one of today's great minds and finest writers. In this elegant volume, he turns his attention to examining the creative, ingenious, complex, and fascinating history of Florence, from nefarious assassinations to masterful paintings, from courtly intrigue to wondrous inventions. Florence may have been small, but like its mascot, David, it packed a powerful punch and made an indelible mark on the history books."

—Noah Charney, professor of art history and best-selling author of
Collector of Lives: Giorgio Vasari and the Invention of Art

"Want to feel the majesty and drama that made Florence the glory of Renaissance Italy? Rothfield's propulsive, witty, erudite history of the city-state is a must. Here's a guide to the genius, passions, politics, and noble and base motives of its creators, its rulers, and those who sought to favor them and usurp them. Rothfield helps us feel how the outsized impact of this remarkable city grew and ultimately faded, and why its power dimmed but its splendor endures. Readers may want to draw contemporary parallels to Renaissance Florence's bravura cultural ambitions and political machinations—go right ahead—but this book's real strength is making a magnificent place magnificently alive."

—Ted C. Fishman, best-selling author of
China, Inc. **and** *Shock of Gray*

"Democracy, freedom, civic participation, prosperity, and social vigor battle tyranny, foreign interference, suppression, disparities of wealth, and pandemics in the rise and fall of the republic. Though the themes strongly resonate today, the setting is Renaissance Florence. Lawrence Rothfield provides a highly readable account of the shaping of this most influential of cities, wonderfully blending the republic's political and economic tensions with tales of artistic creativity and innovation, and adeptly using such characters as the Medicis, Machiavelli, and Michelangelo to do so."

—Richard Kurin, Smithsonian Distinguished Scholar

"A warm and welcoming introduction to Florence and its history, perfect for students and for travelers who want to understand the stories hidden in the city's layers and architecture, all written with true erudition and love."

—Ada Palmer, author of *Reading Lucretius in the Renaissance* and the award-winning Terra Ignota series

"This is just the book I wanted but couldn't find when I first became interested in Renaissance Florence. It's a delightful read, full of fascinating color and detail."

—Jo Walton, award-winning author of *Among Others*, *The Just City*, and *Lent*

"A vibrant chronicle of the political and artistic ventures of Renaissance Florence, whose citizens attempted to stave off encroaching tyranny as humanists delved into ancient texts to forge a new culture and painters and sculptors created glorious artworks. As Rothfield persuasively argues, we still have much to learn from the ways political struggle and artistic experiment intertwined in the scintillating and tumultuous Quattrocento."

—Rebecca Zorach, Northwestern University

The Measure of Man

Liberty, Virtue, and Beauty in the Florentine Renaissance

Lawrence Rothfield

ROWMAN & LITTLEFIELD
Lanham • Boulder • New York • London

Published by Rowman & Littlefield
An imprint of The Rowman & Littlefield Publishing Group, Inc.
4501 Forbes Boulevard, Suite 200, Lanham, Maryland 20706
www.rowman.com

6 Tinworth Street, London SE11 5AL, United Kingdom

Distributed by NATIONAL BOOK NETWORK

British Library Cataloguing in Publication Information Available

Library of Congress Cataloging-in-Publication Data

Names: Rothfield, Lawrence, 1956– author.
Title: The measure of man : liberty, virtue, and beauty in the Florentine Renaissance / Lawrence Rothfield
Description: Lanham : Rowman & Littlefield, [2021] | Includes bibliographical references and index.
Identifiers: LCCN 2020037175 (print) | LCCN 2020037176 (ebook) | ISBN 9781538143360 (cloth) | ISBN 9781538143377 (epub)
Subjects: LCSH: Renaissance—Italy—Florence. | Florence (Italy)—Civilization. | Florence (Italy)—History—1421–1737.
Classification: LCC DG737.4 .R67 2021 (print) | LCC DG737.4 (ebook) | DDC 945/.505—dc23
LC record available at https://lccn.loc.gov/2020037175
LC ebook record available at https://lccn.loc.gov/2020037176

♾™ The paper used in this publication meets the minimum requirements of American National Standard for Information Sciences—Permanence of Paper for Printed Library Materials, ANSI/NISO Z39.48-1992.

Contents

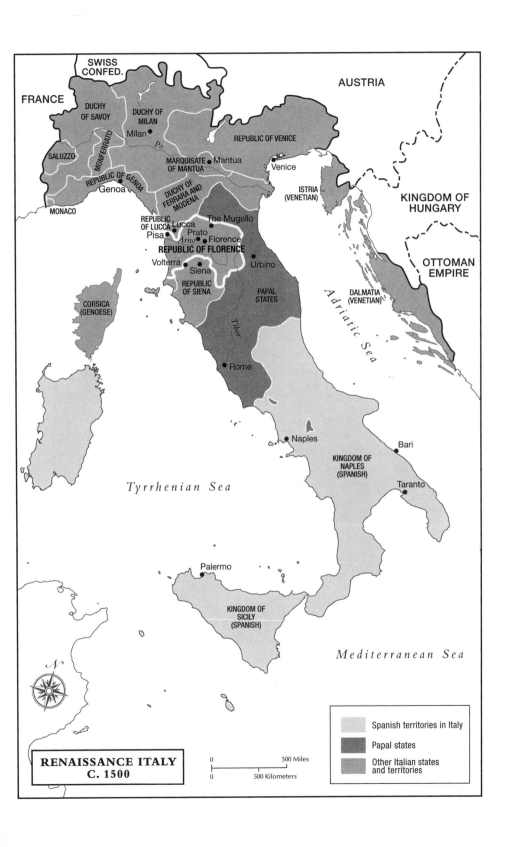

RENAISSANCE ITALY
C. 1500

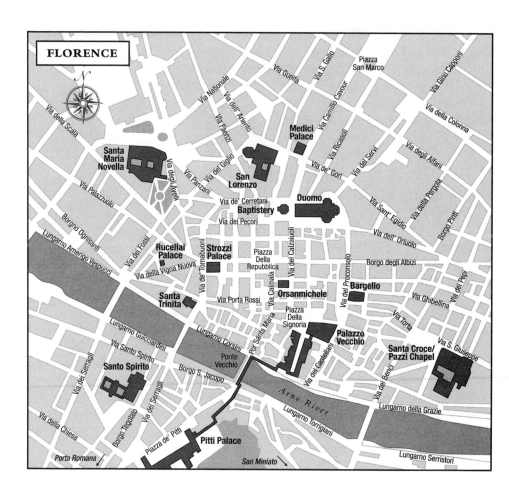

CHAPTER ONE

~

Florence Rising

The enormous surge of creativity we call the Florentine Renaissance burst forth around 1400. But its foundations had been laid long before, over several centuries, an era marked by the normal medieval curses of urban life—floods, fire, famine, and plague—but also, in Florence's case, by legendarily bloody vendettas, vicious factional strife, financial fortune-making, and failure on a scale unmatched before or since, and the first confrontation between urban workers and capitalists in Western history. Out of this welter of ambition, passion, and class conflict the Florentines of the Trecento would haltingly develop the institutions, habits of thought, and political attitudes of free people in a self-governing republic. And they would begin to shape—both literally and symbolically—the civic stage on which the high drama of the Renaissance would unfold.

Everyday Life in Late-Medieval Florence

In 1312 the Florentine merchant Dino Compagni declared of his hometown:

> This city of Florence is very populous and its good climate promotes fecundity. Its citizens are well-bred, and its women lovely and adorned; its buildings are beautiful and filled with many useful crafts, more than any other city in Italy. For these reasons many come from distant lands to see Florence—not because they have to, but because of its crafts and guilds, and the beauty and decoration of the city.[1]

Compagni was exaggerating, especially about the quality of Florence's often stiflingly hot and mosquito-ridden climate. But the city-state on the Arno was certainly already a place worth visiting, even a hundred years before the Renaissance transformed it into the cultural mecca it is today. Before the Black Plague struck in 1348, Florence was one of the largest municipalities in Europe, with around 120,000 inhabitants in 1300, most jammed into an urban center so small, one could walk from one end to the other in less than half an hour. It also was enormously wealthy: by 1400 the commune's revenues were already greater than those generated by Shakespeare's England two hundred years later.

Florence's rise as an economic powerhouse was all the more impressive given its unpromising geographical and political surroundings. The commune was menaced by petty tyrannies, lacked either a port or raw materials of its own, and was situated in a vulnerable river valley rather than on a fortified hilltop. Yet it had prospered nonetheless. Much of the city's success could be traced to the financial genius of its precociously capitalist merchant bankers, the inventors or early adopters of double-entry bookkeeping, cargo insurance, traveler's checks, and international bailout packages to kings. Their dealings, along with the sumptuousness of Florentine textiles and the sophisticated craftsmanship of thousands of potters, glassmakers, goldsmiths, armor makers, cabinetmakers, engravers, leather toolers, ivory carvers, manuscript illuminators, and tapestry weavers, gave late-medieval Florence a commercial dynamism unmatched anywhere in Europe. Its coin, the fingernail-sized gold florin, the dollar of its day, circulated everywhere as the international currency. Its diplomats circulated as well, serving as ambassadors for so many countries that Pope Boniface had compared them to a fifth element distinct from earth, air, fire, and water.

Not that everyone loved, admired, or even respected the Florentines. On the contrary, in a Europe dominated by courtly cultures, where merchant wealth was looked down upon and republics were sneered at as devoid of honor, Florence's shrewd, fast-talking businessmen were despised by many. They were rumored to regularly commit not only usury but sodomy, a reputation that would remain with them for centuries.[2]

In reality, late-medieval Florentine society was neither as venal nor as licentious as its courtly detractors would have it. But life there was far more complicated and vigorous than almost anywhere else in Europe, and far more cosmopolitan. In a still largely feudalized Europe

where most people never traveled more than twenty miles from the farmlands on which they toiled, a visit to late-medieval Florence must have been quite a culture shock. Entering through one of the three main gates in the city's six-foot-thick, forty-foot-high wall, an arriving merchant might note the coat of arms of a whip or dragon signaling he was entering one ward or another (only one of these stone markers remains, on the upper end of the via Sant'Agostino near the church of Santo Spirito). If coming from the east, our visitor would skirt the complex of fetid workshops along the Arno in the Santa Croce area around Corso dei Tintori, where tons of raw English wool were dipped in lye and tinted in vats using secret formulas brought back from the Orient by Florentine entrepreneurs.

As he made his way through a maze of streets, the merchant would find himself assaulted by the clatter of looms from silk-weaving workshops, the sound perhaps punctuated by the distinctive ring of the bell of justice announcing from the tower of the Bargello the opening of court. The going would be slow, through streets clogged with flocks of sheep headed to market, slave girls hurrying on errands, mendicant friars on the lookout for corpses for which they could beg alms from parishioners, and stone carvers lugging their tools and lunch on their backs. Coming upon tiny piazzas where knots of men with the red caps and dark ankle-length gowns of citizens stood arguing in front of one or another of the city's hundred-plus churches, the merchant might ask directions to his destination at the heart of Florence's business center: the communal granary of Orsanmichele. There, in good weather, he would find seventy or more tables set up in the street, each manned by bankers intently changing money and making loans, swearing by the milk of the Virgin or of their own mothers that they would fulfill their end of the bargain.

The swirl of activity in the streets reflected a Florentine work ethic, one so strong that dying parents were known to beg the government in their wills to fine a son one thousand florins if he declined to practice a regular profession. But this was not a Puritan ethic turning the city grim—it was balanced by many diversions. The grandest of these was the festival celebrating the city's patron saint, John the Baptist, during which merchants were required by law to set out for public view their jewels, rich cloths, reliquaries, fine glass, and armor. The festival's processions were stunning: with bells ringing continuously and trumpets blaring, hundreds of clergymen dressed in gold-embroidered gowns would go marching through the city singing

the liturgy, sprinkling holy water and wafting incense as they walked beside chariots bearing John the Baptist's thumb, a nail from the cross, or a thorn from Jesus's crown. Behind came wagons loaded with silver ex-votos or madmen, and huge floats illustrating biblical scenes (including a Moses float made by the Jewish community), with men "dressed as angels, and music and instruments of every type and marvellous songs, all presenting most beautiful representations of those saints and of those relics, to whom they do honor."[3]

Everyday life offered more homely pleasures. In the evenings and on holidays, men could play dice or backgammon, or share a laugh over one of the practical jokes so prized by Florentines for their combination of trickery and cruelty. (Some of the best of these come down to us in the tales of Boccaccio, Chaucer, and Sacchetti.) If a man were so inclined, he might make a nocturnal visit to the *cortigiane di candela*, prostitutes whose pay was measured by the rate at which a candle burned, perhaps seeking out one especially "skilled at wiggling her buttocks."[4] These ladies could be conveniently identified by their gloves and by the little bells that jangled on their heads to warn of, while advertising, their approach.

Virtuous women from the higher classes were much more difficult to meet, being kept at home until marriage, although some flirtation—or at least a fleeting glimpse of a possible mate—was possible at the cathedral on Sunday. For the purposes of marriage, however, a woman's looks mattered less than her lavish dowry—in some cases worth more than the houses owned by the family. The bridal trousseau became the husband's property, an asset to be inventoried and unsentimentally sold or pawned if need be. But choosing the trousseau was up to the wife-to-be. Fashionable upper-class Florentine women took full advantage of this opportunity to get out of the house and head to local convents to pick out fine linen sheets, stuffed pillows, and other luxury handicrafts sewn by the nuns.[5] A cultivated stylishness was also expressed in coiffure and clothing, as commemorated in portraits and busts by Filippo Lippo, Agostino di Duccio, and Antonio Rossellino. If not born blond, women dyed their hair or simply cut out the tops of their hats and let the sun bleach it. False hair made of white or yellow silk was very popular, as was the embroidering of images of peacocks or leopards and the ornamenting of dresses with topazes (believed to ward off impure thoughts), silver buttons, and pearls.

Such vain accoutrements, at odds with Christian teaching, did not go unnoticed by religious authorities. Savonarola, arriving in the 1480s,

was only the last and greatest of many generations of fire-and-brimstone preachers in Tuscany who fulminated against displays of luxury by Florence's well-off wives. Decades earlier, Savonarola's most important predecessor, Bernardino of Siena (1380–1444), whose statue today glowers at the pagan images gathered in the Bargello's great sculpture room, convinced thousands of Florentines to sacrifice "their vanities and amusements and their false hair" to a bonfire lit in the piazza of Santa Croce.[6] To rein in conspicuous display, the city established minutely detailed sumptuary regulations, stipulating, for instance, that only girls under ten could wear embroidery or pearls on their hoods. Such specificity was needed because any loophole would be taken advantage of by those with wealth to flaunt. One anecdote tells of a frustrated official in the 1390s, sent out to enforce the laws, who reported:

> I went out to look for forbidden ornaments on the women and was met with arguments such as are not to be found in any book of laws. For example, there was one woman with the edge of her hood fringed out in lace and twined round her head. My assistant said to her, "Tell me your name, because you have on a hood with lace fringes." But the woman removed the laced fringe which was attached to the hood with a pin, held it in her hand, and said it was merely a wreath.[7]

Bringing Things to a Head

Far more troubling than this literal skirting of the law were the recurrent political upheavals that a century earlier had led Dante to compare Florence's body politic to that of a sick man tossing around in bed, unable to get comfortable. For in a paradox at the heart of the Florentine experience, the city's bustle, prosperity, and pride coexisted with an always ominous threat of strife.

From the very beginning, fractiousness and conflict characterized Florentine political life. The commune had its origin, in the late Middle Ages, as nothing more than clusters of dauntingly tall stone towers, each with its own entry bridge, designed to serve as the strongholds of rich families and their retainers. By the twelfth century, the leading Florentine clans were able to put aside their mutual mistrust long enough to raise makeshift armies against those feudal lords who dared to impose tolls and duties on goods passing by their castles on the way to and from the city. The bell would sound, and workmen, dropping their tools, would march into battle in everyday dress behind the few citizens among their masters who could afford horse and armor.

The rural warlords they opposed were under the nominal protection of the officially recognized ruler of Tuscany, the Hohenstaufen Holy Roman emperor. But Germany was far from Florence, and over time, backed by the emperor's natural rivals France and the Papacy, the commune brought its surrounding countryside to heel. Defeated feudal families were required to parade, candles in hand, through the doors of the cathedral church; their fortresses, like the one that had glowered down on Florence from Fiesole, were "completely destroyed and demolished right down to their very foundations."[8]

No sooner had this pacification been accomplished, however, than another conflict flared within the city itself. This new strife pitted the pro-imperial party of old noble families with feudal connections, the Ghibellines, against the pro-papal, more business-oriented faction of urban aristocrats known as Guelphs.

The century-long struggle was supposed to have its roots in a vendetta of legendary origins, pitting the Buondelmonti clan against those of the Amidei and Uberti. It all began, say the chroniclers, with a scuffle at a feast held in 1216, attended by hotheaded young knights from all three families. Some joker snatched away a plate of food from one of the guests, a friend of a nobleman named Buondelmonte de' Buondelmonti. In the ensuing fracas, Buondelmonte stabbed one of the Uberti entourage.

To restore peace between the families, city elders decided that the extraordinarily handsome Buondelmonte should marry the injured man's niece, a plain-looking girl from the Amidei family. The betrothal ceremony was set for the next day. But as Buondelmonti, described in Villani's telling of the story as "very charming and a good horseman," was riding through the city, a lady called to him from her window, crying out that he would be disgraced if he married. People would think he was afraid of the Uberti, especially since the girl he had been assigned "was not beautiful or worthy of him." Throwing open a door, she enticed Buondelmonti in, saying, "I have kept this my daughter for you." The daughter, Villani tells us, "was most beautiful; and immediately by the inspiration of the devil," Buondelmonti decided to jilt his fiancée.[9] So, we learn from a second chronicler, "when on the following day the guests of both parties had assembled, Messer Buondelmonte passed through the gates of Por Santa Maria [one of the old city gates], he went to pledge troth to the girl of the Donati family; and her of the Amidei he left waiting at the church door."[10]

The Amadei and their relations were enraged, and after some discussion of what to do, they decided on murder as the appropriate response. As their leader put it in what has become a proverb, "*Cosa fatta capo ha*" ("It's best to bring things to a head"; lit., a thing done has a head, a thing done outright is finished, what's needed is not half measures but to get the job done). After the wedding on Easter Sunday, Buondelmonte, "clad in jacket and mantle of white silk, with a garland on his head" and riding a white palfrey, led the bridal party over the city's main bridge, the Ponte Vecchio. In front of the Amidei towers abutting the bridge, "just at the foot of the pillar where was the statue of Mars" (later washed away in the great flood of 1333), his assailants were waiting:

> Messer Schiatta degli Uberti rushed upon him and striking him on the head with his mace brought him to the ground. At once [the man he had wounded at the feast] was on top of him and opened his veins with a knife and having killed him they fled. . . . Great was the uproar in the city. He was placed on a bier; and his wife took her station on the bier also, and held his head in her lap, violently weeping; and in that manner they carried him through the whole of the city; and on that day began the ruin of Florence.[11]

In its meshing of lyricism and violence, subterfuge and tragedy, this is an episode worthy of Shakespeare, and "*Cosa fatta capo ha*" may well have served as a source for the playwright (recall Macbeth's thought about when to carry out his contemplated assassination: "If it were done when 'tis done, then 'twere well / It were done quickly"). But as history, it is highly suspect. The reality behind the tale is far less poignant and more brutal: decades of savage gang warfare in Florence's alleyways between the Uberti and Buondelmonti clans. The Uberti looked for support to the emperor, forming what came to be known as the party of the Ghibellines; the Buondelmonti turned to the other outside power, the pope, naming themselves Guelphs.

For some fifty years, Guelphs and Ghibellines took turns expelling each other from the city and pulling down the towers of their exiled foe. Though neither group could have clearly said what it was fighting for, things got so polarized that it became possible to recognize a Guelph or Ghibelline by the cut of his jacket, by the angle at which he wore the feather in his cap, or by the shape of the battlements crowning the family tower.

When Emperor Frederick II died unexpectedly in 1250, creating a momentary power vacuum on the Italian peninsula, a group of non-noble Guelph merchants seized the opportunity to wrest control of the city from its vendetta-obsessed factions. Calling themselves the First Democracy, they set out to rein in the lawless nobility in both camps. To defend the city and maintain order, the government created neighborhood militias. These were to be controlled by a neutral foreigner. At the ringing of a bell he could summon them to muster in front of a newly designed Banner of the People showing a red lily on a white background (reversing the colors of the older emblem that the evicted Ghibellines had appropriated). To house this "Captain of the People" the city built the daunting palazzo later to be called the Bargello (now the National Museum housing many of the city's greatest sculptures).

The Guelph republic was not to be consolidated, however, without one last bloodbath. It happened in 1260, when the Florentines raised an enormous army of about seventy thousand men with the aim of defeating once and for all the Ghibelline exiles, who had regrouped in Siena. The battle turned out to be one of the greatest military fiascoes in the city's history. The Sienese, greatly outnumbered though they were, caught the Florentines unprepared on the edge of the shallow river Arbia at Montaperti. Turned upon by treacherous Ghibelline sympathizers within their ranks, Florence's noble cavalrymen fled in disarray. They left behind huge numbers of foot soldiers who were quickly routed.

"A great butchery ensued," according to Giovanni Villani.[12] Dante, who must have heard many gruesome recollections of the carnage from his elder Guelph compatriots, reported that by the time it ended, the river was running red with blood. In the debacle, ten thousand Florentines were killed and twenty thousand captives thrown into Sienese dungeons. (Decades later, Dante would take symbolic vengeance on the Florentine turncoat blamed for the debacle, stomping on his face when meeting him in hell in the circle of traitors.)

It took the combined forces of French-born Pope Clement IV and Charles of Anjou, the king of France's brother, to expel the Hohenstaufens from Italy in 1266, and spell ultimate defeat for the Ghibelline party. This time, the victors took no chances. To make clear that the exiled Ghibellines were never to return, the Guelph government razed the houses of the Ghibelline Uberti clan to the ground, with orders prohibiting any houses to be built on the site ever again. That awkwardly shaped clearing became the city's civic gathering place, the Piazza della Signoria. As an assertion of public authority, in 1299

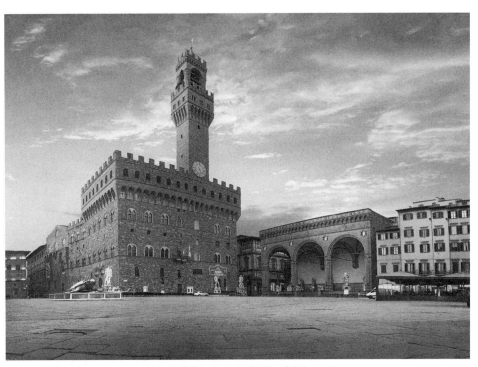
Piazza della Signoria (© iStock/Givaga)

the commune began constructing there a dominating Palace of the Priors (today called the Palazzo Vecchio), deliberately set askew so as not to stand on the accursed Uberti ground. By decree, no taller private towers would be permitted. To further limit the power of the remaining noble clans whether Ghibelline or Guelph, and to symbolize the predominance of the commune over individuals, the government required families who had knighted themselves to put down a hefty sum as bond. This was to be forfeited if any family member broke the peace.

With the age of vendettas finally over, business boomed, fueled by the trading privileges granted by the Guelph axis—the pope and the kings of France and Sicily—to Florence's bankers, who either backed or themselves also went into business as wool and silk merchants. Along with lawyers, doctors, and apothecaries, these captains of industry organized themselves into seven "major" guilds. In the new system of government they instituted in the 1280s, they tried to defuse future potential conflicts between clan-led factions. The city's six priors were to be elected, but only the guilds could nominate candidates. To further guard against any one group gaining influence over the government by swaying those nominated, priors were permitted to serve for only two months and were required to do so sequestered together, insulated from the pressures and private interests of their own families.

Despite such measures, factionalism soon flared once again. With the Ghibellines ousted, the Guelph party itself began to fracture, a new struggle emerging between Guelph merchants preferring independence (the Whites) and Guelph aristocrats welcoming papal influence (the Blacks). Led by the imperious magnate Corso Donato, the Blacks eventually gained the upper hand, with the help of Pope Boniface VIII, who wished to set up his relatives as rulers of Tuscany. Four days after the pope's representative had arrived in Florence in 1301, the exiled Donato announced his return by breaking through the city gates at dawn. He and his allies proceeded to terrorize the city for the next five days, driving out the priors, sacking the houses of his enemies, opening the city's prisons, and inciting released criminals to rampage. In this vendetta, the losers, the White Guelphs, were sentenced to death by the hundreds. Most, including Dante as well as Petrarch's father, escaped by going into permanent exile, where, ironically, they became allies of their former enemies the Ghibelline exiles.

"Death to the Hats!"

The exile of the White Guelphs did not spell an end to factionalism: within a few years one group of Black Guelphs would set fire to the houses of another group, a move that, in typical Florentine fashion, spun disastrously out of control, sparking a conflagration that consumed 1,700 buildings, including the original covered market at Orsanmichele. "What was not burnt up by the fire," Villani tells us, "was carried off by robbers, who were aided by the circumstance that civil war continued to rage throughout the city."[13] But gradually, under a government run by the major guilds, civil strife gave way to more straightforwardly material concerns as the capitalist economy emerged. Fourteenth-century Florentines witnessed the making of unprecedented fortunes, and equally unprecedented financial disasters. Among these failures the most spectacular were the bankruptcies of Florence's two richest banks, the Bardi and Peruzzi—the latter folding when Edward III of England defaulted on a debt of $350 million.

In addition to financial booms and busts, the century was punctuated by natural devastations: periodic floods—one deluge in 1333 washed away two hundred feet of the forty-foot-high city wall—and, of course, plagues. The most horrific of these, the Black Death of 1348, was brought to Europe, the chronicler Villani tells us, by Genoese sailors returning from the Black Sea. Within weeks of its arrival, five out of every eight Florentines would be dead. Villani offered a chilling eyewitness report of the horror around him: "It was a disease in which there appeared certain swellings in the groin and under the armpit, and the victims spat blood, and in three days they were dead. And the priest who confessed the sick and those who nursed them so generally caught the infection that the victims were abandoned and deprived of confession, sacrament, medicine, and nursing." Villani added, "And many lands were made desolate. And this plague lasted till . . ."[14] Here the manuscript breaks off, Villani himself having been struck down by the disease he was documenting.

Notwithstanding such tremendous reversals and hardships, the everyday lot of Florentines improved over the course of the century. The city expanded geographically, erecting a much larger circle of walls, completed in 1333, with gates thirty-five meters tall. (In the 1860s most of the walls were demolished to create Florence's ring road, though the walls and towers on the hills of the Oltrarno side of town

survive.) More and more of the city's residents found themselves in a position to afford the good life, having built up their families' fortunes by reinvesting inheritances and dowries. The new prosperity was reflected in the introduction of some basic creature comforts for the middle and upper classes: fireplaces and stoves were installed in rooms; most wooden buildings were replaced by stone; mattresses and goose down comforters came into more widespread use for bedding.

The newly wealthy also invested in literacy. The top 10 percent of the population—nobles, professionals, and the better-off merchants— were taught to read and write well or trained on the abacus in the rudiments of commercial math. Most of their wives and daughters attained at least basic literacy as well. Even artisans began to be able to leave behind records—chronicles, account books, business ledgers, and handbooks describing how to dye cloth—giving us, for the first time in the history of Western culture, an intimate view of social life below the ranks of the elite.

It's important to note, however, that more than three-quarters of the city's male inhabitants were not merchants, bankers, landowners, professionals, or artisans, but ordinary manual workers: wool carders, silk dyers, laborers, peddlers, and the like. These proles were, legally speaking, recognized only as subjects of the guilds they worked for, not as citizens, and the businessmen running the city passed laws prohibiting them from even meeting to try to form their own associations. Whether Florence's guild government should expand to include the lower artisanal guilds of carpenters and butchers, or whether government was to be controlled by "new men" rising within the guilds or by the Parte Guelfa (an association of conservative older super-elite families that increasingly attempted to dominate the city's politics in the 1370s)—these were secondary questions for the working classes. For them, as for the impoverished masses of unpropertied day laborers below them, a more immediate and constant worry loomed: famine. About once in a decade crop failure would lead to starvation. At such times, Villani tells us, "the agitation of the people at the granary of Orsanmichele [not yet converted, as it would be after 1380, to a chapel for the powerful guilds] was so great that it was necessary to protect the officials by means of guards fitted out with ax and block to punish rioters on the spot with the loss of hands or feet."[15]

The dire poverty of so many stood in stark contrast to the vast wealth of the few perched at the top of the new capitalist economy. The founder of the Medici family's fortunes, Giovanni di Bicci de'

Medici, for instance, would declare in his 1427 tax returns that he was worth eighty thousand florins—almost surely an underestimate, but still a sum large enough to pay the annual salaries of forty thousand wool workers. Given such extreme income inequality, exacerbated by high taxes, it was inevitable that a political challenge would sooner or later erupt from below, threatening the entire system of government. Already in 1345 and 1368, workers had attempted to enfranchise their unions, only to be brutally put down. One organizer was dragged out of bed in the middle of the night and taken into custody. According to a contemporary diarist, his friends "went to the priori and urged them to restore Ciuto safe and sound . . . and said they also wished to be better paid. Ciuto was then hanged by the neck."[16]

In 1378, however, the tables turned, in the first successful urban workers' revolution in modern history. What came to be known as the Revolt of the Ciompi (from the medieval French word for "comrade") began on July 20 when, following demands by lower guilds for representation, eight church bell towers around the city rang out nearly simultaneously, rallying thousands to the Piazza della Signoria. Led by wool carders, the mob stormed the Palazzo della Signoria. Shouting "Death to the hats!" (members of aristocratic families wore hats symbolizing their status) and "Long live the capes!" (worn by guildsmen and the poor), they ripped the chief of police to pieces. He was, according to Machiavelli, "hung on the gallows by one foot; and as whoever was around tore off a piece from him, at a stroke there was nothing left of him but his foot."[17] The revolutionaries then burned the palaces of their aristocratic enemies and chose a new head of state, by the acclamation of the crowd.

The six-week government they set up declared a moratorium on the debts of wage earners and instituted a more equitable system of taxation. It also repealed laws against unions and enfranchised the lower guilds. For that brief period, nearly every male of working age in a city of fifty-five thousand was a guildsman.[18] Though the itinerant day laborers among those who had instigated the revolt were soon once again barred from holding office, the regime that ruled for the following four years still must be considered radically democratic in its composition compared with other contemporary forms of government. The list of those serving now included not just elite guildsmen but those from the lower craft guilds: "Lorenzo, potter; Pizzino, coppersmith; Benedetto, shoemaker; Nino, farrier; Niccolò, knife-maker; Buono, doublet maker."[19]

This historically precocious attempt at a truly broad-based guild republic, however, soon met fierce resistance from above and from below. Business leaders shut shops and cut off the food supply, while the excluded Ciompi tried to set up a rival government. By 1382 the popular guild regime had fallen into disarray, and on January 20 elite families, arming their servants and retainers and bringing in peasants from the countryside, drove the butchers, dyers, and shirt makers from the Piazza della Signoria. Guildhalls were ransacked, the records of the workers' guilds destroyed. The wealthy merchants and magnates who would henceforth control the city's political life would no longer have to bear "the stench of the plebs."[20]

Violent and aborted as it was, the workers' revolt and the brief era of popular government for which it cleared the way nonetheless helps highlight the importance to Trecento Florentines of liberty as a thing to be struggled for. Not intellectually, to be sure. While fighting for control of the commune, its citizens and workers did not pose for them-selves deeper conceptual questions about liberty—what it is, what it looks like, how it should be exercised and practiced, and where it might lead both imaginatively and politically. Freedom for late-Trecento Flo-rentines was not a principle yoked to democratic theory. It was, rather, a habit of mind shared by rich and poor, an attitude rooted in Florence's unique social and economic heritage and reflected in the opportunity for advancement the city offered even to "new men" despised by the city's older ruling class. Tuscany's peasants had been emancipated from slavery centuries before the rest of Italy and Europe; they farmed half for themselves, half for their landlords. And when they arrived in Flor-ence, they found a society in which, as social historian Richard Gold-thwaite notes, social constraints on individual expression—guilds, class hierarchy, a highly personal patronage system—were much weaker than elsewhere.[21]

In politics, the absence of hereditary royalty encouraged an attitude of independence in Florence, as in other northern Italian city-states, a point emphasized by the great nineteenth-century historian Jacob Burckhardt in *The Civilization of the Renaissance in Italy*:

Here was no feudal system after the northern fashion, with its artificial scheme of rights; but the power which each possessed he held in practice as in theory. Here was no attendant nobility to foster in the mind of the prince the mediaeval sense of honor, with all its strange consequences; but princes and counsellors were agreed in acting according to the exi-

gencies of the particular case and to the end they had in view. . . . With such men negotiations were possible; it might be presumed that they would be convinced and their opinions modified when practical reasons were laid before them.[22]

What Burckhardt says of new principates held even more strongly for the Florentine Republic just before the dawn of the Renaissance. Though the merchant elites sought knighthoods and other signs of royal prestige, political decisions could hardly be justified by appeals to knightly honor by businessmen who had expelled their own nobility and did not even know how to joust, and autocratic whims were difficult to indulge where decisions were taken not by one ruler but by a frequently rotated group of citizen priors chosen by lot from a sack containing thousands of names.

The actual distribution and exercise of power, of course, was more restrictive than this electoral mechanism might suggest. Until the 1380s, those lucky enough to be picked from the bag to serve as priors also had to pass the scrutiny of the oligarchs of the Parte Guelfa. If the citizen selected was not to their liking, the unhappy potential officeholder was warned that if he didn't turn down his nomination, the party would brand him a Ghibelline—still at the time tantamount to a death sentence. After the fall of the guild government, however, the oligarchs, seeking political stability, tweaked the electoral rules. They permitted a much larger number of citizens (albeit from a narrower social spectrum) to have their names tossed into the election bag. The worry now was no longer factional vendettas, but plots by ultra-wealthy families to foment another workers' revolution—one that would install the Alberti or Medici as popularly supported tyrants. Just such a tyranny had almost been established by Walter of Brienne, the so-called Duke of Athens. A French nobleman invited into the city in the 1340s to help bail it out financially, he tried and nearly succeeded in mobilizing the masses in support of his bid to become despot; this brief episode, together with the Ciompi revolt just weathered, left deep psychological scars on Florentine elites.

To fend off the real possibility of subversion by the super-wealthy, the government continued to use the time-honored tool of exile: in 1393, for instance, the Alberti, a fabulously rich banking family, were expelled after they instigated a riot by artisans who stormed into the city center chanting "Long live the people and the arts [the suppressed guilds]!" and who nearly succeeded in snatching the Banner of the

People from the Bargello.[23] Against subversion from below, the commune created a political police (known as the Eight) that infiltrated spies into working-class circles. And where the rich might face exile, the penalty imposed on dissatisfied workers who might be hoping for a second Ciompi rebellion was more brutal and summary: execution or imprisonment in the city's notorious prison, the Stinche.

Given such direct and indirect political constraints, it would certainly be wrong to think of Florence as a modern democracy. But for all its shortcomings, the Florentine state was remarkably politically progressive for its time, even after the victory of the oligarchs and the end of the guild regime in 1382. A greater percentage of its inhabitants participated in civic life than any other major city in Europe, not just by voting but also by taking their turns serving two-month stints in one of several thousand public offices. That is not to say that officeholders were all treated equally. In practice, a leadership elite of at most a few hundred, recruited from the wealthiest and most prominent families, tended to define policy, with the rank-and-file citizenry accepting their hegemony. "The commune was really governed in dinner-parties and in [private] studies," grumbled Giovanni Cavalcanti, who went on to describe how one of the oligarchs, Niccolò da Uzzano, slept through a debate only to awaken at the end and announce a policy that was then unanimously agreed to without a moment's hesitation.[24]

Cavalcanti's cynicism aside, his comment registers a key assumption of Florence's political culture: that government required discussion. Whether informally at dinner tables and in studies, or more formally in official policy deliberations, views were shaped through conversations among friends and neighbors. Having an opinion, even if this often meant subscribing to the opinions of others more important than oneself, was necessary for citizens who might well find themselves tapped to participate in the government's *practiche*. These consultative assemblies, established as early as the 1340s, called upon citizens to advise the city's rulers on important issues before they were voted on by the priors. Serving in a *practica* was an honor most Florentines yearned to be permitted to perform. Even before the Renaissance, then, a critical mass of Florentines was used to acting not as subjects but as free citizens engaged in the practicalities of political decision-making, under the aegis of the *libertas* associated with republican government. To remind all of the importance of liberty, the word was prominently featured on the insignia of a shield painted in the center of the facade

of the Palazzo Vecchio (probably around 1350, shortly after the expulsion of the tyrannical Duke of Athens).

Yet the centrality of freedom for fourteenth-century Florentines did not yet translate into political self-consciousness about what it means to value liberty. How a self-governing republic might justify itself, or what the distinctive virtues of republicanism might be, were not yet central concerns. As political theorist J. G. A. Pocock has noted, until late in the Trecento, Florentines took for granted that the city's liberty was legitimated by an affiliation with a larger power—the pope or the Holy Roman emperor—whose dominion in turn mirrored God's eternal order. For the medieval Florentine, as for citizens of other communes, "republic, empire, and apocalypse were all of a piece."[25] Where we might see a contradiction between liberty and empire, in short, they saw none.

Within this worldview, a patriot like Dante could thus assert his identity as at once a Florentine citizen and a citizen of the Empire. More importantly, he and other medieval Florentines could imagine politics as a struggle not to define or defend liberty as such, but to institute good government by overcoming the natural brutishness of man. Such bestiality was reflected in the civic discord of the lawless mob and the furor of factionalism that the commune had suffered from, according to Dante's mentor Brunetto Latini, "at the beginning of this century [1200], when there was neither king nor emperor on earth, justice was unknown, and the people of that time lived in the manner of beasts without law and without any form of communal life."[26]

Civic life was about reestablishing the republic's relation to ideal order by hearkening back to the principles of stability and peace associated with Rome, principles thought to be embodied in the city's ancient traditions. After all, Florence had been founded, it was said, by Julius Caesar's soldiers, and refounded by Caesar's imperial descendant Charlemagne, who was imagined to have visited the city and granted the commune and its people the privilege of being "franco e libero."[27]

Politics therefore should aim not at making history, but at restoring those immortal traditions—traditions whose authority was in turn underwritten, for Dante and others, by the advent of Christ in the age of Augustus. A group of citizens in a republic might be able to bring Florence back into alignment with its ideal origins. A wise ruler could do it just as well, however, and perhaps more easily. Until Florence came to reflect the City of God, things might get messy, and the city

might even fall under rule by a tyrant for a time. As he is shown doing in Domenico di Michelino's painting in the Duomo (Image 1), Dante might remind Florentines of the need to fear the inferno their faction-alism had made of civic life, and show them the mountain they needed to climb to reach Paradise. But since, as the chronicler Goro Dati put it, they believed "a commonwealth cannot die,"[28] any more than God's order could vanish, a Florentine citizen in 1390 did not have to ponder what his city's political destiny could be, or begin to imagine the many ways in which the political virtue of citizens in a republic might be embodied in art, institutions, and selves.

~

The Work of Man

Within a generation, and for the next 150 years, concerns about the nature of civic virtue and the fate of republican freedom would come to haunt the Florentines. As the historian Gene Brucker notes, "No other city explored so systematically the basic problems of government: how to create and maintain institutions that would preserve liberty, how to foster a strong civic spirit, how to persuade citizens to make sacrifices for the good of the whole community."[1] The quest for answers would impel Florentines to turn to the pagan past, and the ideas and attitudes they rediscovered there would find modern expression in the great cultural and artistic achievements of the early Renaissance. But how were Florentines driven to first pose such basic questions of liberty for themselves?

The Viper of Milan

Florence's liberty had always been shadowed by fears—of usurpation by a faction within the city, of plundering by a marauding petty warlord, of the anarchy of vendetta or working-class riots, of plots by exiles harbored in rival city-states. Bad as these possible eventualities might be, however, they did not call into question the very survival of the commune. At the end of the fourteenth century, however, Florence faced a new kind of threat. In Milan, the cunning tyrant Gian Galeazzo Sforza, self-styled "Count of Virtù" (who had his own uncle poisoned in prison, according to Chaucer), had shaped a new kind of state. Regional in

scope, unfettered by feudal tradition, and bent on expansion, Gian Ga-
leazzo's Milan expressed its attitude toward the surrounding city-states
in its ruler's emblem: a coiled viper, its jaws opening wide, swallowing
up a tiny figure who is struggling in terror.

Gian Galeazzo's expansionism was not unique. Florence's oligarchy
itself had, since the Ciompi rebellion, begun to expand the city-state's
dominion, purchasing the town of Arezzo from the French and wading
into territorial disputes with the neighboring republic of Siena and
with Bologna. But these proto-imperialist moves did little more than
nibble away at the territory of bordering city-states. Moreover, this pol-
icy met with domestic resistance. Some Florentines opposed military
action against neighbors on moral grounds, others on the grounds that
"liberty has no greater enemy than war with its expense."[2] The city's
oligarchs, for their part, justified going to war as a defensive measure
taken to buttress the political dikes holding back the Milanese tide.

The autocratic duke of Milan, by contrast, was unapologetically
and relentlessly imperialist. Over the course of the 1390s, slowly
but inexorably Gian Galeazzo gobbled up the medieval city-states of
northern Italy: first Pisa, then Siena and Lucca. By 1399 Florence and
Bologna were ringed by Milanese territories, with little hope of rescue.
Venice wanted no part of a land war, and Rome was busy coping with
the claims of a French anti-pope; the only other possible ally, Naples,
was rent by civil war. Then, in June of 1402, Milanese troops were ad-
mitted to Bologna, leaving Florence as the only free commune left in
the region. As the historian Hans Baron notes, as summer set in "the
northern and central provinces of Italy seemed destined to develop into
one vast and powerful tyrant-state incorporating the entire urbanized
area south as well as north of the Apennines."[3]

Gian Galeazzo needed only to direct his army through now inde-
fensible passes and territory to force his way into the city. He chose
instead to wait. As in the past, the tyrant expected his show of supe-
rior might, the famine caused by his siege, and the poignancy of his
propaganda to kindle treachery and defection in the adversary's ranks.
Florentines were already protesting the heavy taxes the war had im-
posed, and conditions were so dire in the countryside surrounding the
city, according to one chronicler, that "there was no peasant in the
contado who would not have come gladly to burn down Florence."[4]
Sooner or later the commune would crack under the pressure, like
the other city-states, bowing to this new Caesar touted by his pro-
pagandists for bringing peace to a land of factions and stamping out

"the detestable seed, enemy of quietude and peace, which they call liberty."[5] Meanwhile, Gian Galeazzo ordered a crown prepared for his coronation in Florence as king of Italy.

But time, with its uncertainties, proved Gian Galeazzo's nemesis and Florence's salvation. During the summer the bubonic plague began once again to ravage northern Italy, and on September 3 it carried off Gian Galeazzo himself. Without him, the Milanese forces disintegrated. The catastrophe had been avoided by sheer good fortune.

Propagandists of Liberty

Writing of this episode a century later, Machiavelli remarked acerbically that "death was always more friendly to the Florentines than any other friend, and more powerful to save them than their own virtue."[6] But his ancestors would not have agreed. In a battle of nerves and propaganda, they had stood up to the viper. Its citizens came away from the confrontation not only with victory against an autocrat, but also with a new sense of who they were and what their city stood for and against. At the start of its wars against Gian Galeazzo in 1390, the city had proclaimed, "Ours is a commonwealth, not of noblemen—one totally dedicated to trade, but *free*, the most hateful and abominable thing to the Duke."[7] Something like this appeal to freedom had already been voiced earlier, in the mid-1380s, when Florence, at war with Pope Gregory XI, encouraged rebellion by the citizens of papal state communes. Now the appeal was directed to Florentine citizenry itself.

The task of making liberty meaningful fell to a corps of grammarians and rhetoricians schooled in Latin and knowledgeable about ancient history, poetry, and philosophy—the *studia humanitatis*. Mostly from nonelite backgrounds, these intellectuals (not to self-identify as "humanists" until the late fifteenth century) played important roles in the everyday workings of Florence's government. Their duties included writing diplomatic correspondence, providing legal advice to the city's leaders, delivering public orations to visiting dignitaries, and in wartime putting into words the patriotic sentiments strongly felt but dimly understood by Florence's citizens.

Voicing in clear and cogent Latin the often muddled views of merchants serving their terms as priors could be an exasperating job, even for someone as patient as Coluccio Salutati, the public-spirited son of a soldier, who as Florence's long-serving chancellor became the general leading their propaganda war against Milan:

Imagine me attempting to satisfy everyone, surrounded unceasingly with citizens generally unable to state their problem. It is my task to discover from them what the nature of their business is so that, having understood the situation, I might work out what I must set forth in a letter and what is appropriate. Nor am I allowed to do this efficiently in peace but I am frequently interrupted by a call to come to the priors.[8]

Notwithstanding such vexations, Salutati promoted the Florentine cause extraordinarily well. His rhetoric was so effective that Gian Galeazzo is said to have complained that one of Salutati's letters did the Milanese more damage than a thousand Florentine horsemen. Gian Galeazzo responded by concocting counterfeited letters in Salutati's handwriting to have this troublesome chancellor framed for treason. Confronted by the forged letters, Salutati insisted that they were in his handwriting, but he had not written them. So high was his reputation for probity that this denial was immediately believed by all.

Salutati had honed his eloquence by devoted study of those ancient Roman texts accessible to him. His rhetorical role model was Cicero, the statesman/philosopher who had spent his politically engaged life struggling against the rise of tyranny. Salutati's own personal struggle, however, was less political and more intellectual: defending humanists' interest in paganism and history from attacks from churchmen like Giovanni Dominici, the fierce Dominican prior of Fiesole, who argued that "it is better for a man to plough than to read the books of the Gentiles."[9] Against such fanatics, who urged scholars to withdraw from the world to contemplate scripture, Salutati insisted that intellectuals had a practical political role to play, not just as scribes but as teachers versed in statecraft as well as in rhetoric. This was especially important in Florence, whose politicians were not princes groomed from birth to rule, but merchant citizens serving stints in government. For such men, lessons in thinking and speaking well about political life were more than window dressing—they were indispensable prerequisites for dealing with the challenges of republican rule.

In carving out a civic role for the humanists, Salutati helped make it safe for the next generation of intellectuals studying the classics to think seriously about politics and history. He himself, however, remained a conventional Christian not willing to challenge the basic principle that the kind of wisdom the pagans offered was necessarily inferior to Christian doctrine. And in his political theorizing, Salutati continued to frame the contemporary political situation in the old-

fashioned Guelph/Ghibelline terms, as a version of the age-old conflict between allegiances of sovereign communes to either the Papacy or the Empire, those two providential though incommensurable higher orders conferring legitimacy. For him, killing Caesar could be condemned insofar as Caesar was no tyrant but a benevolent despot.

It was left to Leonardo Bruni, Salutati's disciple and successor as chancellor, to explicitly repudiate the imperial/papal tradition and, in the wake of Florence's triumph, definitively recast the battle between Gian Galeazzo and Florence as a conflict between tyranny and republican liberty. The Guelph party which dominated Florence had once tied itself to the Church and its timeless legitimacy. Now, however, Bruni insisted that "from the human point of view," the party and the city it ran should be seen as conjoined instead with liberty—"liberty, without which no republic can exist, and without which, the wisest men have held, one should not live."[10]

Centuries later, Patrick Henry would put the same sentiment more pithily. But Bruni's ringing words need to be taken with a large grain of salt, given that Florence had become markedly less free after the crushing of the Ciompi rebellion. There is no doubt that defining the city's essence as liberty conveniently served the ideological interests of Florence's oligarchs by ignoring the distinction between popular and oligarchic regimes. And in advocating for republicanism, Bruni and other "civic humanists" should not be mistaken as arguing from an abstract ideal of natural rights applicable for all people at all times in all places. They do not condemn one-man rule out of hand. Indeed, many humanists would move from Florence or other republican city-states to new dynastic kingdoms such as Milan, Mantua, or Naples, re-jiggering their arguments to match the challenge of making virtue flourish under princely rather than oligarchic rule. As intellectual historian James Hankins puts it, for the humanists "good government is ultimately about good rulers and not about good regimes."[11] But it would be wrong to dismiss republicanism as nothing more than a cynical ploy. It may have been in bad faith, a lie Florentine citizens told themselves, but if so, it was a lie that worked for many, taking root in hearts and minds, molding character, steeling souls, and galvanizing patriotism.

If men were to be stirred to celebrate the republic's freedom and to declare themselves committed to defending it, however, Bruni's "human point of view" needed to be fleshed out. And so, if Gian Galeazzo had pretended to be Caesar reincarnated, the Florentines would counter by identifying themselves as latter-day Roman republicans. Connecting

the commune to Rome was easy enough. Like the inhabitants of nearly every Italian city, Florentines had long believed that Roman colonizers had founded their town. Traces of its Roman past could be seen in the layout of its streets (even today the outline of the ancient amphitheater is traceable in the curve of the via Torta) and in the statue of Mars that had been washed away by a flood seventy years earlier. Florentines even believed, wrongly, that the Baptistery had originally been a Roman temple. Now, however, it was important to specify that Florence had been founded by *free* Romans at a time when "the Caesars, the Antonines, the Tiberiuses, the Neros—those plagues and destroyers of the Roman Republic—had not yet deprived the people of their liberty."[12] If history was in essence an ongoing struggle against tyranny, the fight against Gian Galeazzo was simply the latest installment:

> This struggle was begun a long time ago when certain evil men undertook the worst crime of all—the destruction of the liberty, honor, and dignity of the Roman people. At that time, fired by a desire for freedom, the Florentines adopted their penchant for fighting and their zeal for the republican side, and this attitude has persisted down to the present day.[13]

This was a stunning revaluation of Florence's Roman inheritance, a view that earlier generations of Florentines would have found incomprehensible. Dante, for example, buried the Roman republican Brutus, Caesar's assassin, in the depths of hell as a traitor. Bruni, on the contrary, exalted him as the essential republican citizen, the self-sacrificing tyrannicide.

The Sacrifice of Isaac

Sparked by Salutati's and Bruni's oratory, Florentine elites suddenly began exhibiting a pronounced taste for what had previously been the hobby of humanist scholars and intellectuals. A fusion of political idealization and cultural identity quest, this new classicist aesthetic quickly made itself evident in what is arguably the first masterpiece of the Renaissance. In 1401, at the very height of the confrontation with Milan, the powerful Guild of Cloth Merchants put up the money to add two gilded doors to the city's most prominent Roman-style building, the Baptistery. The commission would be awarded to the winner of a contest for the best bas-relief of the *Sacrifice of Isaac*. The subject symbolized Florence's deliverance from the plague the previous year. But given the dire situation facing a city under siege by Gian Galeazzo's

forces, the last-minute arrival of divine help surely also must have called to mind, in that moment of crisis, Florence's hoped-for deliverance from the viper of Milan.

If the subject of the competition itself thus lent contemporary historical resonance to a biblical event, the style in which that event was presented made clear that a new understanding of history was emerging. To represent sacred subjects, earlier artists would have relied on standardized Byzantine iconography designed to take the drama out of the moment and convey an allegorical message. Instead, the two finalists, the young Florentines Lorenzo Ghiberti and Filippo Brunelleschi, boldly envisioned the biblical episode as a pagan scene. Both sculptors peopled their panels with figures drawn from ancient Roman statuary—muscular, living bodies caught in real time and space, in mid-action, whether struggling or simply picking a thorn from their foot. In turning to Roman models for this particular story at this turning point in the city's own history, the two competitors for the prize were appealing obliquely to a sense that Florentine virtue should imitate not otherworldly Christian patience but Roman courage and resolve.

The winner of the commission, Ghiberti, would spend the rest of his life casting dazzling gold panels for the Baptistery doors. In these scenes, sacred history is envisioned humanistically, as dramatic moments in which real persons face their destiny. For Ghiberti's second set of doors, Bruni himself was to offer advice about which biblical events should appear, adding that he "would like to be close to the designer to make him grasp every point of significance that the episode carries."[14]

The overt significance of Ghiberti's biblical episodes, to be sure, remained otherworldly and salvational. But the mode of presenting divine history raised the question of how to find meaning in this world, in the Florentine Republic's secular history. Before the crisis with Milan, Florentines had evaded this question by simply declaring that even if "the winding and turning of mundane affairs" seemed to be influenced only by the fickleness of Fortune, worldly affairs ultimately were superintended by a "divine providence, direction, and order"[15] guaranteeing, as a matter of faith, that the commune could not die.

Yet in the showdown against Gian Galeazzo the Florentine Republic *had* nearly perished. And the tragic fates suffered by Brutus, Cicero, and the Roman Republic made it clear that republicanism's survival could not be guaranteed from above. How then could the Florentines make a virtue of the necessity to define their civic life as a precarious social invention rather than an imitation of imperial or divine order? What

Lorenzo Ghiberti, *Sacrifice of Isaac*, detail (Wikimedia/Guidalootti)

image of human authority could take the place of God or monarch? How was the flux of history to be organized, and how might citizens most virtuously go about making that history if it was not predicated by divine providence? To find out who they were, what their city stood for, and what it might become, Florentines now began the immense task of retrieving the ancient past. The hunt for manuscripts was on.

"Hortari, rogare, sollicitare, arguere, conqueri, laudare, commendare"

Leading the quest in search of ancient materials was an acerbic humanist, Niccolò Niccoli. A friend to Salutati and Bruni, Niccoli was the archetypal eccentric antiquarian, a connoisseur notorious for his fastidiousness and preciosity. As a fellow humanist recalled,

> He clothed his body in fine red garments. His senses, especially those of sight and sound from which instruction was to be obtained, were so delicate that he could not bear to see or hear anything unpleasant. He would not hear a braying ass, a rasping saw or a squeaking mouse and he admitted nothing to the sight of his eyes unless it was finely made, fitting and beautiful.[16]

Niccoli channeled this finicky meticulousness into fanatical devotion to classical Roman culture. Admiringly called "censor of the Latin tongue," he usually skipped church because he couldn't stand the medieval Latin spoken by priests; even Dante's Latin, he complained, was so bad that Florence's greatest poet should be "excluded from the company of literate men and left to the woolworkers, bakers, and the like."[17] But Niccoli's perfectionism left him with writer's block, and he wrote almost nothing himself. Instead, he squandered his entire inheritance accumulating classical manuscripts, statues, inscriptions, vases, coins, and gems.

Niccoli's ally and agent in manuscript hunting was the puckish and intrepid Poggio Bracciolini. As secretary for the Florentine-backed claimant to the papacy, John XXIII, Poggio wrote stirring defenses of Christian dogma, but he also penned facetious and popular stories about the corrupt clerisy he belonged to. No saint himself, he fathered fourteen illegitimate children. Poggio's promiscuity prompted a cardinal to berate him for fathering children, which was unbecoming to a priest, and fathering bastards, which was unbecoming to a layman.

Poggio retorted that the cardinal had it backward: having children was normal for a layman and having bastards normal for a priest.

Poggio's jaded view of the Church may have owed something to his boss John XXIII, who was deposed by a church council and imprisoned in Constance after being accused of crimes including poisoning his predecessor and seducing several hundred women. He would end his days in Florence as a guest of the Medici, bequeathing to Cosimo a finger of John the Baptist he had always carried in his pocket; Cosimo commissioned Donatello and Michelozzo to design for the "quondam pope" a magnificent tomb in the Baptistery.

Stranded without position or income after John XXIII's downfall, Poggio jumped at Niccoli's offer to pay the ex–papal secretary's expenses for ferreting out and bringing back to Florence all the early manuscripts he could lay his hands on. For the next few years he scoured Germany and Switzerland, bribing uncooperative monks when necessary for access to literary treasures they didn't know they possessed. In 1416 he trudged twenty miles up a winding mountain road to the monastery of Saint Gall. There he found Quintilian's *The Training of an Orator* moldering in a tower storeroom, "a most foul and dimly lighted dungeon" in which, Poggio reported, the ancient writer "seemed to be stretching out his hands, calling upon the Romans, demanding to be saved from so undeserved a fate."[18] To carry the Roman orator's words back to Niccoli, Poggio spent thirty-two days copying the work in the script he and other Florentine scribes had invented—handwriting so elegant it became the model for the typeface we use today.

In Poggio's rescued Quintilian, along with many more works liberated by other manuscript hunters over the first quarter of the fifteenth century, the Florentines began to perceive a culture that had been planked out of their sight by a thousand years of neglect. Rediscovered texts by Cicero, Suetonius, Vitruvius, Plautus, and Terence revealed a hitherto forgotten pre-Christian society of almost unimaginable moral complexity and intellectual sophistication. Out of the past now surged stories of the misdeeds of debauched and power-mad emperors; treatises on rational architecture; witty and sometimes smutty comedies; and—most stressed by the propagandists of liberty in this first wave of recovery of the pagan past—histories of republican struggles against conspiracies and corruption.

Most Florentines were not humanists versed in classical Latin, to be sure. They might compare a leader to Cicero (whose biography Bruni penned in 1415), or have themselves depicted in frescoes dressed in

togas rather than the red cloaks traditionally reserved for priors, but this was about signaling one was in the know. Yet the recovered classics did transmit to the first generation of Renaissance Florentines something more than a fashion statement or even a body of thought or an alternative set of political images. Ancient Rome modeled an ethical attitude, at once a sensibility and a challenge—an attitude embedded in histories and rhetorics, explored in dialogues rather than worked out in philosophical argument, and oriented toward action.

In the Roman world, as it now appeared thanks to the rediscovered archive, men made their own history, a history shaped by the struggle to form and sustain a republic. Roman historians made clear that politics involved much more than grabbing power from one's enemies: it provided the conditions—tyranny or freedom—for developing or stifling men's creativity and virtues. Bruni could cite the first chapter of Tacitus's *Historia* (a manuscript brought to Florence from the abbey at Montecassino and snatched up by Niccoli) as revealing how "after the republic had been subjected to the powers of one man [i.e., the Roman emperor], those brilliant minds vanished."[19] Bruni would go on to note by contrast that in a republic, where "equal liberty exists for all," not only do "the members of the lower class say: 'I also am a Florentine citizen,'"[20] but, as Cicero taught, the citizenry becomes more creative, more daring, more inventive:

> It is marvelous to see how powerful this access to public office, once it is offered to a free people, proves to be in awakening the talents of the citizens. For where men are given the hope of attaining honor within the state, they take courage and raise themselves to a higher plane. . . . And since such hope and opportunity are held out in our commonwealth, we need not be surprised that talent and industry distinguish themselves to the highest degree.[21]

The difference in attitude between Bruni and his mentor Salutati here is palpable. The older humanist had argued only that engagement in civic life could be defended as virtuous. Bruni leaned in. Political engagement of the kind found in a free republic, he insisted, was the most virtuous activity of all, while loss of liberty by contrast was positively harmful, causing men to "grow lazy and stagnate." And voluntarily withdrawing from civic affairs was to be chastised as both unpatriotic and an invitation to cretinism: "Among the stay-at-homes, who are withdrawn from human society, I have never seen one who could count to three. A lofty and distinguished mind does not need

such fetters. . . . Standing apart from the interchange of ideas with others is characteristic of those whose inferior minds are incapable of understanding anything."[22]

It was now assumed that the exchange of ideas served the republic by making citizens more educated, and gatherings devoted to discussion proliferated. But the ideas exchanged most often concerned literary or ethical rather than political questions. In Vespasiano da Bisticci's book-shop near the Badia, the houses of Roberto de' Rossi, or the monastic chambers of Ambrogio Traversari (a vicar-general of the Camaldolese Order who could translate Greek and Latin as fast as he could read it), younger Florentine gentlemen might be found listening respectfully while Niccoli and Salutati discussed whether Dante and Petrarch belonged in the same literary league as the great ancient writers, or how fathers should treat their children.

In these debates, what counted was not the rigorousness of formal argumentation nor the ability to get a translation of a specific term right (Niccoli himself called for translating the sense of passages rather than their literal meaning). Being correct was less important than being convincing; phrasing mattered more than logic; participating well was the objective, not arriving at the correct conclusion. Conversing eloquently and forcefully now became a virtue, so much so that artists began to show it as an attribute of Christian saintliness. Nanni di Banco's *Four Crowned Saints* outside Orsanmichele are captured in mid-discussion, complete with hand gestures, as are the figures arguing in Masaccio's *Tribute Money* in the Brancacci Chapel (Image 2). Even the Madonna and her retinue now suddenly begin to be presented in a new way, in what is called, tellingly, a *sacra conversazione* (Image 3): a scene in which the figures, as art historian John Shearman notes, coexist as a unity in space, time, and, most important, state of mind, "sharing—as their actions and emotions indicate—a single moment and experience."[23]

In Florentine politics itself, this sudden turn toward the oratorical at the turn of the Quattrocento, when the crisis with Milan came to a head, is striking. The number of recorded debates about policy decisions, and the number speaking during these debates, mushroomed shortly after Gian Galeazzo's death. And whereas Salutati's minutes of meetings from the 1380s noted tersely only the actions recommended, now long orations were summarized laying out reasons for taking actions. Moreover, those speaking began to represent themselves not as party-line guildsmen but civic-minded individuals forming and trying to persuade others of their own opinions. Reflecting this, the minute

writers tracking the commune's deliberations start for the first time to note not just what was recommended, but also the rhetorical tone of the recommendation, using verbs such as *hortari, rogare, sollicitare, arguere, conqueri, laudare, commendare* (encourage, stir, exhort, rouse, deplore, praise, recommend).[24]

Such terms signaled a new, more assertive attitude, more forward-looking and audacious than that of earlier generations. If the Florentines were descendants of ancient republicans, as Bruni's history argued, they remained true to that legacy by treating it not as a sign of inherited merit, but a spur to their own greatness. "He who seeks fame in the ability of past generations," declared apothecary and humanist Matteo Palmieri, "deprives himself of honor and merit, and he who lives on the reputation of his ancestors is certainly a pitiable creature. A man who deserves honor should offer himself, not his genealogy."[25] Florentines would imitate their Roman forefathers most faithfully by copying their ambition to be honored. "The same dignity and grandeur of the parent," Bruni wrote of republican Rome, "also illuminates its sons, since the offspring strive for their own virtue."[26]

Those who saw their city's collective project in such meritocratic terms began to push for policies that would have been unthinkably risky just a few years ago—and which, for the less ambitious citizenry, still were. Pondering whether Florence should offer to host a council aimed at ending the Great Schism which had split the papacy between Rome and Avignon for thirty years, members of the lower guilds urged the city to decline, citing the traditional bond of obedience to the Roman pope and warning that a council held in Florence might lead to partisan conflict—or worse, to a takeover of the city by outsiders. But the leadership, their civic ambition bolstered by humanist educators, felt greater confidence in the commune's stability. They saw hosting the council as a risk worth taking. It was a chance to make history— and perhaps some money as well—that would add to Florence's glory as a self-conceived second Rome.

Such confidence was buttressed by the long-wished-for conquest of Florence's erstwhile local rival, Pisa, in 1406. For Florentines, this glorious victory seemed to confirm that their city-state was now growing into a territorial state on its way to establishing its own Tuscan mini-empire over subject cities. That the Pisans who were besieged and cruelly starved into submission were themselves citizens of a free republic who resisted with calls of "*Viva il popolo e libertà*" was an irony acknowledged only privately in some Florentine chronicles.

The Diggers

To outshine Rome, however, required ambition not just on the part of humanist book hunters and civic leaders, but from a generation of Florentine sculptors, architects, painters, and writers. Inflamed by the same rage for things classical, they too sought to rediscover the long-buried past and then to emulate its spirit. In pursuing this ambition, they would create entirely unprecedented images, edifices, and—for the first time in Western history for artists lacking a pedigree of nobility—distinctive identities and even fame as individuals.

Even as Poggio was digging through far-flung trans-Alpine archives in search of Roman manuscripts, two other young Florentines, Donatello and Brunelleschi, were digging for statuary and foundations in Rome itself. The task they faced there was quite literally archaeological. By the 1400s, the ancient metropolis had long been reduced almost to rubble, its marbled buildings stripped of masonry, its temples covered by dunghills, its forum turned to a cow pasture. Wolves and foxes prowled in woods that had grown up inside the city walls. The population had shrunk to fewer than twenty thousand people, most eking out livings near decrepit Saint Peter's begging for alms or servicing pilgrimage tourists who still came to Rome to gawk at the holy sights. The few who paid any attention to these two young Florentines sifting through the remains of the pagan city imagined they were treasure hunters using magic to locate gold coins.

But Donatello and Brunelleschi returned to Florence having unearthed a far greater treasure. In Roman portrait sculpture Donatello discovered an aesthetic alien to the swirls and stylish gracefulness of the then-dominant school of International Gothic art (exemplified by Simone Martini's golden *Annunciation*, now in the Uffizi), but more true to humanist values. According to Leonardo Bruni's Greek teacher Manuel Chrysoloras, art following classical precepts should show detailed lifelikeness, variety, and intense emotional expression.[27] Importing such realism into his sculpting of prophets for the campanile of Florence's cathedral (now in the Museo dell'Opera del Duomo), Donatello presented Christianity's avatars with astonishing vividness. Rather than a parade of symbol-brandishing saints with typified features showing themselves serenely or severely aware of the divine ends they served, Donatello's prophets appear as human beings caught in mid-deliberation at moments of great crisis. In his work, as in that of his contemporary and admirer Masaccio, the makers of Christian

history are made real even in their monumentality, given furrowed, unshaven, even ugly visages taken from the Florentine present (including one face that looked enough like Poggio for later generations to mistake it as a portrait). These were, as one Florentine contemporary noted in awe, "faces that live," so true to life that Donatello was overheard muttering angrily, while hammering away on the prophet known as *Zuccone*, "Speak, damn you, speak!"

A personality as forceful as any presented in his statues, Donatello was legendary for his volatile temper. As a young man he was charged with beating a man bloody with a large stick, and he once asked Cosimo de' Medici to write letters of transit so he could go to Ferrara to murder an apprentice who had fled there. It was likely his roughness, not simply his genius, that made Donatello one of the very few people the equally bristly Brunelleschi deigned to befriend. The two also shared a deep devotion to ancient Rome, of course. But reflecting their equally difficult yet distinctive personalities, the two men drew different aesthetic lessons from the classical past. Donatello's statues exhibit sincerity and authenticity, qualities reflected in Michelangelo's remark that if the real Saint Mark had in fact had the same "air" captured in Donatello's Orsanmichele figure, "one could believe what he had written."[28] For Brunelleschi, however, the sculptor's realism was excessive, making even Christ look like a peasant. Rome's true treasures, in the eyes of the budding architect, were not the lifelike human figures of her sculpture but the rational, mathematically precise engineering of her buildings, the "musical proportions" of her ruined triumphal arches and collapsed temples.[29]

Rome's colossal edifices, obscured by time though they were, matched Brunelleschi's sense of himself. "Small and insignificant in appearance," Vasari tells us, he hid under that most unpromising exterior a smoldering ambition to take on "difficult and almost impossible tasks and bring them to completion." Deducing architectural principles from the fallen columns and sunken foundations of the ancient world capital was certainly a task worthy of his ambition. As Vasari put it, Brunelleschi's "mind was capable of imagining how Rome once appeared even before the city fell into ruins."[30] He dug, measured, and gauged, keeping voluminous notes—in a secret code only he could decipher—on pieces of scrap paper gleaned from the goldsmiths' work he did to make ends meet. By the time he returned to Florence, he had solved the mysteries of engineering that had allowed the Romans to build their smooth cylindrical columns, semicircular arches, and domed temples.

Donatello, *Habacuc*, better known as *Zuccone* ("pumpkin")
(Wikimedia/Jastrow)

Brunelleschi would eventually put this knowledge to work in a string of great architectural achievements: the Ospedale degli Innocenti, San Lorenzo, Santo Spirito. But first he had to become famous, by doing something many said couldn't be done: showing how to vault the dome of Florence's cathedral.

Duomo

The enormous hole in the roof of the city's main cathedral had been staring Florentines in the face since the mid-fourteenth century, when architects succeeded in vaulting the huge cathedral's nave. Santa Maria del Fiore had always been intended to show off the greatness of Florence's ambition, as the city fathers made clear at the foundation-laying ceremony back in 1295: "The Florentine Republic, soaring ever above the conception of the most competent judges, desires that an edifice shall be constructed so magnificent in its height and beauty that it shall surpass anything of its kind produced in the times of their greatest power by the Greeks and the Romans."[31] The only problem with this optimism was that no one had the faintest idea how to design a dome that could cover the church's massive octagonal tribunal without collapsing under its own weight—as a model of the cathedral designed by its original architect, Arnolfo di Cambio, had done.

In 1418 a competition to produce the best new model of a dome was announced. It laid out some daunting specifications. The diameter to be spanned was 138 feet, with the work to begin a dizzying 140 feet above ground—or rather 30 feet higher, if one added in the drum on which the dome itself would have to sit. Adding to the challenge, the commission stipulated the cupola must be a double shell, octagonal rather than round on the outside, with a pointed rather than semicircular profile, and without visible supports. Last but not least, lumber being in short supply, construction would have to be done without the usual centering support. How was the rising dome's masonry to be supported so far above ground, and once constructed, how could it possibly transmit the bursting pressures of its weight to the ground?

Architects came up with a number of ingenious though far-fetched solutions to the puzzle. One even proposed constructing the vault on a mountain of dirt in which some gold coins could be scattered; when the job was done, it was suggested, the doors could be opened and the poor allowed to cart off the dirt and keep any coins they found. Only Brunelleschi brazenly insisted that the dome could be built and would

stand without the need for any supporting framework whatsoever, either external or internal, and to prove it, he built a twelve-foot-high brick model cupola, complete with woodwork carved by Donatello and Nanni di Banco, which he presented to the oversight committee.

The model was impressive. But wardens and consultants remained skeptical, especially since Brunelleschi had no experience with large construction projects. He had, in fact, only one building to his credit, a house built for a relative. Asked to explain how he would go about constructing his unsupported dome on the vastly larger scale required, Brunelleschi refused to explain his methods, continuing to simply insist with increasing irritation that he knew what he was doing. Finally the argument grew so heated that he had to be carried bodily out of the hall.

In a second meeting, according to Vasari, the commission again demanded that Brunelleschi show them how he proposed to accomplish this seemingly impossible feat. Again he replied that for him, vaulting the transept would be a simple matter—as easy, he taunted, as making an egg stand upright on flat marble. An egg was produced, which the other architects all tried but failed to balance. Brunelleschi took the egg, slightly flattened one end with a light tap, and stood it upright.

Like so many other great stories about Florentines passed down through generations, this has the sound of legend. It is certain Brunelleschi didn't convert the committee with a mere trick, and ultimately no architect was awarded the prize money. But the genius evident in the model soon garnered him three commissions for chapel domes. And Brunelleschi eventually did win the prize that counted: the commission to dome the cathedral.

There was, however, a galling string attached. Following its general policy of getting the most out of artists by teaming up bitter rivals who would then be driven to compete, the committee stipulated that Brunelleschi must partner with his nemesis Ghiberti—the man who had beaten him in the "Sacrifice of Isaac" competition. By now a celebrity thanks to the fame of the Baptistery doors he had been awarded as victor, Ghiberti was the autocratic Brunelleschi's temperamental opposite. He consulted others assiduously and encouraged teamwork (including, for the second set of Baptistery doors, assistance from Uccello, Pollaiuolo, and even Brunelleschi himself). Even more annoying to Brunelleschi, Ghiberti, a sculptor of reliefs, knew nothing about engineering. Sharing the glory with him would be intolerable. So Brunelleschi took to his bed, leaving Ghiberti without a clue as to how to proceed. When the committee members told him that the work

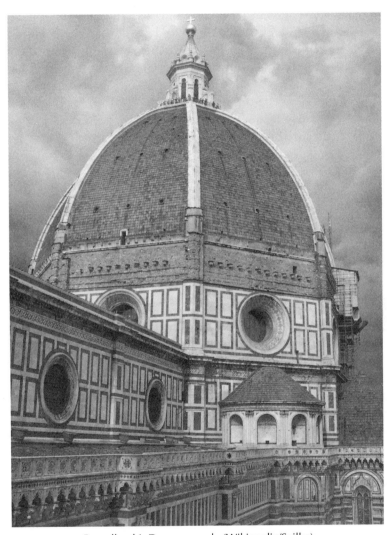

Brunelleschi, Duomo cupola (Wikimedia/Sailko)

had ground to a halt in confusion because Ghiberti would do nothing without him, he retorted, "I would do it well enough without him."

His point made, Brunelleschi returned to work, overseeing the project from quarry to cupola, inventing as he went. He created special molds for bricks fired in kilns kept going day and night, set up canteens on the scaffolding so the men would not have to climb down for lunch, and carved turnips to show the stonecutters how joints should be chiseled. He devised blacksmiths' tools, hinges with pivots to raise the stones, even a new kind of amphibious barge intended to bring the marble from Carrara up the Arno to the city. To keep the bricks from falling as the dome became more inclined, he ordered them laid in a new herringbone pattern. And to keep the double dome's weight from causing it to bulge outward and collapse, he clasped around the inner dome four stone and chain belts, along with a fifth wooden one (still visible to those who make the climb between the two shells to the cupola added decades later by Michelangelo).

After sixteen years the dome was finished. Taller and vaster than any ever erected, it soared 270 feet, twice its diameter, "ascending above the skies, large enough to embrace in its shadow all the people of Tuscany."[32]

Optimism of the Will

The dome visibly embodied a sea change in the way Florentines thought about the power of individual intellect and sheer will. The medieval view of humanity had tended to the sourly ascetic. Man, in Augustine's phrase, was "born between urine and feces" with soul stained by the blemish of guilt and the filth of wickedness. Now humanists began to assert that if man put his mind to it, his ingenuity could overcome the most intractable difficulties, even changing the course of rivers (something Brunelleschi tried to do during a siege of Lucca in 1430, with disastrous results). This can-do attitude is captured well in the title of fabulously wealthy Florentine humanist and diplomat Giannozzo Manetti's treatise "On the Dignity and Excellence of Man." "Everything which surrounds us," writes Manetti,

> is our work, the work of man: houses, castles, cities, magnificent buildings over all the earth. They resemble the work of angels more than man; notwithstanding they are the work of men. Ours are the paintings, the sculpture, the literature, and the infinitely inventive machines. And when we see these marvels, we realize that we are able to make better

things, more beautiful, more adorned, more perfect than those that we have made until now.[33]

The most spectacular representative of this drive toward excellence, the very figure of Renaissance versatility and inventiveness, was the polymath, athlete, and inventor Leon Battista Alberti. An outsider to both his family's city (the Alberti, one of the wealthiest clans in Trecento Florence, were exiled in the 1390s) and to his family itself (he was cheated out of his inheritance by his cousins as an illegitimate son), Alberti might have been expected to emphasize the negative. He certainly felt more keenly than many Florentines how difficult it could be to show one's *virtù*, one's individual merit, in a world "so full of human variety, differences of opinion, changes of heart, perversity of customs, ambiguity, diversity, and obscurity of values . . . amply supplied with fraudulent, false, perfidious, bold, audacious and rapacious men."[34]

Yet even though "everything in the world is profoundly unsure," Alberti persisted in insisting that "it is not in fortune's power, it is not as easy as some foolish people believe, to conquer one who really does not want to be conquered. Fortune has in her hand only the man who submits to her." Others might complain "of being buffeted by her stormy seas," but it is they themselves who "most foolishly, threw themselves into the flood." In reality, he asserted, "in political affairs and in human life generally reason is more powerful than fortune, planning more important than any chance event." We can do great deeds if we have it in ourselves: "Nobility of soul . . . is itself sufficient to ascend and to possess the highest peaks: glorious praise, eternal fame, immortal glory."[35] What is needed above all to succeed is "a certain strength of will and force of reason."[36]

Wielding this power of positive thinking, Alberti molded himself from a sickly child into an Übermensch, both physically and intellectually. He developed such athleticism, so he tells us in an autobiographical fragment (written in the third person as befits the self-fashioning ethos), that he could leap over a man's head from a standing start or throw a coin so high inside the cathedral that it hit the dome. He invented a slew of devices and techniques: the first camera obscura; a cipher wheel for coding and decoding; surveying tools for mapping cities (used by him to make the first scale plan of Rome). While still a law student, he composed a comedy in Latin that he successfully passed off as a discovered work by a Roman author. He went on to produce works on topics ranging from jurisprudence and speech making to horse

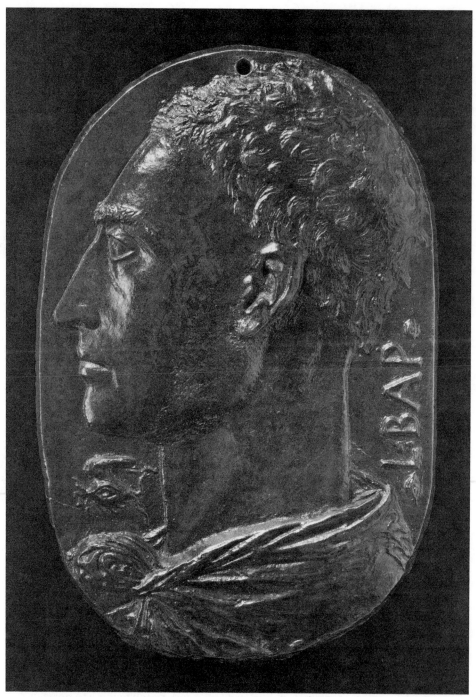

Leon Battista Alberti, *Self-Portrait with Winged Eye Emblem* (Wikimedia / Samuel H. Kress Collection)

breeding and mathematical puzzles, as well as the first history of Italian dialects and the first modern treatise on architecture.

Alberti the practicing architect left his mark on Florence in just two major projects he oversaw: the Rucellai Palace and the facade of the church of Santa Maria Novella. The latter he festooned with classically inspired features: Corinthian columns, a coffered-vault doorway copied from the Pantheon, and geometric designs based on the Roman architect Vitruvius's rules. Alberti's larger vision of a perfectly designed city would be realized by his protégé Bernardo Rossellino in the trapezoidal central square of Pienza, and by generations of architects from Filarete to Palladio. But influential as he was in urban planning and architecture, his most important contribution to the arts was his treatise on painting, which made available to artists everywhere the secret behind the great technical breakthrough made by Florentines in the early 1400s: the mastering of perspective.

Perspective

Alberti's and Brunelleschi's enormous self-confidence and audacity stemmed from a shared faith in the rationality hidden within empirical reality, and in the capacity of intellect to grasp and exploit that rationality. Indeed, for Alberti, whose emblem was a winged eye, seeing clearly and acting decisively were two sides of the same coin. What the mind's eye gauged was the regularity of the universe, an orderliness whose code was mathematical and geometrical. The art and architecture born from this use of intellect would manifest the "lawful construction," the *ratio*—at once mathematical relation and rationality—of proportions and harmonies which organize space.

Thinking of space as composed of geometrical volumes was nothing particularly new, especially for Florentine merchants. After all, their business required them to learn how to gauge the amount of alum that could fit in a cargo hold, the unknown height of a tower, or the width of a river.[37] This ad hoc cognitive style of measurement was formalized into what historian Hans Belting calls "a theory of mathematical space" by a geometrician, Biagio Pelacani, who lectured in Florence in 1389.[38] The original source was an optical theory of visual rays invented by an eleventh-century Arab mathematician, al-Hazen. Brunelleschi, Masaccio, Piero della Francesca, Alberti, and Ghiberti in turn metamorphosed Pelacani's spatial geometry into a technique for creating the appearance of space on a two-dimensional surface, and of organizing space itself.

As Alberti pointed out, painterly and architectural perspective was "a more fleshly Minerva" than the pure mathematical and optical theory that it embodied.[39] As a sensate mode of reasoning, it aimed at literally drawing out the mathematical harmonies inherent in individual perception of volumetric space. The key was to imagine the eye as the apex on a pyramid of vision. Just as a right-angle triangle may be cut by a parallel line to form a smaller triangle proportional to the first, so the space projected from the eye to within a painting or building could be subdivided into regularly spaced proportional triangles. Whether or not included literally in the form of a gridded pavement receding to a vanishing point, such partitioning had the effect of situating viewers, pinning them to a specifiable spot, a point of view, from which they could admire the order they perceived.

Among the first to systematically exploit perspectival geometry for aesthetic purposes was Brunelleschi. In the Pazzi Chapel and in the church of San Lorenzo, as art historian Rudolph Wittkower notes, "everything was done to make the perception of a harmonic diminishing series in space a vividly felt experience."[40] With the publication in 1436 of Alberti's book divulging the secrets of perspective, Donatello and Ghiberti joined in, situating their sculptural relief figures in rooms with grid-like pavements and receding backgrounds. But it was for painters, faced with the need to unfold space out of a completely flat surface, that the exploration of perspective was most impactful. Otherworldly or transcendental appearances could now be made to appear not as emanations from the beyond, but as this-worldly. Even the mystery of the trinity, as depicted by Masaccio in the mid-1420s for the church of Santa Maria Novella, now seemed explicable: the artist presents God looking down upon us from within a simulated chapel real enough to make us yearn to enter it or for God to step out to meet us.

The faith in perspective shown by artists might best be understood as the aesthetic counterpart to the faith shown toward the idea of liberty by civic humanists. Just as Florentine artists and architects sought to rationalize and harmonize the messiness of empirical reality, Florentines of the early Renaissance sought to purify real politics of the civic discord that had destroyed so many other city-states and threatened Florence itself since the days of Guelphs and Ghibellines. In what Hankins calls the "virtue politics" promoted by civic humanism, factionalism—the partisanship that could undermine a republic's liberty—would cede to rational consensus, self-interest to public-spiritedness. Like Jesus and his disciples represented forming a perfect

circle in Masaccio's *Tribute Money* in the Brancacci Chapel, in the ideal republic citizens would naturally group themselves into a rational government ruling by consensus. Each citizen would affirm their virtue by willingly rendering unto Florence its due, as Masaccio's Christ renders unto Rome. It is no accident that Masaccio chose this theme shortly before the institution of the Catasto, the world's first proportional tax system and the first to treat investments and liquid assets (rather than only real property) as taxable wealth.

A virtuous republic governed by reason, living in collective harmony—such was the dream. But just as perspective's gridded pavements only set the stage for what Alberti, in his treatise on painting, called an artwork's *istoria*—the human scenario or drama depicted, at once story and history—so the civic humanists' rationalization of politics and politicization of virtue only set the stage for Florence's *istoria*, the actually lived clash of interests which was to culminate in the rise to power of the house of Medici.

CHAPTER THREE

~

The Age of Cosimo

Florence's actual politics during the age when Florence was ruled by the Albizzi group of oligarchs (1390–1434) involved far more viciousness and anxiety, and far more brutally direct use of power, than was dreamt of in civic humanism's philosophy of deliberation leading to consensus. Cosimo de' Medici's ascendancy, however, showed how in a republic one could achieve, hold, and exercise power more softly, by means of carefully woven and assiduously tended webs of patronage and intermarriage. Crucial to the success of this strategy was the co-opting of civic imagery and values by the Medici. As the attention of humanists and the public shifted subtly away from questions of political virtue to aesthetic and spiritual concerns, a more expansive taste for the beautiful emerged, inclusive enough to encompass Fra Angelico and Filippo Lippi, hermaphrodites and bone-weary Christ figures.

"Discord is on the rise"

As we have seen, the works of Donatello, Masaccio, Ghiberti, and Brunelleschi in the first third of the fifteenth century exude a sense of high seriousness, monumentality, and confidence that mirrors the oligarchic republic's idealization of itself in the writings of Salutati, Bruni, and Alberti. In that sense, one can speak of a culture of civic humanism. Yet these projections of Florentine values could never in themselves succeed in fully masking the realities of Florence's political life: down-and-dirty horse trading, backstabbing, electoral chicanery,

use of the tax system to weaken opponents, repression of dissent, and jockeying for power between interest groups.

These political struggles arose in turn from the changing socio-economic realities of the times, realities within which even the most disinterestedly virtuous of citizens defined and pursued their interests. Less and less bound in corporatist fealty to his occupational guild as in earlier eras, the average Florentine was becoming all the more dependent on his position in the dense local social network of *parenti, amici, vicini* (relatives, friends, neighbors), enmeshed in informal but powerful bonds of obligation, trust, gratitude, reciprocity, and loyalty owed to fathers and patrons.

The importance of these social relations did not escape the notice of civic humanists, to be sure, but they chose to interpret them as integrative, unifying the commune rather than fracturing it. "I should have need of you, and you of him, he of another, and some other of me," Alberti argued. "In this way one man's need for another serves as the cause and means to keep us all united in general friendship and alliance."[1] But as social historian Richard Trexler points out, this was wishful thinking: "Florentines asked too much from their public servants, expecting them to be both objective in office and loyal to friends. No cry was more common than that one should be guided by the *buon comune*, but nothing was more a staple of Florentine political reality than vote trading and lending based on patronal interest, nothing more characteristic of political commentary than the ledger-like reports of 'friends' and 'enemies' in government, no law more common than those favoring individuals and groups when enough 'friends' were in government."[2]

Thus, even at the height of civic humanism in the first third of the fifteenth century, the merchant cabal that dominated Florence (the Albizzi group) lived in constant fear of a political takeover by a band of perceived "enemies" within the city. To mitigate these anxieties, the commune promulgated increasingly strict regulations about when and how citizens could assemble. Even the city's philanthropic confraternities, whose ostensible purpose was to care for the sick, bury the dead, pray for the departed, and fund religious festivals, came under suspicion, suspected as possible hotbeds of threatening dissent. As one alarmed 1419 report to the Signoria about politicking in the confraternities warned, "The minds of the citizens are being confused, and it is apparent that division is being fomented in great measure, that discord is on the rise, and that many difficulties are being stirred up."[3]

One nightmare scenario for the republican oligarchy was a coup by one or another faction led by aristocrats with military pretensions. In the previous century, the commune had attempted to foreclose this possibility by barring knighted Florentines from the privileges of citizenship. Even the staunchest republicans among the elite, however, continued to covet having knighthoods conferred on them. (The regime's leader, Maso degli Albizzi, had reveled in his own knighting in 1388.) To placate this thirst for honors even while legitimating its own authority to the feudal world surrounding it, the commune continued to draw on images of warlike virtue. It sponsored jousts and tournaments, complete with ritual presentation of arms to the Signoria by companies prudently limited to no more than twelve knights each. The "elected" leader of each brigade underwrote the cost of their golden lances and fabulous outfits (bearing his family's insignia, of course). Before the joust, whose outcome was often fixed, aristocrats were permitted to preen before the crowd, ceremonially undressing themselves and their horses, stripping off layer after layer of heavy coats and drapes, tossing them to onlookers.[4]

These shows of private might have, understandably, made the government nervous, and families overdoing it risked exile. That was the fate of Alberti's clan, banished in the 1390s, Machiavelli tells us, because in such festive occasions their magnificence "surpassed every other. . . . The tournaments held by them were not those of a private family but worthy of any prince."[5] But most jousters and paraders were, however, recognized by most as mere pseudo-knights. In the case of middle-class merchants emulating nobility, they became the butt of jokes in witty tales—including one that Cervantes would draw on two centuries later in inventing Don Quixote. Ridiculing the knighted elites within the ruling group, however, was out of the question for humanists serving the regime. Instead, as Leonardo Bruni suggests in a work addressed to the *cavalieri* within the Guelph party, Florentine knights were to be encouraged to think of themselves in terms akin to those of ancient Roman militia: not as vulgar show-offs or seekers of adventure, but as guardians of the republic. We can see this alternative ideal projected in Donatello's calmly determined Saint George (now in the Bargello) commissioned by the armorers' guild for one of the niches in Orsanmichele a few years before Bruni's treatise.

Notwithstanding such stirring imagery and appeals to martial virtue, real military power in Florence did not rest with the aristocrats and their retinues. It had by this point in the city's history long

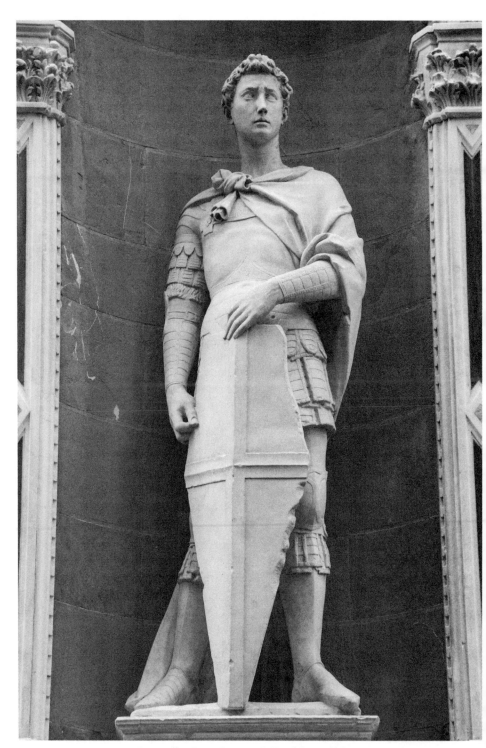

Donatello, *Saint George* (© iStock/lauradibiase)

been vested in the office of Captain-General, a job for which only non-Florentines like the English mercenary John Hawkwood could be hired. That stipulation was intended to prevent usurpation from within. But giving a soldier of fortune such muscle posed dangers of its own, especially if he won popular acclaim by winning battles. So worried were the Florentines about this eventuality that they made a point of honoring heroic condottieri not with marble or bronze statues but only trompe l'oeil ones like Uccello's depiction of Hawkwood, still visible on the Duomo wall.

Turning over military authority to such men was a very sensitive matter. To ensure there was no mistake about who was ultimately in charge, commune or commander, humanists designed elaborate ceremonies filled with carefully thought-through rituals. Before being handed his insignia and the baton signifying his authority, the designated captain was required to stand for hours before a crowd in front of the town hall, enduring a long-winded speech delivered by the secretary of state from a six-foot-high terrace (no longer extant), the *ringhiera*. These admonitory lectures, the original harangues, emphasized the lesson Florentines had learned from the Roman republicans, the same lesson Patrick Henry would repeat in America: that the patriot is willing to give his life for his country. As one speaker put it, "It was for their *patria* that the Romans took upon themselves such unheard of toil and danger, such wounds, and even the bitterness of death."[6] The irony, of course, is that this stirring appeal to patriotic duty was voiced in a ceremony passing off that toil and danger to a non-Florentine.

The Chess Player

Such overheated calls for civic self-sacrifice became more frequent in the 1420s, after the leaders of the city's post-Ciompi oligarchy, Gino Capponi and Maso degli Albizzi, passed from the scene and the ruling group's hold on power began to narrow. From his deathbed in 1420, Capponi complained that "there are more offices than ever before, but power lies in fewer hands." He warned his sons "not to let any particular citizen or family or *congiura* be more powerful than the Signoria," and suggested reimposing the draconian Ordinances of Justice that in the previous century had clamped down hard on the city's aristocrats.[7] Capponi, however, could not have predicted that the regime's nemesis would prove to be neither a magnate with

despotic ambitions nor an armed faction, but a reserved banker who scrupulously obeyed the Signoria at all times.

Cosimo de' Medici was thirteen years old when the Milanese tyrant Giangaleazzo died. His father, Giovanni di Bicci de' Medici, had built the family banking and wool-making business over many years of shrewd deal making. His most lucrative investment was a loan of ten thousand ducats to an ex-pirate for the purchase of a cardinal's hat. The beneficiary, Baldassare Cossa, went on to become antipope John XXIII, repaying Giovanni for the loan by naming the Medici as the Church's revenue collectors, the Holy Grail for bankers. But unlike many other elite Florentines, Cosimo's risk-averse father had kept as low a profile in politics as possible while quietly building a distinctive new kind of patronage network, one based more on friendship than marriage alliances.

Giovanni di Bicci had also seen to it that his two sons, Cosimo and Lorenzo, like most scions of the rich, were educated by the leading humanist intellectuals of Florence. As might have been expected, Cosimo became a humanist enthusiast and bibliophile. He had the resources to collect more books than even his fellow member of the elite Niccolò Niccoli, whose bibliomania led him into bankruptcy. Cosimo honored Niccoli's zeal for the classics by bailing him out of debt and bankrolling his continued manuscript hunting. (After Niccoli's death, Cosimo picked out the secular books he wanted for himself and with the rest founded Europe's first public library, at the monastery of San Marco.)

Young Cosimo himself spent several years book hunting in northern Europe, accumulating seventy volumes, a vast number for that era. But when he told his father that he wanted to travel to Palestine to add Greek manuscripts to his library, Giovanni—who, although "of a kind and humane nature,"[8] owned only three books, all religious—pulled in the paternal reins. Cosimo was ordered to return at once and assume his duties in the family business.

Back in Florence, Cosimo would continue in the 1420s to run in avant-garde humanist circles. His private tastes were very advanced: he readily accepted Antonio Beccadelli's dedication to him of the *Hermaphrodite*, a notoriously obscene collection of verse banned by the Church though admired and read by many. But the public art he supported as a leading member of the bankers' guild—for instance, the bankers' patron saint, Saint Matthew, cast in bronze by Ghiberti for a niche at Orsanmichele—was dignifiedly civic, closer in tone to

Cosimo's own personality than Beccadelli's bawdiness. "He was grave in temperament," his biographer, the bookseller Vespasiano da Bisticci, recalled, "prone to associate with men of high station who disliked frivolity, and averse from all buffoons and actors and those who spent time unprofitably."[9] Rather than jousting or carousing, he preferred playing chess with the city's grandmaster or staying up all night plotting war strategies, always playing his cards close to his chest. And like his father Giovanni, who "had not much eloquence but very great prudence,"[10] Cosimo spoke seldom and cryptically, winning fame for his terse and often ambiguous observations.

"I must obey the Signori"

The goal, it seemed, was to "always keep out of the public eye" as his father had cautioned, so as to avoid any imputation of political ambition, while quietly but assiduously cultivating support beyond the Medici's own neighborhood and immediate family.[11] Cosimo had reason to do this unobtrusively. Another branch of the Medici had already earned suspicion decades earlier as popular demagogues for their involvement in the workers' revolt of 1378–1382. Inevitably, as inheritor in 1429, with his brother, of what was by then the most profitable family business in Europe, Cosimo raised similar fears among the oligarchy that had controlled the city since the end of the Ciompi revolt. Their leaders were the now elderly archconservative Niccolò da Uzzano (image 4), famed for inveighing against Florence's *nuova gente*, and Maso degli Albizzi's son Rinaldo. A reactionary who attacked the new learning as anti-Christian, proposed reducing the power of the lower guilds, and was eager to be recognized as a jousting nobleman, the arrogant Rinaldo could not have been more different from the modestly retiring humanist Cosimo, a popular favorite who never appeared in tournaments.

Things came to a head after a disastrous and costly war against Lucca instigated by Rinaldo. The Albizzi group's reign had been a good one for Florentine imperialism, a time when the landlocked commune expanded its regional control and access to sea routes by buying Livorno and capturing Pisa. Subjugating Lucca would have quashed Florence's main remaining competitor in the silk trade while bringing a rich territory into the Florentine dominion. The Luccan campaign, however, turned out to be a massive miscalculation, leaving the city financially exhausted. Cosimo had at first reluctantly supported the fight, and loans from the Medici and their allies made

up a whopping 63 percent of the money borrowed by the city to pay for it. But within a year he had changed his mind, quit the war committee, and set off for Verona.

In his absence, rumors spread that Cosimo was off hiring military condottieri to overthrow the republic. Rinaldo degli Albizzi urged the regime to move immediately to banish his rival for treason, but found himself thwarted by Niccolò da Uzzano, by this point the last remaining member of the earlier generation of Albizzi leaders. The elderly oligarch pointed out how difficult it would be to paint Cosimo as a traitor to the republic. "The things that make us suspect him," Machiavelli has da Uzzano remark sardonically, "are these":

> that he helps everyone with his money, not only private individuals, but the public, and not only Florentines, but the condottieri; because he favors this or that citizen who has need of the magistrates; because by the good will that he has in the generality of people, he pulls this or that friend to higher ranks of honor. Thus one would have to allege as the causes for driving him out that he is merciful, helpful, liberal and loved by everyone.[12]

In 1432, however, da Uzzano finally died and the conspiracy rumor mill against the Medici started up once again. The vicious polemicist Filelfo, appointed to give public lectures on Dante in the cathedral, used the occasions to attack the Medici; a Medici partisan responded by slashing Filelfo's face. When in the winter of 1433 blood was smeared on the doors of Cosimo's palazzo, he thought it prudent to again leave town, this time for the family stronghold in the Mugello valley to the north of the city. As insurance, he also ordered the bank to transfer monies to Rome and Naples and stash sackfuls of gold florins at the convent of San Marco and the fortified Benedictine bishop's palace adjoining the hilltop church of San Miniato just outside Florence. Meanwhile, Rinaldo had succeeded in manipulating the election of priors to the Signoria to give him the majority he needed. The new government immediately summoned Cosimo back to Florence.

Cosimo's friends warned him he was walking into a trap. "However that may be," he replied, "I must obey the Signori."[13] In the event, his friends were proven right. "When I arrived in the palace," Cosimo would recall, "I found the majority of my companions already in the midst of a discussion; after some time I was commanded by the authority of the Signoria to go upstairs, where I was taken by the captain of the guard into a cell called the Barberia [Machiavelli calls it the

Alberghettino, 'the little inn'[14]], and locked in, and when this became known, the whole city was thrown into tumult."[15]

Two days later Cosimo heard the Vacca, the commune's enormous bell, tolling above him, signaling citizens to assemble in the Piazza della Signoria. There, as long stipulated by the republic's laws, they were called upon to vote by acclamation in favor of the appointment of a committee with emergency powers (*balìa*). To ensure the outcome desired from this putatively democratic exercise of self-government, Albizzi supporters posted at entryways blocked all Medici sympathizers from entering the square. Peering down from the narrow slit of his cell window, Cosimo counted only twenty-three citizens in front of the *ringhiera* approving Rinaldo's kangaroo council.

Some of Rinaldo's followers called for Cosimo to be strangled and thrown from the tower, but even his handpicked committee was wary about going so far. They knew Cosimo had many friends, not only among the thousands of Florentines who "had chosen him as their champion and looked on him as a god,"[16] but also abroad, among leaders he had cultivated over years of diplomatic and business dealings. The Marquis of Ferrara protested, as did the pope's representative Ambrogio Traversari (Cosimo's old humanist friend), and the Venetian Republic sent three ambassadors to try to win his release.

Meanwhile Cosimo also put his money and friends to work from inside his cell. For a mere one thousand florins, he bought the support of Bernardo Guadagni, whom Rinaldo had bailed out of debt to install in Florence's chief executive office of Standard Bearer (he could have had ten thousand florins if he had asked for it, Cosimo would later remark contemptuously). A number of the leading families in the city—the Bardi, the Tornabuoni, the Portinari, the Cavalcanti—were bound to the Medici by business and marriage ties (Cosimo's wife was herself a Bardi), and they spoke up strongly on his behalf. In the Mugello to the north of the city, Cosimo's brother began raising troops. From the west, the condottiere Niccolò da Tolentino's mercenaries rode toward Florence, holding up at Lastra out of fear that Cosimo might be assassinated if they advanced further.

Rinaldo would have to settle for exile. At Cosimo's request—he feared some treachery whereby he would be turned over to "those who stand outside in the Piazza with arms in their hands anxiously desiring my blood"[17]—he was escorted out of Florence in the dead of night. Accompanying him were his brother Lorenzo, his favorite architect Michelozzo, and a *cassone* full of beloved books.

The welcome he received during his journey and on arrival in Venice (where he had salted away fifteen thousand florins) astonished Cosimo. The banker was treated, he wrote to his brother, "as if an ambassador, not an exile," with a degree of honor "scarcely to be believed" for a mere private citizen.[18] He took lodgings in San Giorgio Maggiore, Pope Eugenius's former monastery; commissioned Michelozzo to design a new library at his expense; and settled down to wait for his supporters in Florence to unseat the Albizzi regime.

It did not take long. Rinaldo's increasingly dictatorial methods were extremely unpopular, and no other bankers in the city were willing to lend the government the huge sums the Medici had advanced. After another military defeat in the summer of 1434, Medici supporters finally won a majority of seats to the new Signoria. If they so much as suggested that Cosimo be permitted to return, Rinaldo threatened, he would have them thrown out of the Palazzo della Signoria. But as soon as he left the city for a few days on business, the new priors took charge. Rinaldo returned to find the tables had turned: now, he was the one summoned to appear at the Palazzo. Instead of complying, he rushed to his palace, ordered his five-hundred-man retinue to occupy the church opposite the Signoria, and offered the guard at the door a helmetful of ducats if he would leave it unlocked when the moment came for Rinaldo's followers to storm the building.

Cosimo's priors, however, were not to be taken off-guard. They ordered their own troops to the Piazza in a show of force, brought in siege provisions, barricaded the gates of the Signoria, and sent word for reinforcements. Meanwhile, Rinaldo's adherents began to desert him. His key ally was a patrician even wealthier than Cosimo, Palla di Nofri Strozzi. Like Cosimo an avid manuscript collector, Palla was a committed civic humanist with a reputation for statesmanship, who had never opposed the Medici before 1433. With great reluctance, he agreed to participate in the counter-coup. The plot called for him to bring his own five hundred men-at-arms to rendezvous in the Piazza Sant'Apollinare (the current Piazza San Firenze), from whence Rinaldo hoped to seize the Bargello next door. The conspirators then would attack the Palazzo della Signoria and burn the Medici's houses. But Strozzi arrived at the rendezvous with only two servants, spoke for a moment to Rinaldo, and rode off.

Finally Rinaldo agreed to accept the mediation of Pope Eugenius IV, who at the time happened to be holed up in the Florentine monastery of Santa Maria Novella, having barely escaped from a stone-throwing

Roman mob. Eugenius saw the return of the Medici to Florence as vital to his own chances of returning to Rome. After several hours of argument, he persuaded a dejected Rinaldo that further resistance to the Signoria would be futile.

Two days later the Vacca clanged again, the Medici banishment was revoked, and Cosimo left Venice escorted by three hundred Venetian soldiers. The road back to Florence was lined with well-wishers. Cosimo was accompanied by members of the royal Este family to the city gates, but no farther. The city was extremely touchy about admitting noble foreigners, fearing loss of sovereignty; indeed, they had just pulled down the gate at San Frediano to avoid having to give the keys to the city to the pope.[19] Careful as always about offending republican sensibilities, Cosimo solved the protocol problem by entering the city after sunset. He came in through a small gateway near the Bargello, attended only by his brother Lorenzo, one servant, and a mace bearer from the Signoria.

After spending the night at the Palazzo della Signoria and visiting the pope the next morning to convey his thanks, Cosimo at last returned to his palazzo on via dei Bardi, to the accolades of thousands of supporters filling the streets. "Rarely does it happen," Machiavelli noted, "that a citizen returning triumphant from a victory has been received by his fatherland by such a crowd of people and such a demonstration of good will as he received when he returned from exile. And he was greeted willingly by each as benefactor of the people and [in a deliberate echo of the title given to Cicero on his triumphant return to the Campidoglio] father of his fatherland."[20]

"It would have been better for them to have let things be than to have left Cosimo alive and his friends in Florence," Cosimo's enemy Rinaldo degli Albizzi remarked ruefully when Cosimo's sentence of banishment was rescinded, "for great men must either not be touched or, if touched, be eliminated."[21] The Medici did not countenance outright murder, but they were not about to make the same mistake of halting half-measures their opponents had. By the time Cosimo returned, they had already thoroughly purged the city of Albizzi supporters. More than seventy families were exiled, decimating the citizenry and leaving some Florentines worrying that there would not be enough eligible men left to run the commune. Cosimo drily pointed out, however, that the shortage of those qualified to wear a prior's red cloak could be easily remedied, since all it takes is a few yards of scarlet cloth.

Cosimo's new citizen, to be sure, was less likely than his banished predecessor to be a staunch republican. The ranks of exiles included a

number of eminent patricians steeped in civic humanism, among them the "good and learned" Palla Strozzi, the only man rich enough to have posed a challenge to Medici rule, and Felice Brancacci, sponsor of Masaccio's epoch-making frescoes in the church of Santa Maria del Carmine. After Brancacci's banishment, all signs of his family's contribution to the chapel were expunged, including the Brancacci faces Masaccio had painted into his biblical scenes. (A half-century later, adding insult to injury, Filippino Lippi would fill in the blanks with the visages of Medici supporters.)

It was not only elite anti-Medicean republicans who faced exile, however. Professional humanists who had backed them found themselves expelled as well. Filippo di Ser Ugolino Pieruzzi, the civic humanist notary in charge of formal drafting of laws, was packed off to teach Latin to novices at Badia at Settimo, while the satirist Filelfo, who in exile dispatched an assassin to Florence to try to kill Cosimo's brother, was sentenced in absentia to have his tongue cut out should he ever set foot again on Florentine territory.[22]

One champion of civic humanism, Leonardo Bruni, did stay on as chancellor under the new regime, having always favored Cosimo. He personally drew up a letter warning Siena against sheltering the Albizzi exiles, and wrote elegant dispatches negotiating the transfer of the Council of Basel to Florence. But the status of the chancellorship was changing. No longer a platform for championing civic ideals, the office now devolved into either a sinecure for honored but powerless figures like the old Poggio Bracciolini or an executive post for practical political types like Carlo Marsuppini or Bartolommeo Scala. Bruni himself retreated from politics into culture in his later years, reading Plato even as riots flared in the streets.

The exiled Albizzi party mustered one last effort to regain the city. In 1440 they backed an expeditionary force sent by Florence's enemy, Giangaleazzo's crafty but unhinged son Filippo Maria Visconti of Milan, and led by the great condottiere Piccinino. At a bridge near the village of Anghiari, Piccinino's horsemen, together with townsmen from nearby Sansepolcro, clashed with Florence's mercenaries (complemented by papal troops and Venetian knights). The fight went on for two hours, with the usual cautiousness shown by those fighting for pay. Half a century later, Leonardo da Vinci would depict the engagement in a famous cartoon for the Palazzo Vecchio full of ferocity, but its tenor is far better evoked by the bloodless battle scenes of Paolo Uccello. "Only one man died," Machiavelli noted with disgust, "and he

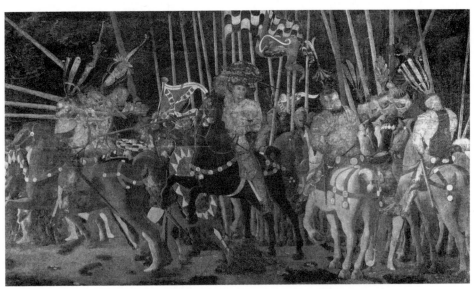

Paolo Uccello, *Battle of San Romano*, detail (© photos.com)

not from wounds or any other virtuous blow, but, falling off his horse, he was trampled on and expired."[23] Always an opponent of relying on mercenaries, Machiavelli ignored the casualties among foot soldiers: a more likely count of the total dead ranges from sixty to nine hundred out of a total of nine thousand fighters. In any case, when the campaign ended, the exiles had been defeated, and Cosimo's position was secure.

Cultivating Public Support: Cosimo's Cultural Program

From then until his death, Cosimo would be the most powerful man in Florence, understood by foreigners to be, as Pope Pius II put it, "king in everything but name."[24] Francesco Sforza, the intrepid condottiere who founded the Sforza dynasty in Milan and was Cosimo's close friend and ally, urged him to simply declare himself ruler; tyrants usurping many Italian city-states did so routinely. But Cosimo understood that his power was fundamentally economic rather than military. He chose instead to exercise his authority without seizing power outright, ruling indirectly through the republic, appealing to its principles when necessary and keeping its citizenry and subjects satisfied.

This meant tolerating criticism. When Cosimo tilted Florence's foreign policy away from her traditional republic-ally, Venice, toward Sforza's Milanese tyranny—a move that stabilized the balance of power among the five major Italian states—his realpolitik angered many in the elite, who were permitted to voice their disapproval. Cosimo also took steps to further cultivate the good opinion of citizens. He married his son Piero to a well-educated, pious, home-grown Florentine debutante, Lucrezia Tornabuoni, rather than some foreign noblewoman; dispensed political patronage far and wide to create a vast web of *amici* ready to return these favors; and appointed men of talent rather than family members as branch managers in the booming Medici banking business, which now had offices in major cities throughout Europe.

Most important of all, he plowed banking profits into public building projects on a scale not seen in Europe since Roman times. A high standard for architectural patronage had been set by his father. Giovanni had helped sponsor Ghiberti's Baptistery doors, Donatello and Michelozzo's monument to his friend Pope John XXIII, and two buildings by Brunelleschi—the sacristy of San Lorenzo (the Medici's parish church) and the foundlings' hospital, the Ospedale degli Innocenti. But Cosimo had more disposable income than his father. As economic historian Raymond de Roover notes, between 1435 and 1455 "the Medici Bank

Domenico Ghirlandaio, *Portrait of Lucrezia Tornabuoni* (Wikimedia / Public Domain)

witnessed its greatest period of expansion and reached the peak of its earning capacity."[25] Cosimo was determined to spend it, especially since "knowing well the disposition of his fellow-citizens, he was sure that, in fifty years, no memory would remain of his personality or of his house but the buildings he might have built."[26] He pumped funds into a new dormitory and chapel at Santa Croce, and commissioned a choir by Michelozzo for Santissima Annunziata, the first clearly designed on a Roman model. In Assisi, he enlarged the Franciscan monastery; in Paris, he restored a college for Florentine students; in Jerusalem, he restored the church of Santo Spirito. The Medici insignia of balls, or *palle* (probably originally derived from the gold coin–emblazoned coat of arms of the money-changers' guild to which the Medici had long belonged), was ubiquitous; even monastery bells were blazoned with it.

Other super-wealthy families in Florence soon followed suit, investing in buildings to advertise themselves. Within a few decades magnificent edifices arose sporting on their facades the crossed chains of the Alberti (on the loggia of the via de' Benci), the sails of the Rucellai (on Santa Maria Novella and the Palazzo Rucellai), and the crescents of the Strozzi (on the Strozzi Palace).

Even as he spearheaded the city's architectural boom, Cosimo cautiously began to morph public festivals, traditionally associated with civic, religious, and feudal powers, into occasions for flattering Florence's leading family. As head of the fraternal Company of the Magi, for example, Cosimo footed much of the bill for the city's most extravagant annual event, the Feast of the Magi. Held on Three Kings Day, the celebration transformed Florence into a mini Holy Land. Gathering in the Piazza della Signoria (repurposed for the occasion into Herod's Palace), a procession of kings would wend its way through the packed crowd to a mock Jerusalem at San Marco to pay respects to an infant Jesus, returning to the Baptistery for a theatricalized Massacre of the Innocents. The spectacle, arranged by important artists such as Michelozzo, was stunning. Up to seven hundred pages led the parade,

> dressed in silk and with pearls and heraldic ornaments and with shields, their faces angelic, riding one after the other with their livery. And after them, on a great and beautiful horse, came an old man with a white beard, dressed in a gold brocade of crimson and a peaked cap of crimson full of large pearls and with other ornaments of the greatest value. . . . And behind this king, in the middle of a float, there was a boy of about three, swaddled and with his hands undone, and in one of them there was a live goldfinch [a symbol of baptism].[27]

Other carts, followed by masked men on stilts posing as giants, wowed the crowd with vignettes including a wild man and—a special favorite—David, one of the city's biblical self-images, slinging rocks at Goliath.

The spectacle's most remarkable feature, however, was the participation of the citizenry in it. Not content with looking on at the pageant, prominent Florentines vied for the opportunity to take roles in it. On one occasion, Cosimo himself, dressed in a gold gown, paraded through the streets as one of the wise men. A less prominent citizen might use another way to honor himself: having his own son don his father's clothes and march wearing a mask with his father's face carved on it. "It was truly lovely," exclaimed one impressed observer, "for the real citizens who had convened at the public buildings to look upon their very selves feigned with as much beauty and processional pomp as the regal magnificence and the most ample senate of the city, which they would proudly conduct before them."[28]

This Renaissance equivalent of photobombing is memorialized in Benozzo Gozzoli's *Procession of the Magi* in the family's private chapel (Image 5) and in Sandro Botticelli's *Adorations*, where various Medici family members pose. But for the Medici, the choice of the Magi story was of more than just narcissistic interest. For both themselves and the public, it helped legitimate their central position in the life of the commune, sanctifying them as philanthropic rulers who magnanimously dispense gifts.

"The greatest discretion":
The Medici Palace and Donatello's *David*

Amid all this wheeling and dealing, and as if to compensate for his public largesse, Cosimo was extremely careful to preserve a persona of modesty and rectitude. As depicted in Gozzoli's *Magi* fresco, so in real life Cosimo rode a mule, and was known to prune his own fruit trees. As a citizen, he did his duty by paying his assessed taxes (though the assessment did undervalue Medici investments by 65 to 75 percent), serving several stints as Standard Bearer, and running his bank while the republic went about his business. "He acted privately with the greatest discretion in order to safeguard himself," his friend and biographer Vespasiano da Bisticci remarked, "and whenever he sought to attain an object he contrived to let it appear that the matter had been set in motion by someone other than himself and thus he escaped envy and unpopularity."[29]

Nowhere was Cosimo's discretion more evident than in the new house he had built for himself on via Larga, on the parade route between the Duomo and San Marco, diagonally across from the Medici's recently completed parish church of San Lorenzo. Brunelleschi had spent years building San Lorenzo. He naturally expected that Cosimo would give him the commission to design a new palace on the lot adjacent to the piazza of the church he had erected. But Brunelleschi's design plan was so grandiose (including having the palace directly face the church) that Cosimo rejected it, infuriating the architect, who smashed his own model to smithereens in a rage. Cosimo turned instead to Ghiberti and Donatello's student, the architect Michelozzo.

A devotee of Cosimo who had followed him into exile, Michelozzo was far more willing than Brunelleschi to take his patron's advice. The result of their collaboration was the first important Renaissance palazzo, and one that served as a model followed by other wealthy merchant families. "Instead of emphasizing semi-public forecourts open to the street" as earlier merchant homes had done, historian J. R. Hale notes, "[the Medici palace] and its successors in Florence were built round a spacious inner courtyard. . . . The change was not so much in the direction of providing individuals with rooms that offered greater privacy or comfort as in emphasizing the right of the family as a whole to withdraw from civic to domestic life."[30]

The emphasis on domesticity was intended, but the reality was more complex. Cosimo loved playing with his grandchildren at home, but he often did so while holding audiences with important foreign visitors as well as a stream of supplicants, merchants, and family hangers-on. (One meeting with Lucchese ambassadors was interrupted when one of Cosimo's grandsons ran in demanding Cosimo carve him a whistle, which he promptly did.) In keeping with this simultaneous assertion and blurring of the difference between private and public, the palazzo did not turn its back on or fortify itself against the world outside. Indeed, this was one of the first buildings to include a stone bench along its outer walls for the convenience of waiting servants or tired passersby, and, in an idea borrowed from Roman edifices, to provide shade for them from a huge overhanging cornice. Nor was the building too grand for an ordinary citizen, as disgruntled anti-Mediceans groused; in terms of sheer size, Cosimo's palazzo was nothing compared to the monstrous pile of stones the Medici's blowhard rival in wealth, the ennobled Luca Pitti, later erected across the river.

These features are no accident. Like Cosimo's other cultural contributions, the Medici palace is both the image and the tool of a new mode of political power—subtle, self-assured, and seductive. To view the facade, with its rusticated facing growing smoother level by level as one lifted one's gaze, and with its combination of Doric and Corinthian columns, was to recognize not a fortress or stronghold but a lesson in elegance. To gaze through the arches of the open loggia on via dei Gori into the square courtyard (inspired by the newly rediscovered architectural treatises of Vitruvius) strewn with ancient busts, inscriptions, and sarcophagi, its lunettes decorated with medallion-sized enlargements of Roman cameos, was to experience not pomp aiming to overawe but an invitation to share in Cosimo's humanist-inspired taste in things classical.

For the average Florentine citizen, that taste would have been notably reflected in the two stunning bronze statues cast for the courtyard, *Judith and Holofernes* (now in the Palazzo della Signoria) and *David*, both by Donatello. Despite their biblical referents, these statues could be, and were, taken to represent not just Humility overcoming Pride, but also the politically virtuous republic thwarting would-be tyrants.[31] To ensure that this message got through, in fact, the base of the *David* was inscribed:

> The victor is whoever defends the fatherland. All powerful god crushes the angry enemy. Behold a boy overcame the great tyrant. Conquer, o citizens.

It is not certain who the "enemy" referred to here is, though given Rinaldo degli Albizzi's reputation for arrogance, the most likely possibility is the Albizzi exiles defeated in 1440 at Anghiari. In any case, for opponents of the Medici, the irony of this appeal to republican virtue by a family they themselves saw as de facto tyrants must have stung. In 1494, after the second expulsion of the Medici, the restored republic would reverse the irony. Donatello's statues were moved from the Medici palace to the Palazzo Vecchio so that their anti-tyrannical symbolism could be turned against their previous owners.

But whatever the direction of its Christian or civic humanist messaging, Donatello's *David* (Image 6), in particular, quite literally outstripped it. Although it was the first free-standing nude male figure sculpted since Roman times, this was no idealized model of Roman

fortitude or strength like the *Saint George* Donatello had sculpted back in 1415 under the oligarchy. Instead, what we see is, shockingly, a real naked body, sensuous and androgynous, with erotic force disturbing enough to the sculptor himself, it was said, that Donatello changed his style radically after finishing it. "It is so soft and flexible," remarked Vasari, "that it is hard to believe it was not cast from a living figure"[32]—and a figure not just alive but aware. With its enigmatic half-smile, its gaze steady or introspective depending on one's view of it, this *David* appears to know it harbors under its civic veneer a second, secretive significance.

And it does—though recognizing the coexistence of these two distinct senses, one civic and moral, the other esoteric and aesthetic, is more difficult now that the statue no longer stands in the Medici courtyard. There, it was viewable from afar by passersby peeking in through the palazzo gate or from below by supplicants waiting in the courtyard for their turn to be ushered upstairs for an audience with Cosimo. From those public points of view, the statue's republican didacticism was unmistakable even for those too far away to read the inscription on its base.

Those lucky enough to be able to look down on the same statue from the second-floor arcade above, on the other hand, could discern other crucial details difficult to see from below. David's toe nestles in Goliath's beard while his other foot cruelly crushes one of the wings on Goliath's helmet; the other wing caresses the inside of David's leg; and most telling, a relief etched in Goliath's visor depicts Eros pulling Aphrodite's carriage in a Triumph of Love. For those in the know, these mysterious details suggested the beautiful boy was an emblem not of a Roman-inspired civic fortitude but something quite different, and quite novel, in Florentine culture: a Greek metaphysics of sexual desire tamed and harnessed by the power of beauty.

"A jewel in a mass of dung"

Esoteric iconography aside, the *David*'s intense physicality in itself reminds us that Florentine humanists discovered in classical culture not only civic ideals but also a great trove of erotic and homoerotic material, which they consumed avidly and even imitated. To be sure, in a culture still dominantly Christian, one had to be discreet, for the Church regularly banned books deemed perverse. But the early humanists were able to reconcile writing and reading even the most licentious

Donatello, *David*, detail (Wikimedia/ketrin1407)

literature by allegorizing its indecent passages, as the Church fathers had done. When Cardinal Cesarini caught his secretary reading Beccadelli's banned *Hermaphrodite*, for example, he forced the poor fellow to tear up the book. "When this was done," reports Vespasiano da Bisticci, "he said, laughing, 'If you had known how to give me the right sort of answer, perhaps the book need not have been destroyed. You should have told me you were searching for a jewel in a mass of dung.'"[33]

Excusing the study of carnal things is not the same thing as promoting it, however, and official Catholic doctrine continued to frown on the notion that physical beauty could lead one to divine truth. Donatello might point to the biblical story in which David strips off the armor Saul gave him as justifying full-frontal nudity, but this was clearly a fig leaf (so to speak), hardly convincing as an excuse. Nor was civic humanism much help in this regard, fixated as it was on stoic self-sacrifice, secular political engagement, and the active life. To fuel the kind of investigation Donatello was spearheading, to make it acceptable to celebrate bodily desire, beauty, and pleasure as mysteries to be plumbed rather than muck to be waded through or bawdiness to be indulged in, a different philosophy was needed. The Florentine Renaissance might have stalled here had it not been for the fortuitous weakness of a pope and his counterpart in the Eastern Church.

In the mid-1430s, Eugenius IV found himself fending off threats by the national churches to cut back his income and to reduce his authority. At the same time, the emperor of Byzantium, John Paleologus, was begging Europe for military help to counter the onslaught of the Turks against his rapidly dwindling empire. Beset as they were, both leaders found it mutually advantageous to make yet one more effort to heal the Great Schism that had divided the two branches of Christianity for six hundred years. Accompanied by the patriarch of Constantinople, spiritual leader of the Eastern Church, Emperor Paleologus journeyed to Italy for an epochal conclave, arriving in Venice trailed by an entourage of seven hundred delegates. They met with the pope's party first in Ferrara, a small city with a lively intellectual and cultural ambience underwritten by its rulers, the Este family. Things went very badly there. After months of procedural wrangling in the cramped city, the pope, who had agreed to pay the enormous expenses of his guests, was so short of money that he had to mortgage a castle.[34] When plague broke out and Cosimo offered to foot the entire bill for housing and expenses if the council would decamp for Florence, Eugenius leapt at the offer.

The two churches were most at odds over what to us might seem an arcane doctrinal issue, but which had split them since the seventh century AD. Did the Holy Spirit proceed from the Father *and* the Son (the Latin formula) or from the Father *through* the Son (the Greek version)? It was a question that could not be resolved simply by logic-chopping argumentation, or by citing earlier manuscripts. What was required was a historical approach to words, one that could go behind these ancient phrases seemingly cast in stone to the human situations in which they were originally set down and to which they had originally responded—precisely the rhetorical attitude toward language that the Florentine humanists had championed. And it was Florence's leading humanist monk, Ambrogio Traversari, together with the Greeks' master mediator, Bishop Bessarion, who ultimately convinced both sides that the two texts were saying the same thing. The other points of dispute were quickly resolved, and the decree of union triumphantly read out in Latin and in Greek from the pulpit of the cathedral on July 5, 1439.

Although memorably commemorated in Ghiberti's Baptistery panel showing the meeting of Solomon with the Queen of Sheba, this reconciliation of Catholic and Orthodox Christianity was both short-lived and ineffectual. Upon returning to Constantinople, the emperor and patriarch were forced by a furious populace to abrogate the agreement, and they waited in vain for the military help promised them by the West. Fourteen years later, the last outpost of the Byzantine Empire fell to the Ottoman Turks. Their leader, the brilliant sultan Mahomet II, decapitated the last emperor and displayed his severed head atop a porphyry column.

For the West in general, the loss of Byzantium was an unmitigated disaster—Pope Pius II called for a Crusade in vain, and the Ottoman Empire went on to control the Balkans for centuries. For Florentines, however, Constantinople's fall turned out to be fortunate. It dealt a body blow to their Venetian competitors, whose most important trade links had been to the defeated Byzantines. Florence's commerce with the Ottoman Empire, on the other hand, boomed, so much so that by 1472 it exceeded the city's trade with France or Naples.

But the biggest windfall the council and its aftermath delivered to Florence was neither economic nor military, but cultural. For years afterward artists would draw on the exotic imagery of leopards and camels, ancient headdresses, and abundant beards they had glimpsed during the processions of their Byzantine visitors. The more fundamental impact

of the Greek sojourn on Florentine art, though, was via the intellectual change it fostered.

Greek culture had been considered important by Florentine humanists since the mid-fourteenth century, when Boccaccio hired a Calabrian monk to translate Homer into Latin prose and had him installed as western Europe's first professor of Greek at the recently established University of Florence. In 1397 Florence brought the Byzantine scholar Chrysoloras to lecture in the city for three years and teach a generation of Florentine intellectuals to read Greek. The burgeoning demand for Greek texts led to imports in the 1420s of huge batches of Greek manuscripts, introducing humanists to hitherto unknown plays of Aeschylus, Euripides, and Sophocles; Homeric epics; the histories of Herodotus and Thucydides; the speeches of Demosthenes; and the full corpus of Plato.

But the civic humanists of the 1420s, as we have seen, were public intellectuals, more interested in practical matters than metaphysics or literature. Their interest in Greek culture was framed by the desire to define and inculcate civic virtue, to instill in the city's rulers the patriotism, courage, and loyalty that had made Rome great. For them, the Greeks who mattered most were the Aristotle of *Nichomachean Ethics* and the Plato of the *Republic*, defining and urging virtue in the polis. Not that Florentines were completely ignorant of other more dangerously unorthodox Greek views. As the historian Ada Palmer has shown, the "proto-atheistic" atomism of the Greek philosopher Epicurus was accessible to readers via Lucretius's much-admired Latin work *De rerum naturae* (the sole surviving manuscript of which was rediscovered by Poggio in 1417). But as Palmer notes, most readers in the first half of the fifteenth century ignored the parts of Lucretius that would be so influential later, focusing instead on Lucretius's vocabulary, moral advice, or imagery.[35]

The Byzantine scholars attending the council introduced Florentines to a different Greece altogether, a culture of philosophical myths and mysteries, not stiff and austere but rich and strange. Its presiding spirit was Plato the mythmaker, the neo-Platonic version of the ancient philosopher. For the neo-Platonists, Plato's stories offered veiled allegories of the soul's metaphysical quest for truth and meaning. In Bessarion's lodgings, and in lectures held between council sessions by the Byzantine pantheist Gemistos Plethon, the basics of this approach were presented to rapt audiences. Cosimo, who already knew some Greek, attended. So did Ciriaco da Antona, father of

classical archaeology (included in the crowd in Gozzoli's *Procession of the Adoration*). Ciriaco had already discovered the sanctuary at Delphi and visited the Acropolis. Over the next decade he would journey again through Greece, bringing back detailed drawings and descriptions of the mystical scenes depicted on the Parthenon. The esoteric meanings of those scenes would in turn be elucidated by the refugee Greek scholars fleeing Constantinople as the Ottoman noose tightened during the 1440s and early 1450s.

For Cosimo, as for the philosopher Marsilio Ficino, whom Cosimo ensconced in a villa with orders to translate Plato's works, Platonism was more than a set of postulates. It was a quasi-religion, a precursor to Christianity. Ficino went so far as to declare that Plato's texts ought to be read in churches—an odd thought, since fifteenth-century Christian asceticism was antithetical in spirit to the call to joyfulness Ficino found in Plato. "In no way inclined to sexual love" himself, according to a contemporary disciple,[36] the pint-sized thinker promoted what he was the first to call "Platonic love" as the stepping-stone from bodily desire for the beautiful to joy in God. Beauty, passion, and pleasure could be redemptive. Myths such as Venus's adultery with Mars, or the bawdy humor of Beccadelli's *Hermaphrodite*, Ficino argued, had been condemned mistakenly by the Church. Rightly interpreted they conveyed not momentary titillation but hidden moral truths about the eternal. Even biblical stories might be interpreted as manifesting Platonic doctrine. David's victory over Goliath, for instance, might illustrate not just Humility triumphing over Pride, but also Plato's assertion in his *Symposium* that Eros inspires soldiers to bravery when they are lovers.

The Angel and the Rascal

Cosimo had reason to think about eternity. At the time of his return to Florence in 1434, he was forty-five—already an old man by Quattrocento standards—and afflicted with crippling gout. As a banker who loaned money for interest, he was uncertain whether he would be saved or not in the afterlife. What is more, his rule over the city "was bound to leave him with certain matters on his conscience," as his biographer Vespasiano delicately put it.[37] In 1436 he confided his anxiety about salvation to Eugenius IV. The pope, himself in exile from Rome and in financial straits, pointedly mentioned that the Dominican convent of San Marco was in dire need of repairs. Cosimo

pledged ten thousand ducats. He ended up spending forty thousand, but the cost overruns were worthwhile. Michelozzo's magnificent complex provided monks and visitors access to the first fully endowed library since ancient times, as well as dozens of otherwise Spartan cells adorned with exquisite frescoes. Most, including the *Adoration of the Magi* in the cell reserved for Cosimo, were painted by a friar lodged there known as Angelic Brother John.

A saintly man who knelt in prayer every morning before mixing his colors, and who often would break into tears when depicting Christ's sufferings, Fra Angelico understood his images not as illustrations of doctrine but as spiritual tools, aids for prayer. As art historian Michael Baxandall has shown, serving this function placed considerable constraints on Angelico's artistic license. In a culture where religious advisors urged their charges to intensify their engagement with the Christ story by shaping "in your own mind some people, people well known to you, to represent for you the people involved" in a given holy episode, the painter needed to stay out of the way of the viewer's imagination. At best, he would provide evocative but non-individualized types, providing what Baxandall calls "a base . . . on which the pious beholder could impose his personal detail." And if the demands of prayer radically limited the range of expressions an artist could represent, these same demands also determined which moments from a given story should be portrayed: not the most suspenseful, but the most emotionally rich. "Moving slowly from episode to episode," the faithful were advised, "meditate on each one, dwelling on each single stage and step of the story. And if at any point you feel a sensation of piety, stop: do not pass on as long as that sweet and devout sentiment lasts."[38]

The stages of religious stories, along with the feelings they should induce, were stipulated by popular preachers such as the flamboyant Fra Roberto Caracciolo da Lecce. For Angelico's favorite subject, the Annunciation (Image 7), for example, Roberto parsed the blessed event into four distinct moments, each with its own particular mental state attached, represented by Mary's gestures: disquiet at the angel's salutation; reflection on what the greeting might mean; inquiry about how a virgin could conceive; and submission as handmaiden kneeling to the Lord with hands crossed.

Angelico stayed within the pattern, showing particular fondness for submission—but as the Victorian sage John Ruskin put it, Angelico's work stands out nonetheless "like a piece of opal among common marbles." His angels, Ruskin wrote, provide us with "the best idea of

spiritual beings which the human mind is capable of forming," appearing "entirely shadowless; the flames on their foreheads waving brighter as they move; the sparkles streaming from their purple wings like the glitter of the sun upon the sea."[39]

This kind of art seems as far away as imaginable from the sensual nudity of Donatello's *David*. But both artists were favored by Cosimo, and humanists interested in Greek-inspired thought were gathering regularly in the library at San Marco, where Fra Angelico worked. His 1440 *Crucifixion* in the convent's Chapter Room, in fact, includes an effigy of one of the key figures in the neo-Platonic canon, the philosopher Pseudo-Dionysius, who in his writings urges us to seek to "see and to know that which is above vision and knowledge."[40] That is not a bad description for what Angelico's painting is about. His paintings present figures that are themselves perspectively perfect, but we do not see them as through a window onto an empirical world subjected to our rationalizing gaze, as the followers of Brunelleschi and Alberti would seek to do. Angelico's visions appear to us from the beyond, and are not to be contemplated rationally from a distance. We are instead encouraged to experience them as if we were already immersed in the scene, a sensation familiar to anyone who has climbed San Marco's convent stairs toward the *Annunciation* on the landing above.

Most Florentine artists, to be sure, were not as spiritual as Fra Angelico, nor as platonically serious in their sensuousness as Donatello, nor as interested in perspective as a science as Alberti. Like the burgeoning Florentine middle class their work appealed to, these artists celebrated instead the pleasures of the mundane, the goods of this world. "With Fra Filippo, Gozzoli, and Ghirlandaio," Mary McCarthy points out, "beds, pots and pans, pitchers and basins, chairs, tables, platters begin to tumble into stories of sacred history as if dumped by a firm of house-movers."[41] This profusion was justified by Alberti's dictum, in his groundbreaking art manifesto, that art should aim at being richly varied, its space teeming with "a properly arranged mixture of old men, youths, boys, matrons, maidens, children, domestic animals, dogs, birds, horses, sheep, buildings and provinces."[42] Of more interest than things themselves, however, are the quintessentially Florentine attitudes captured in these paintings—the look of satisfied materialism on the smiling face of a puckish angel, the streetwise expressions of spectators witnessing miracles.

No artist better exemplifies this down-to-earth aspect of Florentine Renaissance life than the rascally Filippo Lippi, who includes himself

as bystander in a number of his paintings, including the *Coronation of the Virgin* (now in the Uffizi), in which he leans his chin on his hand while giving the viewer a quick, searching glance. A character as vivid as any he painted, at least if we believe Vasari, Lippi was orphaned at two, brought up by Carmelite nuns, and captured by Barbary pirates. Defrocked after eloping with a nun who was posing for him as the Virgin, and rumored to have been fatally poisoned by relatives of a girl he seduced, Filippo brought a desire to his painting that was straight-forwardly lustful. In one version of his *Annunciation*, he even aims the rays from the Holy Spirit directly at a slit in Mary's gown.

"Filippo is said to have been so amorous," Vasari tells us,

> that when he saw a woman who pleased him he would have given all his possessions to have her; and if he could not succeed in this he quieted the flame of his love by painting her portrait. This appetite so took possession of him that while the humor lasted he paid little or no attention to his work. Thus, on one occasion when Cosimo was employing him, he shut him up in the house so that he might not go out and waste time. Filippo remained so for two days; but, overcome by his amorous and bestial desires, he cut up his sheet with a pair of scissors, and letting himself out of the window, devoted many days to his pleasures.[43]

Lippi's shenanigans would have been unthinkable for earlier generations of humanist-inspired artists, who might have been obstreperous like Brunelleschi or hotheadedly intense like Donatello but not self-indulgent. By mid-century, however, that cohort of artists, like their civic humanist supporters, were passing from the scene. Fra Angelico, already fifty when he began painting Cosimo's San Marco frescoes in 1437, had moved on to Rome, where he would die in 1455. Eleven years earlier, the fountainhead of civic humanism, Leonardo Bruni, had been laid to rest in a magnificent tomb in Santa Croce, sculpted clutching his masterpiece, the *History of Florence*, in gratitude for which the city had exempted his heirs from taxes. He did not survive to witness the unveiling of the second set of Baptistery doors he had advised on, which the now elderly Ghiberti finally completed in 1452 after twenty-eight years of work. Within three years the great bas-relief artist too would be dead. Brunelleschi, his competitor in the original competition for the commission of the doors back in 1401, had passed away six years earlier. Cosimo himself had been thirteen when the doors were begun; now he was in his sixties. Only Donatello, Cosimo's

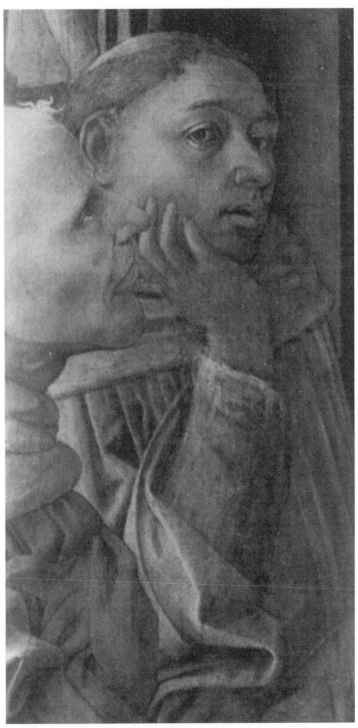

Filippo Lippi, *Coronation of the Virgin*, detail: self-portrait of the artist
(Wikimedia / Public Domain)

favorite artist, remained active throughout the 1450s, returning to Florence in 1454 at the age of sixty-six.

The mood of Donatello's hometown had changed enormously since his departure for Padua in the early 1440s following a spat with Brunelleschi, and not just because so many of his colleagues were gone. In 1453 Florence was shaken, both figuratively and literally, by Constantinople's fall, assaults on the pope, severe storms, and an earthquake. But the city's mood was also being soured by deeper causes. The *ottimati* (as elite Florentines began to call themselves) who had supported Cosimo's return had optimistically expected Florence to evolve into a stable regime with power invested in an oligarchic Signoria on the model of Florence's republican ally Venice. But Cosimo instead flipped Florence's alliance from Venice to Sforza's Milan. In doing so he pointedly ignored objections in the Signoria that a republic should not be allying with a despot against another republic. Marginalized elites began calling for a broader regime that would answer to the supposed desire of the people for "a recovery of the old ways and their pristine liberty," reflecting rising frustration at Cosimo's increasingly tight hold on the reins of power. Non-Medicean elites were slowly coming to realize, as John Najemy puts it, "that they were all gradually being reduced to the status of clients in a hegemonic patronage system" controlled by a single family and operating both privately and through government.[44]

All this made civic humanism's celebration of republicanism seem increasingly naive and outdated. Humanists from within the elite who at this point still supported the regime continued to praise Cosimo in republican terms, but poets from poorer families seeking Cosimo's patronage began to flatter him as a latter-day Augustus. Giannozzo Manetti, author of the quintessential humanist opus, *On the Dignity and Excellence of Man*, abandoned Florence for Naples, where his family had made their banking fortune, preferring the court of a king who admired humanism to the animus of Cosimo's government, which feared his combination of patriotism, principle, and financial independence.

The man of the hour in the city was no humanist, but the opposite of one: the archbishop Saint Antoninus. A protégé of Coluccio Salutati's old adversary Fra Dominici, Antoninus started by imposing discipline on the corrupt clergy. He forbade the wearing of fur-lined habits, forced priests to sign their breviaries so they could not sell them, and even separated friars from their mistresses. When Antoninus proposed banning gambling by priests, however, Cosimo, who admired the tiny

saint but thought his methods too severe, asked, tongue in cheek, "Shouldn't we begin by banning them from using loaded dice?"

Antoninus's response is not recorded, but he is unlikely to have been amused. Like most saints, the archbishop of Florence was not one for half-measures. He intended to reform the city as well as the clergy, and was not above using the whip on immodest women or burning a heretic at the stake outside the cathedral. By 1454 he had accumulated enough influence to force the government to ban from religious procession the fantastic floats produced by competing confraternities, and in a much-reprinted work he chastised artists for painting female nudes that might "provoke to desire" as well as "oddities which do not serve to excite devotion but laughter and vanity, such as monkeys and dogs chasing hares, and the like, or vain adornments of clothing."[45]

Whether or not Antoninus was referring here directly to the details of Gozzoli's *Procession of the Magi*, there is no doubt that he saw the vivid life portrayed there as a stumbling block to piety. Writing to Lucrezia Tornabuoni (Cosimo's politically savvy, deeply religious daughter-in-law and the mother of Lorenzo the Magnificent and his brother Giuliano) in response to her request for more demanding and rigorous spiritual exercises, the archbishop spoke bitingly about the difficulties she faced in maintaining her soul's purity in such a moral swamp as the Medici palace:

> In your house you are not comforted by the others with prayers and other good words, as we are, that would allow you to maintain a devout mind, but rather, in your situation, it is the complete opposite since, if by your hard labor you do acquire some devotion, you'll necessarily lose it, either completely or in part, because of the many things heard in your house from the entire family—hateful, dishonest, criminal, and worldly words—and because of the fact that generally each person speaks according to their own particular loyalties.[46]

Lucrezia's response to this is not recorded. But her concurrence may well be reflected in the *Adoration in the Forest* by Filippo Lippi (Image 8). A devotional work for the family chapel almost certainly commissioned by her, it seems intended to counter Gozzoli's lively and proud Magi imagery on the chapel walls surrounding it. With a severity not native to Lippi's own artistic sensibility, the artist pointedly replaces Gozzoli's kings and their worldly retinue on parade with a far more serious scene. The adoration is set in an allegorically resonant background

of arduous paths winding their way through a Dantescan dark wood, peopled by ascetics, to a purgatorial mountaintop.

The new atmosphere of introspective spiritual stringency emanating from Lippi's *Adoration* is also captured in Donatello's last important work. For what was probably originally intended as a monumental tomb for Cosimo at San Lorenzo, but incorporated after Donatello's death into two pulpits there, the elderly sculptor, suffering from progressive paralysis, produced a harrowing series of reliefs depicting Christ's burial and resurrection. The *Resurrection* should celebrate triumph over death—as it does most famously in Piero della Francesca's roughly contemporaneous version, where Christ stands upright and athletic—but Donatello's risen Christ is still shrouded and so exhausted he is hardly able to lift himself out of the tomb.

Donatello's bone-weary Jesus may also reflect the personal bleakness of Cosimo's last years. In 1458 he was driven to do as had been done to him by the Albizzi in 1434. To avert a coup attempt, he arrested the opposition, surrounded the Piazza della Signoria with mercenary troops to keep all but Miceans from entering, and had those allowed into the square okay an emergency government, while he remained in the Palazzo Medici protected by his own armed retinue. From then until his death the old banker, crippled by arthritic gout, would remain at home. There he could watch the same disease ravaging his eldest son Piero, Lucrezia's husband, who was not expected to outlive him by long. He vested his hopes for the family on his second son, Giovanni, and on Giovanni's little boy. But the beloved grandson died young in 1461 and two years later the stupendously fat Giovanni suffered a fatal heart attack, leaving Cosimo muttering as he was carried about the palazzo that it was "too large a house now for so small a family."[47]

Brought to his villa in Careggi in the summer of 1464 in failing health, Cosimo lay in bed for hours with his eyes shut, "to get used to it," as he told his wife. By his side when he died on August 1, 1464, was Ficino, promising him life beyond the grave on authority of Plato's Socrates. As Cosimo had instructed, he was buried in the vault of the family church, San Lorenzo, without any pomp or demonstration, and without the free-standing tomb he had earlier favored. The city, however, did insist on memorializing him in a way consistent with civic humanist ideology, ordering the words *Pater Patriae*—Cicero's honorific title, originally bestowed on Cosimo back in 1434 upon his triumphant return from exile—inscribed on his tomb.

Donatello, *Right Pulpit*, San Lorenzo, detail: Christ's resurrection (Wikimedia / Miguel Hermoso Cuesta)

~

Magnificence

The thirty-year period between 1464 and 1494 constitutes the second great epoch of Florentine culture, an era dominated by Cosimo's grandson Lorenzo. Like Lorenzo himself, the art, literature, philosophy, and science associated with his age was truly magnificent. Yet beneath this splendor lurked a brooding unhappiness within elites about the hollowing-out of Florence's republican institutions, the concentration of power under Lorenzo's rule, and the concomitant promotion of a public image of aristocratic elegance not just for Lorenzo but even for civic icons like the biblical David. Even within pro-Medicean art and humanist thought of the period, including Lorenzo's own poetry, one can sense if not unhappiness, certainly wistfulness over the fragility of the city's good fortune—an uneasy feeling that even the most tranquil Botticellian beauty floated on a tumultuous sea of murderous violence.

"Heads always in the trough": Republicanism Attempts a Comeback

Cosimo's passing left Florentines anxious about the future leadership of the city. Who would represent the commune's interests in dealings with foreign potentates? Who would bankroll the city's cultural institutions, its charities, its wars? Whose recommendations for appointment to public offices would be heeded? Without Cosimo at its center, his vast but delicate patronage system, the web of competing interests among *amici* which he had diligently brokered (sometimes by recommending

more than one candidate for the same post!), began to fray. Citizens who previously crowded the courtyard and anterooms of the Medici palace now began instead to solicit help at Luca Pitti's massive palace, carrying gifts of trout or starlings.

In the Signoria, the Medici hold on power was loosening. An idealistic orator, Niccolò Soderini, argued successfully to curb the power of the *accoppiatori*, the screeners who controlled which names were allowed to go into the bag from which the three highest offices of the land were picked. This electoral device had long been abused, by the Albizzi oligarchy and then by the Medici, to pack the Signoria with their favored candidates. The new policy did away with such manipulation, restoring the ancient republican principle that priors should be elected by lot. On taking office as Standard Bearer, Soderini also reduced the tax on wine, for which "the people called down blessings on his head."[1]

In the *practica*, citizens began to once again speak out. Calls were now heard for "a more broadly based and freer government, as is appropriate for a *città popolari* like ours." For their part, the elitist *ottimati*, who ardent Medici supporter Benedetto Dei tells us had long chafed at being "stripped of all honor and office . . . with their heads always in the trough," waited eagerly for the right moment to mount an outright challenge to Medici leadership.[2]

When the Medici's closest ally, Cosimo's old friend Francesco Sforza, died in Milan early in 1466, the time finally seemed ripe for a coup. It was left to Cosimo's gouty son Piero, who would have preferred to spend his time poring over Roman coins, to deal with the crisis. The move came in the dog days of August 1466, while Piero was lying ill in Careggi. The conspirators were led by Pitti, Soderini, and Agnolo Acciauoli, an erstwhile Medici supporter who had been exiled in 1433 along with Cosimo but had turned against him in later years. Their troops rode out to the villa expecting to be able to seize the invalid easily, only to find the place deserted. Piero had caught wind of the conspiracy and was already being carried back to the city on his litter. Traveling in advance, his sixteen-year-old son Lorenzo came upon a second band of armed men sent to waylay and murder his father. Passing unrecognized, he sent back a warning to Piero to take another route into town.

Once there, Piero barricaded himself in the Medici palace, bought up all the bread and wine available in the city, mobilized the Medici's own private army of eight thousand, and called for troops from Florence's Milanese allies. Niccolò Soderini rode to the Pitti palace to urge

his co-conspirators to attack the Medici in the name of liberty. But Pitti and the others were anxious that sacking the Medici's house might lead to a general insurrection by the people, as it had during the Ciompi Rebellion of 1378. Their hesitation proved fatal, and when Medici forces arrived and surrounded the Piazza della Signoria to control as always who could enter to participate in the *parlamento*, the ersatz "popular" vote authorizing emergency powers, the republicans' rebellion was over.

Pitti, Soderini, and Acciauoli were all quickly sentenced to death, the latter two in absentia. Piero pardoned Pitti, a canny move that transformed the former Medici antagonist into a staunch ally stripped of any political influence: "In his house one saw great solitude, where before it was frequented by very many citizens."[3] Piero also intervened to have the sentences of Soderini and Acciauoli reduced to exile. These were, after all, former friends and allies of the family. Acciauoli expected those bonds to count for even more, and wrote to Piero trying to shame him into restoring his citizenship, reminding him that he had "lost my country and my estates for your father [Cosimo]." Piero replied with typical Medici tact, framing the issue as one in which the political trumped the personal: "I do not deny your friendship with my father and with us, which ought to have made you regard me as a son, and as such I considered myself." But, he went on, "your guilt is manifest and so great that neither my intercession nor that of any other person would be of any use. . . . I have pardoned every offense; the Republic cannot and should not. . . . The public injury I cannot, will not and may not pardon. For myself personally I forget everything, forgive all wrongs, and remain as a son ought to be towards such a father."[4]

When Piero died just a few years later, the Medici party turned to his twenty-year-old son Lorenzo, asking him to take over as leader of the regime, with the assistance of his younger brother Giuliano. "Their proposal was naturally against my youthful instincts, and, considering that the burden and danger were great, I consented to it unwillingly," Lorenzo later recalled. "But I did so in order to protect our friends and property; since it fares ill in Florence with anyone who is rich but does not have any share in government."[5]

Murder in the Cathedral

Lorenzo may have been young—and if Verrocchio's portrait bust (Image 9) is any indication, not particularly handsome, unlike his brother— but he had been groomed from birth to succeed his grandfather and

father: as a ten-year-old reciting a poem for the ruler of Milan; at age twelve writing letters asking his father to honor him by doling out patronage to a family client who had approached Lorenzo for help; as an adolescent being sent on diplomatic missions to meet the sons and attend the marriages of kings, dukes, and doges. Yet having accepted leadership of the regime, he badly flubbed his first foreign-policy test.

Near the subject city of Volterra, prospectors had discovered a new source of alum, a mineral crucial for wool dying. The Medici, who enjoyed an extremely lucrative monopoly on alum mining, persuaded the Volterran priors to lease the mine to a Medici-led company. On learning of this deal, the Volterrans rebelled, killing two of Lorenzo's investors. Fearing reprisal, the Volterran government sent a delegation offering to restore the mine to Lorenzo. Against the advice of most of his own Signoria, Lorenzo refused, forcing the Florentine government to back his call to punish what he framed as an affront to its authority.

To conduct the siege, Lorenzo hired the one-eyed condottiere Federigo da Montefeltro (whose portrait by Piero della Francesca in the Uffizi shows him discreetly portrayed in profile to hide his missing eye). Federigo was a highly cultured man and a good general. At Volterra, however, he lost control of his mercenaries, who sacked the city with merciless fury. On hearing of the massacre, Lorenzo immediately rode to Volterra and distributed alms to the survivors, a gesture that only seemed to his enemies to confirm he was ultimately to blame.

Lorenzo's ability to persuade the Signoria to agree to his Volterran policy in the first place proved he was in charge. But it also showed there were very real limits to the young man's popularity, at least among the elite, who feared his autocratic tendencies. They had not forgotten that Lorenzo's first public act, at age seventeen, had been to ride fully armed into the Piazza della Signoria to join the Medici-backed troops there "protecting" the *parlamento* of 1466, crushing the republican revolt. Wary of this prince-like behavior, the citizenry's formal request to Lorenzo and Giuliano to govern had included a caveat: they "would accept the youths as sons and they, the citizens, as fathers," not vice versa.[6]

The worry was justified. Lorenzo was distanced from his fellow *ottimati* not just in politics but also in business and marital alliances. Ignoring important families in Florence, he was turning to non-Florentines to manage the Medici banking branches. And his father's decision to marry him not to a Florentine society girl but to a haughty, unintellectual heiress from a feudal Roman family, the

Orsini, had been widely unpopular, not just because it indicated the Medici were joining themselves to the highest Italian aristocracy rather than strengthening local ties, but also because the Orsini had its own army that Lorenzo might call upon.

To mollify the city, but also to promote their own aristocratic magnificence, the Medici hosted a tournament in Piazza Santa Croce in 1469. Lorenzo appeared decked out in white silk and velvet, his cape strewn with rubies and diamonds, riding a white charger, a gift from the king of Naples, that he then exchanged for a combat steed given him by the duke of Ferrara. The wedding celebration held four months later was even more lavish: for three days banquets were held nonstop in the Palazzo Medici. More than five thousand pounds of sweetmeats, two thousand capons, and three hundred barrels of wine disappeared down the throats of throngs of guests.

Such public-relations largesse was nothing unusual for a Medici, to be sure. Lorenzo describes finding a notebook in 1471 listing the sums spent by his grandfather and father for public benefit. The total, 663,755 florins, struck even Lorenzo as "incredible," though well spent, as "it gave great honour to our State."[7] Lorenzo, however, could no longer rely on the Medici bank's profits to underwrite Medici magnificence, as his predecessors had done. Gone were the days when raw materials like English fleece could be easily purchased and shipped to Florence. Newly assertive governments had begun demanding hefty loans in exchange for export licenses. At the same time, Florence's northern markets were being drained of money by the extraordinarily corrupt papacy of Sixtus IV.

A self-made man elected in 1471 by promising preferments to undecided cardinals, the pudgy Sixtus treated the papacy as nothing more nor less than a family business, selling benefices and indulgences, while handing over lucrative bishoprics to five of his nephews. For a sixth, Girolamo Riario, Sixtus hoped to set up a new state. He arranged for Girolamo to marry the duke of Milan's daughter, ten-year-old Caterina Sforza (later to become one of the Renaissance's most intrepid rulers and the grandmother of Florence's Duke Cosimo I). Pope Sixtus then asked the Medici bank in Rome for a loan to purchase for Girolamo the stronghold of Imola in the Romagna, a vital source of Florentine grain and the route to Florence's Adriatic trade port. Lorenzo had been about to close the deal to buy the town himself when the pope intervened, and he refused to make the loan. Infuriated, the pope immediately dropped the Medici as papal bankers, a

serious financial blow to Lorenzo. Worse still, Sixtus hired as his new bankers the Medici's leading competitors, the Pazzi.

A much older family than the Medici, the Pazzi had a Crusader in their past, an international business empire rivaling the Medici's, and their own commensurate social capital. As members of the highest elite, Pazzi children had literally run in the same circles of royalty and aristocracy as the youthful Lorenzo, marching with him in processions honoring visiting princes. Cosimo had done his best to take advantage of this social networking to co-opt the family, engineering the marriage of Lorenzo's sister Bianca to Gugliemo de' Pazzi. Gugliemo would a few years later shepherd sixteen-year-old Lorenzo to Milan to witness the ceremonial turning over of Ippolita, nineteen-year-old daughter of the duke of Milan, to the thirteen-year-old son of the king of Naples (a proxy for his elder brother, whom she was to wed).

But these affiliations and social interactions could not prevent the Pazzi from feeling increasingly resentful at their position in Lorenzo's regime. They felt keenly that he was not adequately recognizing the honor that should be their due as leading citizens in the republic. Their aggrievement was exacerbated by Lorenzo's claim, backed up by his listing of ten Pazzis selected to serve as priors between 1439 and 1472, that the civic standing the Pazzi enjoyed had been given them by "our house."[8] Such words must have been particularly galling since under Lorenzo any real power priors once might have held was being drained by "reforms" vesting actual governing authority in new executive councils packed with Miceleans.

It is hardly surprising then that when Lorenzo responded to the Pazzi's Imola deal with Pope Sixtus by passing a law designed to deprive the family of the large inheritance one of their wives expected to receive from her father, Pazzi resentment over honor gave way to a sense that Lorenzo was out to get them. For his part, Lorenzo complained that the Pazzi were badmouthing him. "If they go on making trouble for him," the Milanese ambassador reported hearing Lorenzo say, "he would make them regret it."[9]

To the pope's nephew Girolamo Riario, now ensconced in Imola, the Pazzi must have seemed perfect choices as accomplices for a high-risk/high-gain plot he was now hatching. The plan was to assassinate both Lorenzo and Giuliano and seize power for himself in the name of the republic. Jacopo de' Pazzi, the family patriarch, was approached first, but he rejected the plot out of hand as dangerous and foolish. Undeterred, Girolamo turned to Jacopo's hotheaded son

Francesco, who agreed to take part. Together with Francesco Salviati, who blamed Lorenzo for having tried to block his appointment as archbishop of Pisa, they enlisted an assassin, a well-regarded soldier named Montesecco. They then headed to Rome to get the pope's blessing for their bloody objective. Sixtus first told them only that he wished Lorenzo gone. On being pressed to support the plot, however, the pope gave them carte blanche—adding, for the sake of appearances, "but no bloodshed." Now backed by Sixtus's support, Girolamo and Francesco were able to convince the vacillating Jacopo de' Pazzi to change his mind and join the plotters.

To try to get within striking range of the brothers, the conspirators attached themselves to the entourage of the pope's innocent grandnephew, the young Cardinal Raffaello, on a visit to Florence. Lorenzo (perhaps hoping to mend fences with the pope) had invited the cardinal to lunch at the Medici villa in Fiesole. The assassins' plan to attack there fell apart, however, when Giuliano failed to show up for the meal.

The plotters then turned to plan B. They arranged for the cardinal to inveigle an invitation from Lorenzo for the cardinal and his retinue to join the brothers for a tour of the fabulous art collection in the Medici palace the next day, a Sunday, after Mass. A platoon of crossbowmen dispatched by the pope's condottiere Federigo da Montefeltro was deployed outside the city, prepared to rush into Florence at a time synchronized with the killing, in order to help secure the city. But this plan went awry as well when the cardinal, instead of going directly to the cathedral for Mass, stopped first at the palace. The unforeseen delay meant the approaching archers would arrive too soon, putting the whole enterprise at risk.

The only possible remaining solution at this point was to attack the Medici brothers during Mass in the cathedral. The signal would be the ringing of the sanctuary bell at the raising of the host. Lorenzo was assigned to Montesecco, but the soldier balked at killing in a sacred locale, declaring that he did not want to "accompany treachery with sacrilege."[10] Riario replaced him with two priests, one a vengeful Volterran, the other a tutor to the Pazzi family. Giuliano was to be set upon by Francesco de' Pazzi and Bernardo Baroncelli, an adventurer deeply in debt to the Pazzi. While the assassins were striking, the archbishop Salviati was to rush to the Palazzo della Signoria, along with Jacopo Bracciolini, the impoverished son of Cosimo's old humanist friend and book hunter Poggio (and, with Lorenzo himself, a former participant in Ficino's Platonic circle). While they entered the building and took

control of the government, Jacopo de' Pazzi, the head of the family, would take to the streets to rally the people against the Medici.

But first came Mass. Cardinal Raffaello and Lorenzo walked together from the palace to the cathedral. To the alarm of the conspirators waiting there, Giuliano was not with them: he had decided to skip church to rest an injured leg. Francesco de' Pazzi and Baroncelli went back to fetch him. As Giuliano limped toward the church he leaned on Francesco, allowing the assassin to ascertain with pleasure that he was wearing neither a hidden breastplate nor a sword. Famously well-mannered, Giuliano politely followed Francesco and Baroncelli through the crowded cathedral to the northern side of the choir. On the other side of the high altar, Lorenzo stood with five friends, including the poet and family tutor Poliziano. Behind them lurked the two priests.

At the sound of the bell, as the congregation bowed their heads, the assassins pulled their daggers and struck. Wounded in the neck by the bungling priests, Lorenzo drew his sword and fended them off. He then vaulted over the altar rail and ran for the vestry doors situated under della Robbia's beautiful choir loft, as Cardinal Raffaello, cowering in terror, remained kneeling at the high altar. Once Lorenzo was safe inside the vestry's massive bronze doors, a Medicean supporter sucked the wound in his neck in case the daggers had been poisoned. As he did so, Lorenzo looked around wildly for his brother, asking, "Giuliano—is he safe?"

From outside came the sound of the terrified congregation shouting wildly and beating on the sacristy doors. Finally one of Lorenzo's boyhood friends climbed a ladder to the choir loft, from where, Poliziano says, "he could see down into the church, and at once he knew what had been done, for he could see the body of Giuliano lying prostrate." Giuliano had been killed almost instantaneously by a dagger blow from Baroncelli that almost split his head, lowered for the sacrament, in two. Lorenzo's lookout saw "that those who stood at the doors were friends"[11] and yelled down to open up. Thronging around Lorenzo, his followers formed an armed bodyguard for him and took him home, exiting through a side door so that he should not come across his brother's body.

Meanwhile, Archbishop Salviati arrived at the Palazzo della Signoria with Jacopo di Poggio Bracciolini and a group of Perugian thugs disguised as his followers. Under the pretext of delivering an urgent message from the pope, he demanded to see the Standard Bearer, Cesare Petrucci. Salviati was ushered into a waiting room alone, while

Bertoldo di Giovanni, *Medallion Showing the Murder of Giuliano de' Medici* (bpk-Bildagentur / Florence Cathedral / Reinhard Saczewski / Lutz-Jürgen Lübke / Art Resource, NY)

Bracciolini cooled his heels out in the corridor. The Perugians were told to wait in nearby offices. When Petrucci finished his dinner and appeared, he noticed Salviati's evident nervousness and, immediately suspicious, called for the guard. At this, Salviati shouted to the Perugians to attack. But they could only bang fruitlessly on the doors. Petrucci, it turned out, had recently had all the locks in the Palazzo fitted with special self-bolting latches that once closed could be opened only with a key. In desperation, Jacopo di Poggio rushed into the waiting room to attack Petrucci, who grabbed him by the hair and threw him down. Then, snatching up a cooking spit, the Standard Bearer turned to Salviati and beat the archbishop to the ground.

By then the great bell was clanging and the Piazza was boiling with incensed Medici supporters. They rushed into the Signoria, butchered the trapped Perugians, and rushed off again, holding aloft the heads of their victims on the ends of their swords. Minutes later, Jacopo de' Pazzi belatedly rode up to the Palazzo della Signoria, desperately shouting the old republican rallying cry, "Liberty and the People!" The enraged mob responded with curses and the Medici counter-chant of "*Palle, Palle!*" (referring to the balls on the Medici family crest) and Jacopo quickly fled. Writing decades later, Machiavelli (who would have been an impressionable nine years old at the time) recalled that "the whole city was in arms. . . . Throughout the city the name of the Medici was being shouted, and the limbs of the dead were seen fixed on the points of weapons or being dragged about the city; and everybody pursued the Pazzi with words full of anger and deeds full of cruelty."[12]

When the news of Giuliano's murder reached the Signoria, Jacopo di Poggio and Archbishop Salviati were thrown from a window with ropes around their necks, along with Francesco de' Pazzi, who had been dragged naked and bleeding from his house. The poet Poliziano tells us that the archbishop, still dressed in his clerical robe and miter, struggled at the end of his rope, fixing his teeth into the flesh on Francesco's shoulder (an image of damnation the poet may have lifted from Dante).

Although Lorenzo appeared at the window of the Medici palace to urge calm, neighborhood gangs of teenagers continued to rampage through the city for several days. "The streets were filled with the parts of men," Machiavelli writes. More than eighty people associated with the conspirators, whether implicated or not in the plot, were massacred. Among them was pitiful old Jacopo de' Pazzi, who was caught by villagers, brought back to the city, tortured, stripped, and finally

hanged from a window of the Signoria next to the archbishop. This was not dishonor enough, however. "Messer Jacopo was entombed first in the sepulchre of his ancestors, then dragged from there as excommunicated, and buried along the walls of the city," Machiavelli tells us.[13]

In his diary, the apothecary Luca Landucci offers an eyewitness account of what happened next:

> At about 4 p.m., some boys disinterred it a second time, and dragged it through Florence by the piece of rope that was still round its neck and when they came to the door of his house, they tied the rope to the door-bell, saying: "Knock at the door!" and they made great sport all through the town. And when they grew tired and did not know what more to do with it, they went to the Ponte al Rubiconte and threw it into the river. And they sang a song with certain rhymes, amongst others this line: "Messer Jacopo is floating away down the Arno." And it was considered an extraordinary thing, first because children are usually afraid of dead bodies, and secondly because the stench was so bad that it was impossible to go near it; one may imagine what it was like, from the 27th April till the 17th May! And they must have had to touch it with their hands to throw it into the Arno. And as it floated down the river, always keeping above the surface, the bridges were crowded with people to watch it pass. And another day, down towards Brozzi, the boys pulled it out of the water again, and hung it on a willow, and then they beat it, and threw it back into the Arno. And it is said that it was seen to pass under the bridges of Pisa, always above the surface.[14]

All the other conspirators eventually met fates similar to Jacopo's. The two inept priests, caught cowering in the Badia, were first castrated and then hanged, while Montesecco, the soldier who had refused to murder where "God would see him," was more honorably beheaded in the courtyard of the Bargello. Baroncelli fled to Constantinople, where he was recognized, seized, and returned to Florence by the sultan; he too was hanged, after torture. In keeping with Florentine custom, Lorenzo paid an artist—Botticelli—to paint effigies of the hanged Pazzis on the wall of the Bargello; Lorenzo himself provided the epitaphs inscribed beneath the images.

Botticelli's effigies and Lorenzo's epitaphs have long since faded. But we do have a sketch of Baroncelli's hanging corpse. It was dashed off by another artist who enjoyed attending executions and was just making a name for himself in 1478 (despite having been denounced to the Night Officers two years earlier for allegedly sodomizing a seventeen-year-old goldsmith's apprentice): Leonardo da Vinci.

Leonardo da Vinci, *Drawing
of Hanged Conspirator
Bernardo di Bandino Baroncelli*
(Wikimedia / Public Domain)

Laurentius

Gangs of pro-Medicean teenagers were still roaming the streets of Florence when word of the Pazzi conspiracy's failure reached Sixtus in Rome. On hearing that the archbishop sent to assassinate Lorenzo was dangling in full regalia from a window of the Signoria, the pope roared with anger. He immediately arrested all the Florentine merchants and bankers in Rome, confiscated the Medici bank's assets, repudiated the papal debt, and excommunicated Lorenzo as well as the entire Florentine Signoria. If at the end of two months their property was not turned over to the church, their houses razed to the ground, and Lorenzo handed over to papal justice, Sixtus thundered, the entire city would be excommunicated. Perhaps realizing the hollowness of these spiritual threats (Tuscany's bishops, in fact, issued their own decree excommunicating Sixtus in return), the pope also declared war upon Florence, inviting King Ferrante of Naples—who already had designs to expand into southern Tuscany—to join him.

Defiantly, the Signoria retorted that "the Keys of St. Peter were not given to you to abuse in such a way." The city, they declared, would "resolutely defend her liberties, trusting in Christ who knows the justice of her cause, and who does not desert those who believe in Him; trusting in her allies who regard her cause as her own; especially trusting in the most Christian King, Louis of France, who has ever been the patron and protector of the Florentine State."[15] As the Florentines soon discovered, however, placing such trust in France to save the republic was a mistake. The French king was especially fond of the Medici—he had granted Lorenzo's father permission to mark one of the Medici balls with a fleur-de-lys—and Lorenzo counted on this friendship in appealing to Louis for help. "I well know and God is my witness that I have committed no crime against the Pope," Lorenzo wrote, "save that I am alive and having been protected by the grace of almighty God have not allowed myself to be murdered."[16] But Louis had his hands full bringing his feudal nobility to heel while imprisoning his own advisors in iron cages. He offered sympathy, but no soldiers.

Florence's other allies, Venice and Milan, were equally useless in this crisis. Venice was focused on getting aid to a strategically located Venetian fortress in Albania besieged by a massive Ottoman army seeking a stepping-stone to Italy. Milan was too busy dealing with her own internal feuding among the successors of the murdered Duke Galeazzo to send more than a small force. With an enormous joint papal-Neapolitan

army now advancing methodically toward Florence under the command of the efficient Federigo da Montefeltro, it seemed only a matter of time before Lorenzo's regime would fall.

Despite urging from the Signoria to confront the enemy, Florence's hired commander, Ercole d'Este, ruler of Ferrara, prudently refrained from joining in battle with the Neapolitans' commander, the duke of Calabria (his own son-in-law). The fighting season ended in November 1478 without any resolution. By then, within Florence itself the mood had changed from defiant to bleak. Bands of outlaws were terrorizing the Tuscan countryside, and cases of plague began to crop up inside the city walls. One man was even found dead sitting in a pew at Santa Maria Novella. "And at this Christmas-time [1478], what with terror of the war, the plague, and the papal excommunication," wrote Luca Landucci in his diary, "the citizens were in a sorry plight."[17] The poet Poliziano, packed off to the country with Lorenzo's children to act as their tutor, sat by the fire in wooden sandals moodily ruminating "about death and wars, and the pain of the past and the fear of the future."[18] Things went from bad to worse the next year, when at the end of the fighting season the strategic hamlet of Colle di Val d'Elsa finally fell in November 1479 after holding out for months. The pope's troops were now within striking distance, only thirty miles from Florence.

Lorenzo recognized that the city could not survive another campaign. In a gutsy move, arrived at without consulting the priors, he decided to risk traveling to Naples alone to try negotiating a peace treaty with King Ferrante. Having raised sixty thousand florins by mortgaging some Medici properties, Lorenzo rode off to Livorno, where he had arranged for Neapolitan galleys to transport him and his entourage. On the road, he sent back a note to the Signoria explaining his decision. Insisting that the situation "demands acts and not words," he went on:

> Seeing that all other endeavors have been fruitless, I have determined to run some peril in my own person rather than expose the city to disaster. Therefore, with the permission of Your Excellencies of the Signoria, I have decided, with your approval, to go voluntarily to Naples. Being the one most hated and persecuted by our enemies, I may also, by placing myself in their hands, be the means of restoring peace to our city. . . . Having a greater position and larger stake in our city, not only than I deserve but probably than any citizen in our days, I am more bound than any other person to give up all to my country, even my life. These are the feelings with which I go, for perhaps our Lord God desires that this

war, which began with the blood of my brother and my own, should be put to an end by me. My ardent wish is that either my life or my death, my misfortunes or my well-being, should contribute to the good of our city. . . . I go full of hope, praying to God to give me grace to perform what every citizen should at all times be ready to perform for his country. [signed] Laurentius de' Medici[19]

The civic humanist commonplaces Lorenzo invoked in this letter—self-sacrifice for one's *patria*, the duties of a citizen, the humble asking of permission from the rulers of the republic, even the use of Latin for his signature—were by this point in Florentine history almost quaint. Certainly, coming from Lorenzo they rang hollow for some republicans. Soon after his departure, in fact, handbills were scattered around the city scrawled with the phrase "And yet the tyrant has gone," implying the time was more than ripe to take back the liberty Lorenzo had usurped. But his claim in the letter to be placing his life on the line, whether it was for the city or for himself and his family, was not mere boilerplate. The risk was real. Another recent guest of the inscrutable and treacherous King Ferrante, the famed condottiere Jacopo Piccinino, had been murdered at a banquet the king had hosted in his honor, and the king delighted in conducting visitors on tours of his "museum of mummies," which displayed the embalmed bodies of opponents dressed in the costumes they had worn when alive.

Lorenzo was not flying totally blind, however. He had felt out the situation carefully with help from merchant-banker Filippo Strozzi, whose family had made their fortune in Naples and who was known to "have great credit with his majesty the King."[20] Lorenzo also had helpers in Naples. He was friendly with the king's son and with his wife, Ippolita, having met her back in 1465 in Milan, as well as with Ferrante's chief advisor, a fellow humanist. And he knew, too, that the king was worried about France's increasingly bellicose claims to his throne, as well as about the Turks threatening his kingdom's Adriatic coast.

Lorenzo set to work, charming Ippolita and appealing personally to Ferrante's shared taste for hunting, poetry, and humanist literature. He pointedly and repeatedly alluded to exemplary Greek and Roman peacemakers and argued that Florence would be a far more useful friend than the selfish pope. Yet negotiations dragged on. Finally, after ten weeks, Lorenzo announced that he could wait no longer, and hurriedly left the city. Ferrante took the bluff, and quickly dispatched a courier to overtake the Florentine party with a signed peace treaty.

That left Sixtus. The pope came to terms in 1480, after Turkish troops took Otranto, a small town on the tip of Italy's heel, sacking it, killing all its inhabitants, and establishing a heathen beachhead on the peninsula. Desperate to muster resources to counterattack, the pope retracted his hard-line stand against Florence. He offered individual citizens indulgences in exchange for confession, penance, and a contribution to the war effort. From the republic itself he no longer demanded surrender, but merely financial support for fifteen galleys.

Perhaps as a direct outcome of the peace agreement, within a year Sixtus would summon Ghirlandaio, Botticelli, and other Medici-favored artists to Rome to fresco the new Vatican room he had had erected, called the Sistine Chapel after him. Only months earlier, Botticelli had painted the pope's Pazzi conspirators as hanged men on the wall of Florence's customs house. Now, ordered to be sure to include in his painting oak trees associated with Sixtus's della Rovere family coat of arms, Botticelli pointedly situated the devilish pope's oaks in a forest where Jesus is tempted by Satan.

The crisis was finally over. Lorenzo's negotiating skills had weathered the storm. Throughout Italy he was widely hailed as a diplomatic genius. Over the next dozen years he would be asked on at least six occasions to perform his diplomatic magic to bring peace among the great powers of Italy.

"In Florence, a city eager to speak, which judges things by results," the mood was jubilant. "Lorenzo, if he had left as great, returned to Florence very great," Machiavelli says, "and he was received by the city with the joy that his great qualities and recent merits deserved, as he had exposed his very life to gain peace for his fatherland."[21] To commemorate the triumph over Naples, Botticelli was commissioned to paint *Pallas and the Centaur*, in which Athena, her gown festooned with Medicean rings, subdues a beast whose face is thought to resemble Ferrante's.

Nonetheless, even after the peace treaty was implemented, the city remained jittery. Before he finally had his throat slit by the Imolans, the pope's nephew Girolamo had tried twice more to assassinate Lorenzo, who now went about with an armed escort of a dozen or more men brandishing drawn swords and crossbows. When a hermit was caught at Lorenzo's villa of Poggio a Caiano, he was accused of intending to murder Lorenzo and tortured to death. "It was said," Luca Landucci recorded in his diary, "that they skinned the soles of his feet, and then burnt them by holding them in the fire till the fat dripped off them; after which they set him upright and made him walk across the great hall."[22]

Landucci added tellingly that "opinions were divided as to whether he were guilty or innocent," evidence that not all citizens felt comfortable about the power to terrorize that Lorenzo wielded. And with good reason. For the republic was now, more than ever, bent to his will. To strengthen Medici control of the government, Lorenzo took away most substantive political power from the Signoria, vesting it instead in a new Council of Seventy. The council, a sort of senate more or less handpicked by Lorenzo, would from now on elect the Signoria, initiate legislation, and conduct foreign and domestic affairs. Politics was to be restricted to an inner circle of three hundred or so. Even the *practiche*, or consultative assemblies, where citizens once were expected to exercise their humanistic training in rhetoric by deliberating together, were quietly disbanded. Yet Lorenzo remained a citizen and Florence a republic, at least in appearance. "That the old forms, as hollowed out as a forest of dead oaks, were nonetheless left standing," notes the historian Ferdinand Schevill, "testifies to a public state of mind which obliged the cautious Lorenzo substantially to continue the inherited Medicean anonymity and to refrain from too visibly playing the signore."[23]

In truth, Lorenzo's power was still by no means absolute. The Council of Seventy insisted on doing more than merely rubber-stamping his policies. Moreover, the Medici financial empire was faltering, part of a Europe-wide economic downturn in the last third of the fifteenth century. That made it hard for Lorenzo to provide loans to rulers as a form of leverage, as his grandfather Cosimo had done so effectively. The decline in Florentine banking in general was precipitous—from thirty-three firms in 1460 to only six in 1492, the year of Lorenzo's death—but the reversals suffered by the Medici bank were especially spectacular. Lorenzo's general manager, Francesco Sassetti, had himself depicted proudly standing next to Lorenzo in *Confirmation of the Franciscan Rule by Pope Honorius III*, the altar wall lunette fresco Sassetti commissioned from Ghirlandaio for his family chapel in the church of Santa Trinita (Image 10). But he also ran the bank into the ground, and his branch managers made disastrous investment decisions.

Another bank manager, Tommaso Portinari, managed to deliver Hugo van der Goes's massive altarpiece (now in the Uffizi) to Florence from his station in Bruges, introducing Florentine painters to the heightened beard-stubble realism achievable using oil paints; unfortunately, he also bankrupted the Bruges firm by backing Charles the Bold, duke of Burgundy, who was killed in battle in 1477. The death in 1483 of Louis XI of France likewise set off a ruinous run on the Medici's

Lyons branch, and the Medici bank in London failed when Edward IV welched on a loan during the War of the Roses. Small wonder then that when a new progressive income tax was levied in Florence in 1481, Lorenzo noted apologetically on his return: "In making out this report, I shall not follow the same procedure as my father in 1469 because there is a great difference between that time and the present, with the consequence that I have suffered many losses in several of my undertakings, as is well known not only to your Lordships but to the entire world."[24]

Lorenzo made good many of the bank's losses by dipping into the public till and by expropriating his nephews' inheritances. The crash would come later, after his death, by which time most of the Medici family's capital had been transferred from banking into landed holdings that would ensure their financial security for the next several hundred years. Meanwhile, the Florentine economy was beginning to adjust to new international conditions. The same Florentine trade that had brought spices, dyes, and pigments from the East was now bringing to the city some of the commodities produced by the nascent empires of Europe's emerging nation-states. "I bought some of the first sugar that came here from Madeira; which island had been subdued a few years before by the King of Portugal, and sugar had begun to be grown there," Luca Landucci reported in 1471, adding proudly, "I had some of the first."[25]

Florentines themselves were now looking beyond Europe or the Middle East. In quest of new markets for their cloth, Benedetto Dei and other merchants traveled deep into Africa. The cartographer Paolo Toscanelli went even further without even leaving Florence. An ingenious scientist who had studied the stars with Alberti, taught geometry to Brunelleschi, and turned the Duomo itself into a giant measuring instrument to determine the summer solstice, Toscanelli gathered geographical data from Central Asian slaves, Armenians who had visited Cathay, and the tales of Marco Polo. Putting it all together, he drew a world map showing Asia close to Europe. A young Genoese sea captain got word of Toscanelli's work, and wrote asking for help charting a westward path to the spice islands. When he finally sailed in 1492, Christopher Columbus carried with him, transcribed into the fly-leaf of a book, a copy of Toscanelli's map.

"Lorenzo is brilliant and makes the whole company gay"

The elderly Toscanelli formed part of the dazzling intellectual and cultural circle that gathered around Lorenzo. At the democratically

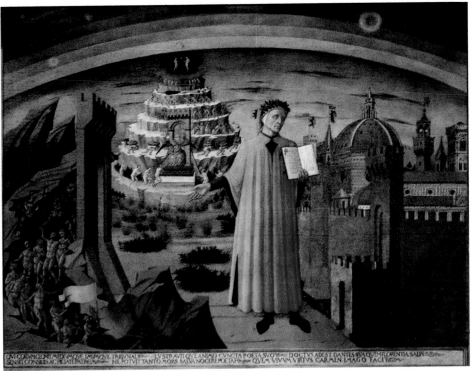

Image 1. Domenico di Michelino, *Dante with the City of Florence*. Duomo, Florence (© iStock / lexan)

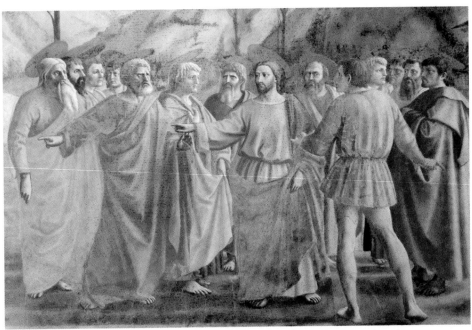

Image 2. Masaccio, *The Tribute Money*, detail. Brancacci Chapel, Santa Maria del Carmine, Florence (Wikimedia / Public Domain)

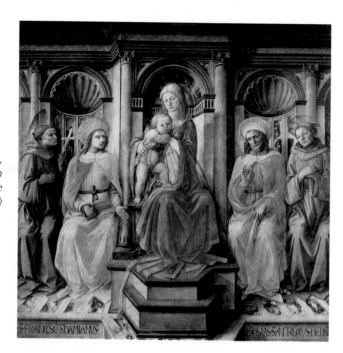

Image 3. Filippo Lippi, *Madonna Enthroned with Saints*. Uffizi, Florence (Wikimedia / Public Domain)

Image 4. Donatello, *Neri di Gino Capponi* (often misidentified as *Niccolò da Uzzano*). Bargello, Florence (Erich Lessing / Art Resource, NY)

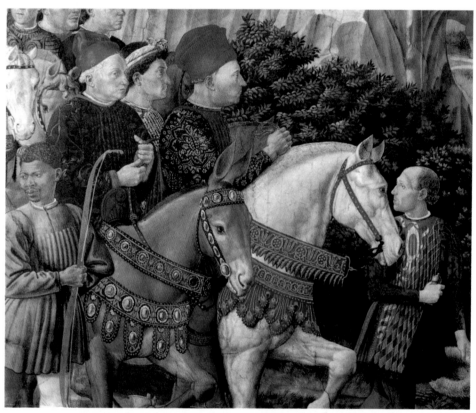

Image 5. Benozzo Gozzoli, *Procession of the Magi*, detail: Cosimo de' Medici riding a donkey, Piero on horseback. Cappella dei Magi, Palazzo Medici-Ricardi, Florence (Wikimedia / Public Domain)

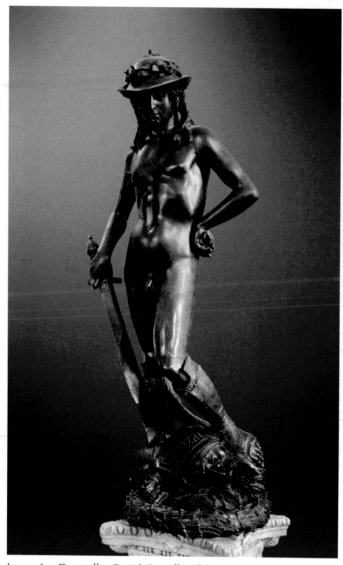

Image 6. Donatello, *David*. Bargello, Florence (Wikimedia /
Patrick A. Rodgers)

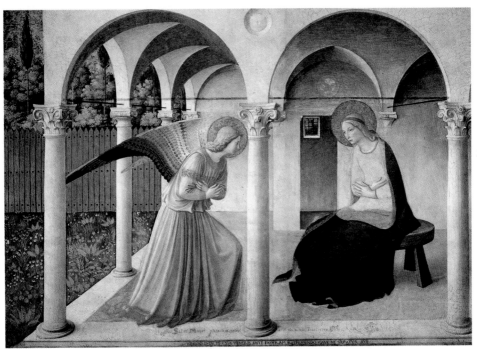

Image 7. Fra Angelico, *The Annunciation*. Museum of San Marco, Florence (Wikimedia / Public Domain)

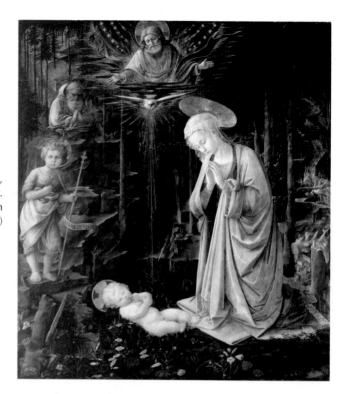

Image 8. Filippo Lippi,
Adoration in the Forest.
Gemäldegalerie, Berlin
(Wikimedia / Public Domain)

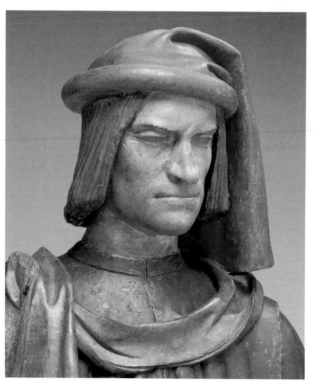

Image 9. After Andrea del
Verrocchio, *Portrait Bust of
Lorenzo de' Medici.* National
Gallery of Art, Washington, DC
(Wikimedia / Public Domain)

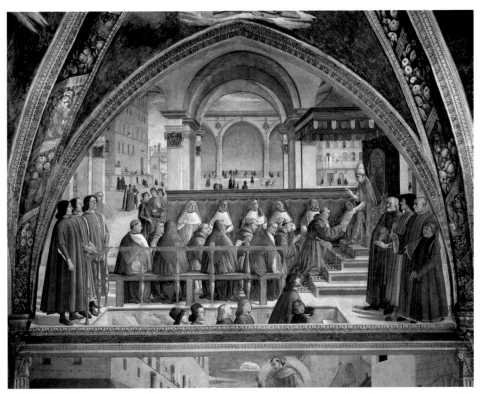

Image 10. Domenico Ghirlandaio, *Confirmation of the Franciscan Rule by Pope Honorius III*. On the steps are Poliziano (with long hair) leading young Piero to meet Lorenzo (dark hair, in profile), standing next to Francesco Sassetti. Santa Trinita, Florence (Scala / Art Resource, NY)

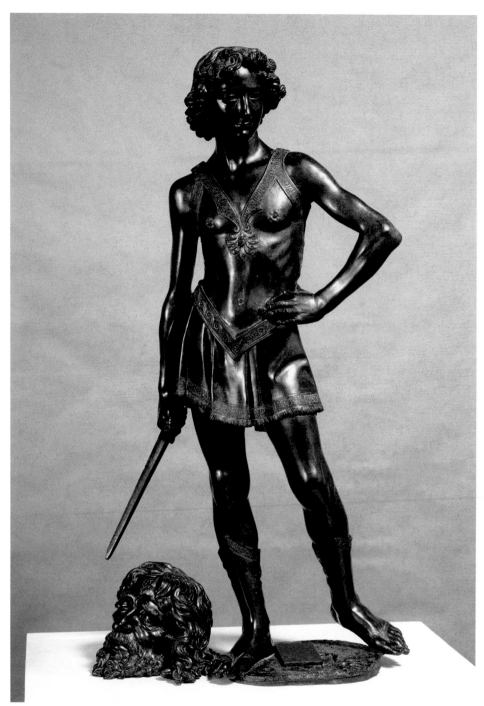

Image 11. Andrea del Verrocchio, *David*. Bargello, Florence (Scala / Ministero per i Beni e le Attività culturali / Art Resource, NY)

Image 12. Sandro Botticelli, *Adoration of the Magi*. Cosimo bathes infant Jesus's feet; to the right is Lorenzo (in profile), and on the far right Botticelli gazes out at the viewer. Uffizi, Florence (Wikimedia / Yair Haklai)

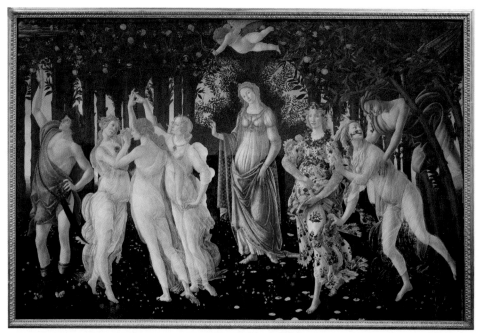

Image 13. Sandro Botticelli, *Primavera*. Uffizi, Florence (Wikimedia / Livioandronico 2013)

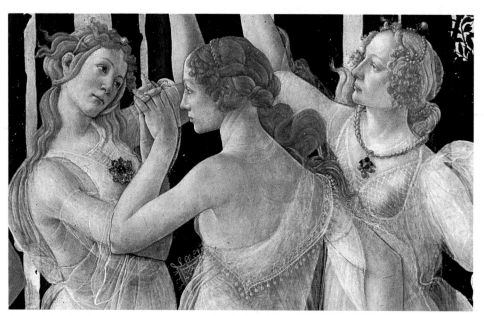

Image 14. Sandro Botticelli, *Primavera*, detail: the three Graces. Uffizi, Florence (Wikimedia / Public Domain)

Image 15. Fra Bartolomeo, *Portrait of Girolamo Savonarola*. Museum of San Marco, Florence (Wikimedia / Public Domain)

Image 16. Michelangelo Buonarroti, *David*, detail. Accademia, Florence (Wikimedia / Jörg Bittner Unna)

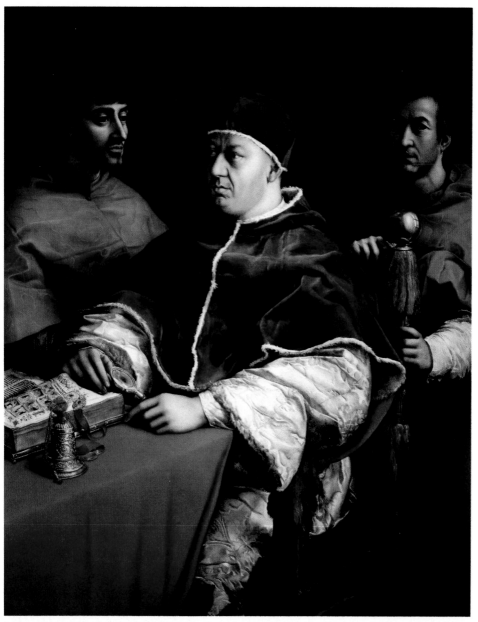

Image 17. Raphael, *Portrait of Pope Leo X and His Cousins, Cardinals Giulio de' Medici (future Pope Clement VII) and Luigi de' Rossi*. Giulio is to the left of Leo. Uffizi, Florence (Wikimedia / Public Domain)

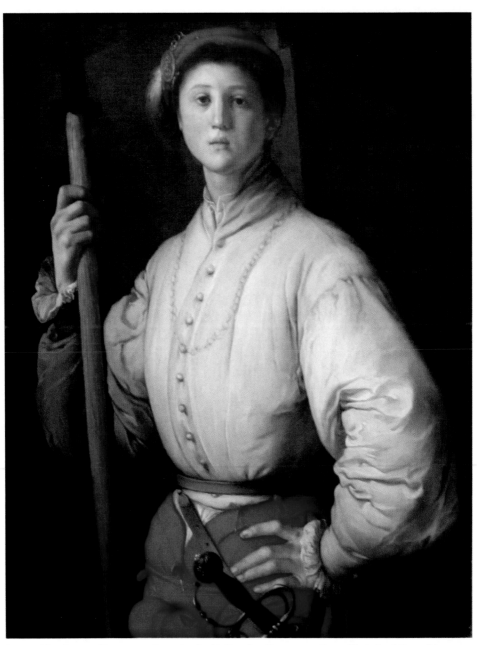

Image 18. Jacopo Pontormo, *Portrait of a Halberdier* (*Francesco Guardi?*). J. Paul Getty Museum, Los Angeles (Wikimedia / Public Domain)

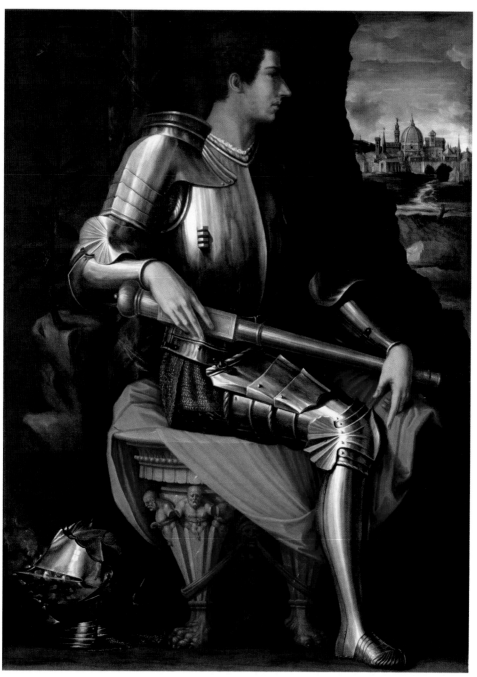

Image 19. Giorgio Vasari, *Alessandro de' Medici*. Uffizi, Florence (Wikimedia / Public Domain)

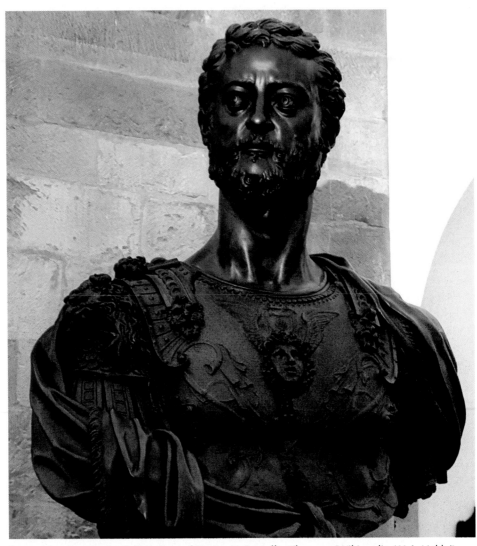

Image 20. Benvenuto Cellini, *Bust of Cosimo I*. Bargello, Florence (Wikimedia / Yair Haklai)

informal dinner table in the Palazzo Medici, where there were no fixed seating arrangements, could be found on any given night a who's who of poets, artists, and philosophers: Poliziano (depicted in Ghirlandaio's *Confirmation* leading up the stairs his pupils, Lorenzo's sons Giuliano, Piero, and Giovanni), the greatest poet of his age, whom Lorenzo had found in tatters translating the *Iliad* into Latin hexameters; the now aged bookseller and biographer Vespasiano da Bisticci; the great musician Antonio Squarcialupi, befriended as a boy by Cosimo's son despite having a butcher as his father, and whom Lorenzo excused for personal failings, saying, "If you knew what it takes to excel in any [artistic] activity you would speak more gently and moderately of him";[26] even, for a week or two before he died, Cosimo's old slanderer Filelfo, exiled since 1434, whom Lorenzo permitted to return to Florence in 1481 after the savage polemicist turned his poison pen against Sixtus IV.

It was not Lorenzo's power alone that attracted the Florentine intelligentsia, but also his superb cultural attainments and immense personal charisma. His highly accomplished mother (and, Lorenzo said on her death, his most trusted advisor), Lucrezia Tornabuoni, had seen to it that the young Lorenzo received the best humanist education. From the future ambassador to France, Gentile de' Becchi, he had learned the art of oratory and writing; from the first modern literary critic, the Dante commentator Cristoforo Landino, and Landino's friend, the now elderly arch-humanist Leon-Battista Alberti, Lorenzo had been taught to appreciate and honor poets; and from the great refugee scholar from Constantinople, Argyropoulos, he had acquired proficiency in reading ancient Greek.

Lorenzo's most important teacher, however, was Cosimo's pint-sized protégé Ficino. It was Ficino who introduced the young, athletic sportsman to the mysteries of Plato. At Ficino's villa in the pine forest at Montevecchio, the philosopher conducted symposia in which later generations of Medici suggested Lorenzo participated periodically. This reincarnation of the ancient Platonic Academy supposedly delved into such deep questions as the essence of true nobility, the virtues of the active as opposed to the contemplative life, and the nature of God. Legend also had it that every November 7, Lorenzo celebrated Plato's birthday with a banquet at his villa in Careggi, where votive candles burned in front of an enshrined bust of the philosopher.

As James Hankins has shown, these stories are myths.[27] Certainly Lorenzo was supportive of Ficino, but he also paid the salaries of others who attacked Platonism instead of supporting it. The reality is that the

intellectually voracious Lorenzo never became a mere epigone of the humanists who hoped to steer him. He was too restless and too responsive to physical beauty to submit to ascetic discipline. Fascinated by Ficino's neo-Platonic talk about the soul's ascent from the carnal to the spiritual, he also loved French romances, hunting, soccer, and, as we have seen, the competitive pageantry of jousts. He yearned to withdraw from the rigors of his political duties to the calmness of villa life. But in the countryside he was less likely to be found secluded in a Platonic grove than carousing: "Like Antaeus able to restore his strength (they say) by falling to the ground," he joked in one of his poems, "my thirst by means of drink grows all the more."[28]

Lorenzo sponsored Ficino, but one of his dearest companions as a youth was the ribald satirist Luigi Pulci, who mercilessly mocked Ficino's neo-Platonism: "They cite Aristotle and Plato, / and they hope that the soul rests in peace / Among sounds and songs; and they dance around so much / That it muddles up your head."[29] (For his part, Ficino described Pulci as a liar, a barking dog, and a madman.)

For those lucky enough to join his inner circle, daily life with Lorenzo was, literally, a moveable feast, as Poliziano described it in a quick, vivid note dashed off on the fly to Lorenzo's stay-at-home wife Clarice:

> Yesterday, after leaving Florence we came as far as San Miniato al Tedesco, singing all the way and occasionally talking of holy things so as not to forget Lent. At Lastra we drank zappolino wine, which tasted much better than I had been told. Lorenzo sparkles and makes us all triumphant—yesterday I counted, in the party accompanying him, twenty-six horses. Yesterday evening, having arrived at San Miniato, we began to read a little of St. Augustine; and this lesson then resolved itself into music and watching and giving directions to a well-known male dancer who is here. Lorenzo is going to mass now. I will finish another time.[30]

Wine, women, and song, interspersed with serious conversation about the flight of the soul and a little Saint Augustine: we have come a long way from the sober gravitas of the civic humanists and of cautious, restrained Cosimo.

From one point of view, the change in humanism reflected in Lorenzo's magnificent lifestyle and Poliziano's participation in it is an unmitigated loss. Salutati, Bruni, and other Florentine thinkers of the first half of the century had been either energetic manuscript hunters like Poggio Bracciolini, scholar-tutors, or political men of

letters vigorously engaged in the republican oligarchy's civic life. Under Lorenzo, by contrast, intellectuals instead tended to be either academic pedagogues restricted to the city's university or dependent courtiers concerned, in the opinion of intellectual historian Eugenio Garin, with "nothing but literary elegance"[31] and consumed by vicious backbiting. This judgment, while severe, pales in comparison to the moral disgust expressed by Garin's great nineteenth-century predecessor Jacob Burckhardt, who saw in the humanists of Lorenzo's age not just toadies but "the most striking examples and victims of an unbridled subjectivity" and "licentious excess."[32]

Burckhardt's disgust was shared by Machiavelli, an intellectual who came of age only after the end of this era. Florentine humanism's loss of civic focus, he suggested, went hand in glove with cultural decadence. The young men of the city, Machiavelli tells us, "alienated from the values of the past, spent excessive amounts of money on clothes, banquets, and lascivious pleasures, and because they were idle, they squandered their time on games and women. Their chief care was to appear magnificently dressed and to be wise and witty in conversation, and the one who was cleverest at insulting the others was considered the smartest and most admired."[33]

That is too harsh, certainly. But it is undeniable that by the 1480s Cicero was being read less, Ovid and Lucretius more. The civic humanism of Salutati and Bruni, forged around 1400 in response to the threat to the oligarchic republic by Gian Galeazzo Visconti's Milanese tyranny, no longer held sway. It had already begun to morph as early as the 1440s, under the double pressure of Greek thought and Cosimo de' Medici's hegemony over the republic. That earlier cultural-political shift, as we have seen, was registered symbolically in the differences between Donatello's marble *Saint George*, heroic and stalwart behind his shield, sculpted in the early 1400s for the city, and his inward-looking nude bronze *David*, created around mid-century for both city and Cosimo. Now, during the age of Lorenzo, a second sea change within the Florentine imagination of power was at hand. And as earlier, this change is manifested by a bronze *David*.

Verrocchio, one of Lorenzo's favorite artists, created his version of the biblical giant-killer for the Medici sometime in the late 1460s at around the time Lorenzo was coming to power. The Jewish shepherd-king traditionally exemplified civic humility and restraint, traits that non-Medicean republican elites at the time still hoped Lorenzo would

imitate. So, for instance, in a 1474 dialogue dedicated to Lorenzo, the humanist Bartolomeo Platina first has Lorenzo's father Cosimo compare himself to David—like David, Cosimo went into exile rather than shed blood to take power. Platina's imaginary Cosimo then admonishes young Lorenzo not to imitate David's son Absalom, since Absalom in seeking to seize the city showed "insolence and audacity."[34]

Yet insolence and audacity are precisely what is on unabashed display in Verrocchio's *David* (Image 11). Its insouciance stands in stark contrast to the pensiveness of Donatello's earlier version. Both Davids have just killed the giant. But Donatello's hero pauses, leaning on his sword with his foot planted on Goliath's head, as if seeking to fathom, in the neo-Platonic symbols on Goliath's helmet, the meaning of his deed, even as he maintains a publicly humble attitude. Verrocchio's princeling *David*, on the other hand, is the opposite of thoughtful, devoid of philosophical symbols, and not at all humble. Originally gilded to accentuate the elegance of his outfit, he is already turning away from Goliath's head, toward us. With sword slightly raised and the trace of a smirk on his face (thought to be modeled on the visage of Verrocchio's apprentice Leonardo da Vinci), he fixes his self-satisfied gaze confidently on us, proud of himself, expecting us to appreciate his genius.

Or if not appreciate it, then fear it. In 1476 Lorenzo and his brother sold Verrocchio's sword-brandishing statue to the Signoria, the first time the government had purchased a work for itself. That it did so at this delicate moment in Lorenzo's relations to the republic, and that the Medici sold the statue at a steep discount, make clear that this was a decision made with political ends in mind. Tellingly, the statue was placed not in public view on ground level (as with Donatello's *David* in the Medici palace courtyard), but up a flight of stairs, parked just outside the door to the government's main meeting and reception room, the Sala dei Gigli, whose frescoes would within a few years be decorated under Lorenzo's direction. In the run-up to the Pazzi conspiracy, it could not have escaped the notice of priors that a cocky boy-prince was brandishing a sword toward them as they ascended the stairs to do their civic duty.

Primavera

For average Florentines not opposed to the Medici, neither Verrocchio's *David* nor Lorenzo's very public self-presentation would have

carried such unsettling political implications. On the contrary, both were marveled at for their magnificence. That was no accident. It was, in fact, part of a cultural strategy to divert Florentines from brooding on their loss of liberty by focusing their attention on spectacle and elegance. To that end Lorenzo promoted youth groups and authorized new festive associations of silk weavers and wool beaters (long banished from processional as well as from political participation), while sponsoring the lavish jousts, races, and feasts of the 1470s. For these events, artists of the caliber of Botticelli and Verrocchio were commissioned to create gorgeous pagan-themed banners and ornate helmets to be given as prizes to the winner. Without fail the prize would go to Lorenzo or Giuliano.

Such fixing of the competition did not sit well with every Florentine, however—not for political reasons, but because, especially in races like the Palio, some were in it for the money. Luca Landucci, for instance, notes sourly in his diary that though his brother Gostanzo had beaten Lorenzo's horse in a close race at Siena, he had not contested Lorenzo's getting the prize, "out of respect." Luca himself shows considerable bitterness about this, going on to recall another occasion on which Gostanzo lost the race despite having already crossed the finish line and dismounted when the Medici rider passed the winning post. "A very great injustice, that a rider who had not won the palio should receive it!" wrote Landucci in disgust, concluding sadly that "it was most unfortunate, as my brother had such a good horse."[35]

Whatever the justice or injustice of Lorenzo's magnificence, it would be wrong to see it as aristocratic preening, or mere partying, or only as an ideological tool to distract and seduce the Florentine populace. To dismiss in these terms the culture Lorenzo presided over would be to miss one of its key features: its tone of wistfulness and anxiety. This sense of what Baudelaire would centuries later name *ennui* is captured in Ficino's observation that "in the midst of our pursuit of pleasure we are sometimes despondent, and when the curtain falls we leave sadder still than before. . . . Whenever there is nothing to keep us busy, we feel out of place and overcome by sadness, although we cannot tell why."[36] Ficino himself usually suppressed this feeling by following the blandly hopeful injunction he had inscribed on the wall of his Platonic enclave: "Rejoice in the present."[37] Lorenzo himself, a poet of no small talent, was able to capture in a famous drinking song both the spirit of Ficino's maxim and the deeper, quieter desperation Ficino left out:

Quant'è bella giovinezza,
Che si fugge tuttavia!
Chi vuol esser lieto, sia:
Di doman non c'è certezza.

How beautiful youth is,
Yet it flees so quickly!
He who wishes to make merry, should:
There's no telling about tomorrow.

The profoundly modern sense of insecurity registered here signals a different kind of humanist ethos, inspired by neo-Platonism, less rational than that of civic humanism but more emotionally demanding. As J. R. Hale puts it, "The neo-Platonists were not so much interested in man as a political animal as in man as a self-expressive and perfectible personality."[38] In place of public virtue, neo-Platonism spoke of the purpose of existence; in place of civic engagement, a spiritual quest for transcendence by way of desire. It was less an ideology than a quasi-religious sensibility. No wonder then that it found its most beautiful expression in the art of a painter who had begun his career depicting pensive Madonnas and would end it mourning Savonarola: Sandro Botticelli.

The young painter was picked up early on by the Medici, from whom he won a commission to depict Cosimo, Piero, Lorenzo, and Giuliano as Magi (and the artist himself, who gives us a cool sidelong glance from the edge of the crowd) in an *Adoration of the Magi* (Image 12) far more elegant than Gozzoli's earlier version also packed with Medici faces. Like a sponge, Botticelli soaked up the precepts Alberti laid out for good painting: aim for fluency and gracefulness; depict figures in motion; use clothing and hair to accentuate the feeling of movement; draw on allegorical subject matter as the ancients did. But he put this technical expertise and erudition into the service of expressing a very un-Albertian attitude—not Verrocchio's worldly liveliness, but oneiric yearning.

Nowhere is this spirit more palpable than in Botticelli's *Primavera* (Image 13), that great hymn to neo-Platonic love. The panel was painted to hang in the bedroom of Lorenzo's second cousin, also confusingly called Lorenzo (di Pierfrancesco de' Medici), an aesthetically inclined pupil of Ficino and Poliziano. It is their philosophy and poetry that Botticelli incarnates in this enigmatic masterpiece.

As the art historian Edgar Wind explains in his magisterial analysis of the *Primavera*, Ficino and his followers taught Lorenzo di Pierfran-

cesco and Botticelli how love takes three forms—carnal, Platonic, and spiritual. At first glance these seem utterly incommensurable. For the neo-Platonist, however, they can be grasped as properties of a single essence, firmly linked to each other by relations of opposition, agreement, and agreement-in-opposition; only one property of love can be grasped at any one moment, but the movement of mind leads us from one to the next.

Most minds would have trouble following such woolly philosophical reasoning, Ficino and his followers granted. But they argued that the Greeks before Plato provided a way for non-philosophers to experience imaginatively what they could not yet conceptualize. Plato's teaching is already implicit in Greek myth's metamorphoses and mysteries. The dialectic of love, for example, is perfectly imagined as the interaction between the three Graces, so much so that "he who understands profoundly and clearly how the unity of Venus is unfolded in the trinity of the Graces, . . . knows the proper way of proceeding in Orphic theology."[39] And this same form of dialectic, Ficino insists, pervades the entire universe of pagan myth. It should then also lie hidden within the Ovidian myth Poliziano shared with Botticelli, telling how the innocent wood-nymph Chloris, touched by the amorous Zephyr, the wind of spring, "produces flowers from her breath," metamorphosing into the goddess Flora.

Both the myth of Chloris and Zephyr and the three Graces appear in Botticelli's picture. But how does the complex mythical scenario orchestrated by Botticelli in the *Primavera* make use of this story and these figures to illustrate how the unity of love unfolds itself?

On the right side of the painting, Botticelli depicts the linear unfolding of the myth of Chloris, Zephyr, and Flora. Out of the union of opposites—chaste love represented by the awkward, fleeing Chloris; sensuous love by Zephyr swooping in toward her, bending the trees with his gale of passion—the splendid, spiritual figure of Flora emerges, striding toward us. The scene's spatial discontinuities are truly startling: Flora appears oblivious to what is happening, even as Chloris seems to be falling into her (note how the fingers on Chloris's hand penetrate impossibly into the flowers on Flora's dress, flowers that in turn are impossibly identical to those cascading from Chloris's mouth). Within the context of the myth, this uncanny special effect makes both visual and philosophical sense. Chloris touched by Zephyr is metamorphosing into Flora, just as opposites resolve in synthesis through the movement of thought.

The same triad of chaste, passionate, and spiritually resplendent love appears again, and more clearly, in the interaction of the three Graces on the left (Image 14), but there transposed from a linear into a circular movement. The Grace on the left restrains the impulsive movement of the Grace in the center, while a more ornately coiffed and refined-looking Grace to the right pulls and pushes the other two. No viewer can fail to appreciate Botticelli's unparalleled delicacy of line and rhythmic elegance. What is often missed, however, is the conceptual counterpoint built into every detail: variations in dress, ornament, hairdo, even in the way the Graces' hands interlace. As Wind points out, "Insofar as dialectic can be danced, it has been accomplished in this group"[40]—with Venus in the center of the painting keeping the tempo for both dancers and viewer.

It is worth contrasting Botticelli's circle of Graces with the circle of apostles gathered around Jesus in Masaccio's *Tribune Money*, or the circle of saints in Nanni di Banco's 1415 sculpture in the niche at Orsanmichele. As we have seen, those figures, inspired by civic humanism, are deeply engaged in seeking the truth through argument. Botticelli's Graces are in no way arguing. They are dancing. Yet they too are engaged, impelled toward truth. They glide leftward, an action motivated by the central Grace, Chastity, who has been pierced by arrows of tempestuous love shot by blind Eros (hovering over his mistress Venus). Chastity turns her back on the world and gazes longingly toward Hermes, who seems peculiarly unconcerned with the action in the picture, instead turning heavenward to probe the clouds with his wand. "The highest wisdom," Ficino taught, "is to know that the divine light resides in clouds,"[41] and it is Hermes's function, as god of interpretation and leader of the Muses, to guide the chastely-loving spirit from earthly passions to the beyond of intellectual contemplation.

The painting's sweep from left to right thus carries the desiring viewer ultimately out of this world. Yet this is no dead end, for it is from within those mystical clouds touched by Hermes that his complementary opposite cousin Zephyr will dive back into the world, beginning anew the metamorphoses of love. "What descends to the earth as the breath of passion," Edgar Wind explains, "returns to heaven in the spirit of contemplation."[42]

If this sounds vaguely Christian, that is because it is, despite its distinctly un-puritanical embrace of sexual desire. Ficino and his neo-Platonist followers, who went so far as to identify the spirit of Eros with the biblical spirit moving upon the waters, gave Botticelli

the intellectual permission to imbue physical passion with deep spiritual significance. It was Botticelli's genius, however, to make the equivalence of erotic and holy seem not only reasonable but lovely. As Joseph Cronin has noted, in *The Birth of Venus*, a work that may have originally formed part of a larger cycle with the *Primavera*, the painter went so far as to set the head of a Madonna (with its scrupulous chastity) on the nude body of Aphrodite, and depict the pagan goddess's birth as a quasi-baptism, complete with scallop shell—all without any sense of incongruity, strain, or violence.

The Testicles of Uranus

Yet, for a way of thinking that required oppositions and contradictions for its dynamism, violence had to be inherent even in this most serene of scenes. And Greek myth provided it. After all, we learn from the Greeks that "Venus could not be born if the severed testicles of Uranus did not fall into the waters of the sea"—a point made with evident relish by a radical young philosopher who was to bring out, in deed and word, the explosive implications of the neo-Platonic dream: the precocious, rich, and impetuous Count Giovanni Pico della Mirandola.

Like Ficino before him, Pico set out to "examine all writings, reconcile every school," to reunify all known religions and philosophies, making "Moses and Timaeus bear witness" to the same truth. Perhaps the first true multiculturalist in the West, with a memory so phenomenal he could recite Dante's *Divine Comedy* backwards, he went further afield than Ficino, mastering not just Latin and Greek but also Arabic, Chaldean, and Hebrew, even delving into the Kabbalah. But Pico was also a far more passionate man than Ficino—he was known to burst into tears after listening to music, and had once run off with a married woman, leading to a battle in which eighteen men were killed or wounded—and his Orphic theology was at once wilder and fiercer. Man, he announced, is a "Proteus," a "chameleon," "pure uncertainty," "constrained by no limits": we can "become what we wish to be."[43]

With his insistence on the power of human will, Pico sounds something like his humanist precursor Alberti. But where Alberti had celebrated a will governed by reason, Pico's will is instead, like his teacher Ficino's, constrained only by love and our own will. Moved by love, if we are worthy we may penetrate into the mystery of reality, embracing Sphinx-like contradictions that the rational intellect would otherwise exclude. For Ficino this embrace of the unthinkable is paradisiacal,

joyful, self-confirming. Pico's love is the opposite: strenuous, Diony-
sian, vehement. In going beyond all limits, he insists, we faint, we blind
ourselves, we metamorphose to the point of self-annihilation. Though
nicknamed the Duke of Concord by Ficino, Pico was far more inter-
ested in the struggle, the "deeds and labour" required even by angels
contemplating God. They do not stay still but go up and down Jacob's
ladder. When we become like them—and we *can* become godlike, Pico
insists—we shall "descend, dashing the one into many with Titanic
force like Osiris, and ascend, with Phoebean might collecting the many
into one, like Osiris' limbs."[44]

The asexual, quietist Ficino had become a priest. But Pico's own
titanic force drove him where angels feared to tread, into public con-
troversy. Fired with "holy ambition," and backed by his own immense
wealth, the twenty-three-year-old polymath rode to Rome, where he
published a list of nine hundred theses and offered to pay the expenses
of anyone willing to come debate them. His propositions were a bewil-
dering array of quotations from ancient sources and assertions of his
own, couched in sometimes impenetrably obscure language. Neverthe-
less, the Church understood seven of them well enough to find that
"they savor of heresy," and Pico fled from the Inquisition to France,
where he expected tolerance. Instead, he was clapped into prison. His
friend Lorenzo interceded on his behalf, obtained his freedom, and in-
vited him to live in Florence, where Pico arrived in June 1488.

Portents and Prophecies

The city seemed calm enough. Certainly there was none of the
political strain of the Pazzi period. This was due partly to Lorenzo's
tightening of control, partly to the general demise of civic humanism
as the favored ideology of Florentine gentlemen. Older republican pa-
tricians like Alamanno Rinuccini had retired from public life to write
elegies for the liberty based on civic equality which the city had once
enjoyed. Far from urging their sons to seek honor in the state, suc-
cessful merchants like Giovanni Rucellai now advised against seeking
offices and political influence. "There is nothing which I esteem less,
or which seems less honorable," Rucellai sniffed, "than to be involved
in public affairs."[45] Instead, over the last third of the fifteenth cen-
tury, rich Florentines increasingly focused on patronage of the arts,
understood now, however, as an aesthetic pleasure rather than a social
duty. As Rucellai put it, "For fifty years I have done nothing but earn

money and spend it; in so doing I have learned that I enjoy spending money more than earning it."[46]

The result was a boom for the arts, presided over by Lorenzo. Constrained by his financial problems, he himself preferred collecting ancient gems, cameos, and objets d'art; he was said to enjoy fondling small bronzes such as Pollaiuolo's *Hercules and Antaeus*. But Lorenzo used his reputation as a connoisseur to promote the interests of various Florentine artists. To the duke of Milan he recommended Leonardo da Vinci; to the Vatican, Ghirlandaio and Filippino Lippi. Under his sponsorship, the cathedral commissioned busts of Giotto, Dante, and the composer Squarcialupi, signaling that for the first time in European history, great artists were to be honored as individuals worthy of reverence. Vasari's *Lives of the Artists* was still more than a half-century to come, but the first biography of an artist since classical times, Manetti's *Life of Brunelleschi*, appeared in 1480.

Lorenzo also influenced the city's architecture, submitting his own design for the cathedral's facade (competing against the likes of Verrocchio and Botticelli) and counseling rich Florentines eager to follow the Medici lead by erecting their own classically inspired palaces. "Men were crazy about building at this time," diarist Luca Landucci noted.[47]

Perhaps the craziest was the egomaniacal Filippo Strozzi. Exiled at age six as a scion of the anti-Medicean humanist patrician Palla Strozzi, Filippo returned in 1466. Determined to show he was on board with Medici rule, he assisted Lorenzo with his Neapolitan trip (as we have seen) and assiduously sought public offices from then on despite remaining justly cynical about how little real power those offices held in Lorenzo's regime. Lorenzo, however, could not prevent Filippo from winning honor by building a new house for himself. His gigantic palazzo, begun on August 6, 1489, at a time astrologically fixed by three physicians, a bishop, and Marsilio Ficino, is the last great one to rise in Quattrocento Florence. Dozens of houses were demolished to make room for the huge edifice. For neighbors like the aggrieved Landucci, whose pharmacy was opposite the construction site, the hubbub made life miserable: "We shopkeepers were continually annoyed by the dust and the crowds of people who collected to look on, and those who could not pass by with their beasts of burden."[48]

All in all, things were going well enough for Ghirlandaio to sign his *Life of Saint John the Baptist* in Santa Maria Novella with the date and a self-satisfied addendum: "1490, during which this most beautiful city, famous for its victories, arts and buildings, enjoyed great

prosperity, health and peace." Yet beneath the placid surface, deep currents were stirring. Discontent there was, at once political and spiritual. The old civic rhetoric had called for citizens to be willing to die for their *patria*; now this same demand for self-sacrifice was being heard again, but as a religious rather than civic imperative, a matter of salvation rather than virtue.

Even the orators in the Company of the Magi, Cosimo's old civic humanist confraternity that met in Gozzoli's chapel, were using their considerable rhetorical skills to urge religious self-sacrifice. "He who created you was content to die for you, in order to set you free from the ancient noose," Alberti's old friend Landino exhorted members, who were entreated "to cast away a couple of sighs and shed four teardrops so that they may be the wind and water to put out the fire prepared for the punishment of our sins."[49] As Rab Hatfield notes, the Magi themselves were now seen as spiritual rather than fashion models, not just kings but wise men. The new concern with the soul is reflected, historian Sharon Strocchia has shown, in a marked jump in the number of masses paid for, reflecting "a heightened sense of spiritual anxiety in the Laurentian age, particularly among the upper echelons of Florentine society."[50]

As we have seen, Pico della Mirandola had contributed to this inward turn with his own writings. These influenced only the elite, however. The average Florentine was more likely to be listening, mesmerized, to fiery preachers like the Franciscan monk Bernardino da Feltre, who used his Lent sermon in the cathedral to incite listeners against the Jews. On Lorenzo's orders, the government's security commissioners quelled the anti-Semitic riot that followed and expelled Bernardino. "This seemed a bad prognostic to those who were desirous to live a Christian life, as he was considered a saint," commented Luca Landucci, who added with grim satisfaction that many of the commissioners soon came to bad ends.[51]

With Bernardino banished, Pico, himself on the verge of a religious conversion, recommended that Lorenzo replace him with a Dominican monk he had met at a conclave who had impressed him with his fervor. Girolamo Savonarola (Image 15) had already spent a short stint in Florence in the early 1480s, tutoring the monks at San Marco while failing utterly in his preaching. In his sermon of May 18, 1496, looking back on those days when, he recalled, "only some simpletons and a few little women" showed up for his sermons, he admitted that he did not know at the time "how to move a hen."[52] It did not help that he was

ugly and wizened, hook-nosed and thick-lipped, with a grating voice and frighteningly intense green eyes.

Although initially most Florentines preferred the urbane sermonizing of the Augustinian monk Fra Mariano, Savonarola gradually gained a following mesmerized by his jeremiads. By April of 1492, fifteen thousand people were packing the cathedral to be awed by sermons so terrifying that fifty years later Michelangelo said he could still hear that harsh voice ringing in his ears. Savonarola claimed to have been gifted with visions of an apocalypse soon to come, which would cleanse a world that had become utterly corrupt. "In the primitive Church the chalices were of wood; the prelates of gold," he noted; "in these days the Church hath chalices of gold and prelates of wood."[53]

The Church, Savonarola predicted, would be scourged and regenerated. The Florentine people, too, would be terribly punished unless they repented of their sins, renounced their luxuries, and returned to the ways of primitive Christianity. The palaces of the wealthy, he thundered, are built on the blood of widows and orphans. The rich must give up gambling, card games, fancy clothes, and cosmetics. Such frivolities as the Palio horse races and carnival should be abolished, and the money given to the poor. Prostitutes were nothing but "pieces of meat with eyes"[54] and must be chastised; flirtatious women should be driven from the cathedral; sodomites should be burned at the stake.

Above all, Florentines must extirpate humanism. Humanists "tickle men's ears with talk of Aristotle and Plato, Virgil and Petrarch, and take no concern in the salvation of souls," Savonarola chided. "Why, instead of expounding so many books, do they not expound the one Book in which is the law and spirit of life!"[55] Plato, Aristotle, and the other philosophers, Savonarola insisted, are rotting in hell. Socrates, who thought he could find divine beauty in the physical beauty of his young friends, was tempting God; Ovid was mad; comparative religion dangerously obscured the gap between pagan wisdom and Christian revelation. Small wonder that listening to these harangues, Pico felt his hair standing on end and his blood running cold.

Lorenzo might have been expected to raise some objections, especially since Savonarola wasn't satisfied with attacking intellectuals. Invited to preach to the city's priors in the Signoria, he pointedly referred to the Medici as tyrants and is said also to have warned Medici supporters to go and tell Lorenzo to repent of his sins or God would punish him and his family. But by the beginning of 1492, Lorenzo was too ill to concern himself with the friar. The gout inherited from his

father had given rise to uricemia, the agonies of which he had tried in vain to alleviate by taking the waters at the spa his mother had established at Montecatini. Bidding farewell to his seventeen-year-old son Giovanni, who was headed for Rome to be elevated as the youngest cardinal ever—an event Lorenzo exulted in as the family's greatest achievement—he was carried off to Careggi, accompanied by his two friends Poliziano and Pico.

From Florence came news of frightening portents. Two lions caged behind the Palazzo Vecchio (to be loosed on the Piazza della Signoria during festivals to attack calves or horses while onlookers cheered) turned on and mauled each other. Ficino saw giants struggling in his garden. Lightning struck the cathedral lantern, sending one of its marble balls crashing into the Piazza del Duomo. It fell toward the Palazzo Medici, leading Lorenzo to conclude that he was doomed. His doctors prepared an emulsion of crushed pearls and jewels, which he swallowed eagerly, to no avail. On April 8, 1492, at the age of only forty-three, the magnificent Lorenzo died. His body was returned to Florence and ceremonially carried by the Company of the Magi from San Marco to the Medici's family church, San Lorenzo. There, in the sacristy Brunelleschi and Donatello had long ago designed for his great-grandfather, Lorenzo was laid to rest next to his slain brother Giuliano.

Savonarola had predicted Lorenzo's decease. Just a few weeks later he made a second, more horrifying prophecy. In a Good Friday sermon he announced that he had seen a black crucifix inscribed "The Cross of God's Wrath" rising from Rome to cover the earth, while a second cross of gold rose from Jerusalem—a vision Botticelli would later re-create in his *Mystic Crucifixion* (now in Harvard's Fogg Museum). "Wait no longer," the friar admonished his flock, "for later there will be no room for repentance."[56] The apocalypse was at hand. It would take the form of an invasion from the north. A prince accompanied by "barbers armed with gigantic razors," Savonarola railed, would come from "beyond the mountains, as Cyrus, and the Lord will be his guide and leader, and no one will be able to resist him."[57]

New Jerusalem, New Republic

In the two decades following Lorenzo's death, Florence underwent a dizzying pendulum swing with profound effects on both politics and culture. With the expulsion of Lorenzo's son and the rise to power of Savonarola, the city was to be transformed from a hotbed of Renaissance neo-Platonism into a New Jerusalem in which pagan vanities would be consigned to flames. And then, with equally stunning swiftness and ferocity, this turbulent experiment in theocratic democracy would come to a literally apocalyptic end in Savonarola's own burning. The neo-republican regime that rose phoenix-like from the ashes of Savonarola's bonfire would find itself confronting something its predecessors had never had to face: nation-states with vast territories, enormous armies, and imperial ambitions on a global scale, overwhelming the old order of city-states and sowing chaos on the Italian peninsula. To meet the challenge, the republic's geniuses, Machiavelli and Michelangelo, would develop new political strategies and new ways of symbolizing civic virtue and its anxieties.

"If you sound your trumpets, we will ring our bells!"

"The Sword of God" foreseen by Savonarola turned out to be a most unlikely figure—the dwarfish, twitchy, nearsighted son of Louis XI of France. Charles VIII had inherited a kingdom that was finally emerging from the disaster of the Hundred Years' War. It was a sleeping giant of a country, with a population thirty times that of Tuscany, led by noblemen

who still defined glory in chivalric terms. Charles himself was described by the courtier Philippe de Commynes as "rarely in the company of wise men." Barely literate, he knew no Latin, but he had been steeped in the knightly exploits of Roland and yearned for adventure.

His excuse for action came when Lodovico Sforza, the regent of Milan, decided to hang on to power even after his nephew, Gian Galeazzo, came of age. Gian Galeazzo's incensed wife appealed to her grandfather, Naples's King Ferrante, who agreed to send troops to oust the usurper. Desperate to fend off Ferrante's armies, Lodovico turned to Charles. He invited the young king to reassert a long-standing French claim to the Kingdom of Naples and—piquing Charles's crusading fantasies—to the Kingdom of Jerusalem which went with it.

When Ferrante died on January 25, 1494, fulfilling another of Savonarola's prophecies, Charles immediately claimed Naples and Jerusalem for France. Eight months later, backed by a hundred-thousand-franc loan arranged by Lodovico, he crossed the Alps with an army of thirty thousand men, the largest ever brought to Italy. If that were not fearsome enough, Charles's troops also brought with them what Guicciardini described as a "diabolical rather than human weapon" never before seen in Italy: horse-drawn artillery batteries capable of firing not stone cannonballs but far more lethal iron projectiles.[1]

In retrospect, this "barbarian invasion" would be recognized as a catastrophe for the entire peninsula, leaving Italians, in Machiavelli's famous words, "more slave than the Hebrews, more servant than the Persians, more dispersed than the Athenians."[2] But it was a disaster that had been waiting to strike for some decades now, given the recurrent appeals that each of the five major Italian powers—Florence, Milan, Venice, Naples, and the Papacy—made to the French to intervene on their behalf to tip the balance of power (a term coined by Lorenzo's friend Bernardo Rucellai in his account of the French invasion). In the 1480s Lorenzo had recognized the threat for what it was, defused several crises, and tried to draw the Papacy into his alliance with Milan and Venice to ward off any possible invasion. All the while he had maintained good relations with France, a major market for Florentine goods and a kingdom from which the Medici had received the personal honor of being permitted to add the fleur-de-lys to their family crest, an honor the city itself had earlier been granted in the age of Guelph alliances.

Charles's move put Florence in an awkward position. Led by Lorenzo's untested twenty-two-year-old son Piero, the commune had

remained neutral before the invasion, despite pressure from Charles to declare openly for France. Now the French invader forced the issue. He advanced unopposed to the border of Tuscany, where he sent envoys to Florence demanding that his claim to Naples be acknowledged and his troops permitted to march through Florentine territory toward the great prize to the south, Rome.

Like his father Lorenzo before him, Piero found himself in a desperate position, threatened by a militarily superior foe. Taking power, he too had faced a *popolo* and citizenry that according to the anti-Medicean silk merchant Piero Parenti, "generally desired true liberty, and waited for the opportunity."[3] But Piero's allegiances were more complex and less knitted into Florence's social networks than Lorenzo's had been, in part because his father had wed a Roman noblewoman and had arranged for Piero to marry the daughter of an Orsini count raised in the Neapolitan court. And Piero had none of his father's charisma. The young ruler of Florence was arrogant (Parenti said his behavior made the whole city want to throw up), immature, and a bit spoiled. It was said, perhaps apocryphally, that he had even ordered Michelangelo to sculpt him a statue out of snow during a rare snowfall.

Piero should have tried to shore up local ties. Instead, he did the opposite, narrowing the ruling circle to only ten people. Even old friends of his father's were alienated, including Bernardo Rucellai, who shifted his allegiance to the rival Medici family branch headed by Piero's cousin Lorenzo di Pierfrancesco. Meanwhile, other erstwhile friends of Piero's father Lorenzo were seduced by Savonarola, including Pico della Mirandola and Poliziano. Piero did not submit passively to these defections, and both Pico and Poliziano soon died of arsenic poisoning, murders later confessed to by one of Piero's adherents.

Small wonder then that at this moment of crisis the city's elite balked at Piero's demand that the Signoria allocate funds to shore up Florence's defenses. Resisting the French invasion, they feared, would lead only to defeat and financial ruin for the city. A more charismatic leader might have persuaded them to steel themselves and face the challenge with courage. A more ruthless prince might have cowed them by ordering his cousin Lorenzo di Pierfrancesco murdered or imprisoned for life (as the city's executive council the Seventy recommended) after it was discovered that Lorenzo was cozying up to the French. But Piero was neither eloquent nor efficiently brutal enough. The Signoria rejected his demand for funds, and Lorenzo di Pierfrancesco was merely exiled to his country villa, where the art

connoisseur could bide his time musing on Botticelli's *Primavera* or his *Pallas Taming a Centaur*.

By the end of October, Piero saw only one way out: to duplicate Lorenzo's daring mission to Naples that had saved the Medici regime back in 1478. Acting on his own, he rode to the French camp, sending back to the Signoria an imitation of his father's famous letter pledging to give his life for his country if necessary. Charles, however, interpreted Piero's arrival as a sign of weakness. After greeting him frostily, the French king demanded a huge loan, as well as the right to occupy Pisa, Livorno, and several Tuscan fortresses for the duration of what he called "the Enterprise." To the astonishment of all present, Piero immediately capitulated on every point.

Although the Signoria never dreamt of resisting the French outright, they were livid at the terms their "schoolboy leader" had had the effrontery to make without consulting them. When Piero arrived back at the Palazzo della Signoria on November 9, he found the main gate locked. The priors sent word that he could enter by a side door, but without his guard. Piero refused, and after a hot exchange at the gate with some priors, the bell atop the Signoria, the Vacca, began ringing amid cries of "*Popolo e Libertà!*" Crowds gathered, hissing and throwing stones, until Piero was persuaded to go back to the Medici palace, where later that day Luca Landucci saw Piero's brother Giovanni at a window kneeling in prayer. When darkness fell, Piero, Giovanni, and their cousin Giulio, loaded with as many small valuables as they could carry, fled the city with their families. After sixty years, the reign of the Medici was over.

As soon as word got out that the family was really gone, the Medici palace was sacked, Lorenzo di Pierfrancesco's exile was rescinded, and a price was put on the heads of Piero and Giovanni. Meanwhile Charles marched into Pisa and declared it freed from Florentine tyranny. "We heard that the Pisans had risen and taken possession of the city," Luca Landucci tells us, "and pulling down a certain marble *marzocco* [the stone lion emblematic of Florentine rule] had dragged it all over Pisa, and then thrown it into the Arno, crying '*Libertà!*'"[4] At Pisa, Charles met the Florentine ambassadors to work out the details of his entry into Florence. Among them was Savonarola, who hailed Charles as "the Minister of God, the Minister of Justice" and declared him welcome as such, saying: "Come then, glad, secure, triumphant, since He who sent you forth triumphed upon the Cross for our salvation."[5]

Charles's entry was indeed staged like a triumphal parade. The king led the way, riding beneath a canopy held overhead by knights, wear-

ing his crown and gilt armor, carrying his lance lowered in the pose of a conquering knight. Behind him marched drummers, fifers, Swiss guards with enormous halberds, Breton archers, Scottish crossbowmen, armored cavalry, and musketeers. Following Savonarola's lead, the city pulled out all stops for this gigantic show. Triumphal cars and portable stages rolled through the streets, while men on stilts decked out as spirits or giants towered over the crowds gathered to gawk at the procession. After receiving the keys to the city at the Palazzo della Signoria, where the arms of France had been hurriedly tacked above the doorway, Charles made his way to the Duomo for Mass. "All Florence was there, either in the church or outside," recorded Landucci. "Everyone shouted, great and small, old and young, and all from their hearts, without flattery." Landucci noted, though, that when Charles dismounted "he seemed to the people somewhat less imposing, for he was in fact a very small man."[6]

Despite the hoopla, the situation remained tense. As negotiations between Charles and the priors dragged on, the French troops seemed to Landucci to act more and more like masters of the city: "They did not allow the citizens to go about armed, day or night, but took away all their weapons, and kept striking and stabbing them."[7] The city was in great dread of being pillaged, but also on the verge of an uprising. Florentine women and children harassed Charles's troops, pelting them with stones thrown from windows, and thousands of peasants from the countryside filtered into the city, hiding in palazzos and preparing for the signal to rush to the piazza.

Finally the two sides came to an agreement. Its major feature was a 150,000-ducat "contribution" by the republic toward Charles's purported quest to retake Jerusalem. When the document was read out, however, the sum written in was only 125,000 ducats. Furious, Charles leapt up. Reinsert the original figure or, he threatened, he would order his trumpeters to call his men to arms and sack the city. On hearing this, the republican aristocrat Piero Capponi angrily tore the treaty to bits, shouting in a voice Guicciardini described as quivering with agitation, "Since such shameless demands are being made, you sound your trumpets, and we will ring our bells!"[8]—the signal at which thousands of Florentines would pour into the streets to battle the French soldiers.

Charles blinked. Settling for the smaller sum, and having arranged for the transport back to France of thirty tons of Florentine artwork and dozens of Florentine artists and craftsmen, the crusading king departed,

sweeping onward toward Rome with his army, "ruining all the country like a flame of fire" as they went.[9]

"Go into the fire"

The threat from Charles averted, the elites who had engineered the coup against Piero and the Medici tried to have themselves installed as an oligarchy. "In Florence," one leader, Gino Capponi, insisted, "it is not possible to govern by popular consensus, nor by law, but only if 25 or 30 aristocrats, setting aside their private passions, ambitions and avarice, take charge of this poor city."[10]

This appeal to a politics of civic virtue designed to favor the elite, however, fell on deaf ears. A fervor for liberty and desire for civic reform was now afoot. Florence was now ideologically firmly in the hands of Savonarola. The fiery orator had been prophesying fire and damnation. Now his message turned positive. The Lord, he announced, had charged him to make Florence a holy city, with Christ as its King: "Christ, your Captain, will conduct all your affairs, and you will be the reform of all Italy and even outside of Italy."[11] To provide the city with "firm foundations and give her a government which favors virtue"[12]— now understood not as merit but as piety—Savonarola revamped the government. The restrictive Medici councils were abolished, replaced with the most broadly based legislative body yet seen in Florence: a Grand Council of some three thousand members with rights to attend and vote on all legislation and in all elections. To accommodate such a huge crowd, an enormous room, now known as the Hall of the Five Hundred, was carved out of the interior of the Palazzo della Signoria.

To emphasize the anti-Medicean cast of the new regime, Savonarola not only recommended death for anyone advocating their return from exile, but systematically turned Medicean symbols against the family. The Medici, we have seen, had appropriated Florence's civic iconography to blur the distinction between themselves and the government. Now the republic wanted its images back. Donatello's *Judith* was provided with a new inscription and, together with his bronze *David*, was carried from the Medici palace to the Palazzo della Signoria to stand guard as a warning to tyrants like her former owners. Lorenzo's famous carpe diem song, "*Quant'è bella giovinezza*," was given new words beginning: "May Christ the King, Leader and Lord live in our hearts."[13] The Signoria ordered the phrase "Father of his country" inscribed on Cosimo's tomb chiseled off, on the grounds that "he didn't merit that

title, but rather that of 'tyrant.'"[14] Even the Company of the Magi was refunctioned. The old public procession of the Magi, co-opted so powerfully by the Medici, was replaced by a new private ceremony. In it, Savonarola and two other priors played the roles of adoring Magi behind closed doors inside the church of San Marco, as a lucky few watched through the cracks.

But the change that had come over the city was not merely symbolic or spectatorial. Florentines of all stripes, from apothecary Luca Landucci to the Strozzis, were won over heart and soul to Savonarola's vision of a new Jerusalem. "At this time," Landucci wrote, "the Frate was held in such esteem and the people were so devoted to him, that there were many men and women who, if he had said, 'Go into the fire,' would have actually obeyed him."[15] Hundreds decided to join the Dominicans, including even Pico della Mirandola. (Pico died before he could take orders, however, and Savonarola imagined the former neo-Platonic humanist burning in purgatory tormented by the flames of his own anguish.) So many citizens were following Savonarola's call for fasting that a special dispensation had to be arranged to keep butchers from going out of business.

The most extraordinary change, though, was among the youths of Florence. Squads of white-robed altar boys, hair cropped above the ears, danced through the streets or gathered on the Duomo steps before sermons to sing so beautifully that to observers it seemed the angels had come down to earth. Instead of the usual carnival game of throwing rocks to crack each other's skulls, six thousand children instead went about asking alms for the poor: "Gifts were given without avarice," reported Luca Landucci; "it appeared as though everyone wanted to give what he had, and the women gave most of all." Luca added, with amazement and a touch of pride: "I have written about these matters which are true, and I have seen them and felt such love; and some of my children were among those blessed and chaste groups."[16]

All this piety had a darker side, to be sure. Landucci reports that, ordered to overturn the baskets of Lenten cake and the card tables of the gamblers, as well as to chastise the licentious ways of women, Savonarola's squadrons of militant Christian children could often be found roaming through the city hunting out the unchaste or unblest. "If anyone had rebelled against them," Landucci noted, "he would have been in danger of his life."[17] Suspected homosexuals had been clamped down on in the early 1470s by Lorenzo the Magnificent to consolidate his rule by signaling he was abandoning his own youthful frivolity, but

they had enjoyed a period of relative toleration in the 1480s, as historian Michael Rocke has shown.[18] Now, under the rewritten sodomy laws, violators were no longer to be merely fined but pilloried, branded on the forehead, or burned at the stake.

Not content with suppressing behavior deemed immoral, Savonarola called for a purge of all luxury from churches and homes. Even the beautiful Madonnas of Lippi and Botticelli came in for censure. "You painters do ill," Savonarola thundered in 1496, "you fill the churches with every vanity. Do you believe that the Virgin Mary went about dressed as you paint her? I tell you that she went dressed like a poor girl, simply, and veiled so that her face could scarcely be seen. . . . You show the Virgin Mary dressed like a whore."[19] Not even the nuns of Le Murate, who lived in voluntary seclusion behind the walls of their convent, were spared criticism, in their case for making beautiful gold and silver embroideries.

This puritanical spirit reached its peak with the Bonfire of Vanities of 1497 in the Piazza della Signoria. On an enormous scaffold, paintings and sculptures of nudes by artists including Donatello, Botticelli, Fra Bartolommeo, and Lorenzo Credi (the latter two contributing their own works) were tossed. Together with them were piled wigs, veils, perfumes, and mirrors; chessboards and dice; books of spells; carnival masks and costumes; lutes, bagpipes, and cymbals; and unchaste works by Boccaccio, Dante, and Petrarch. When a visiting Venetian, either appalled or seeing a bargain, offered to buy all the artwork, his portrait was quickly sketched and it too was thrown on the pyre. Then, while the Signoria looked on from a balcony and three rings of devotees danced and chanted around the pile, the bonfire was set ablaze, to the sound of bells and trumpets.

This degree of zeal did not sit well with everyone. Many anti-Medicean republican patricians had cooperated with Savonarola's government at first. Now many followed Bernardo Rucellai's example and withdrew from politics altogether, refusing to hold office. From the pulpits of Santo Spirito and Santa Croce came denunciations from anti-Savonarolan clergy such as Fra Giorgio da Perugia, who wondered "how the Florentines, who are regarded as people of considerable skill and *ingegno*, could stoop so low as to conquer children in so vile a fashion, and seek to rule over them."[20] Another priest spread rumors that Savonarola, Fra Domenico, and all the friars at San Marco were sodomites; he was forced to recant in the square of San Giovanni and thrown into a cage in the Stinche, Florence's notorious prison.

Other Florentines began agitating against the friar on different grounds. They were angered by his failure to get Charles VIII to fulfill his promise to return the coveted port city of Pisa to Florence. They ought to have blamed the French king, Savonarola supporter Luca Landucci confided to his diary, but instead "they turned their hatred against the Frate, going round San Marco at night shouting and calling out unseemly things: 'This wretched pig of a monk, we will burn the house over his head!'"[21]

Savonarola's most powerful antagonist, however, was not a Florentine but the ruler of that Rome whose destruction for its depravity the friar had prophesied: Rodrigo Borgia, elected Pope Alexander VI in 1492.

If ever a city deserved punishment for its sins it was Alexander VI's Rome, where "virgins were being abducted, matrons were selling themselves, sacred objects were being defiled, houses were being looted, people were being thrown here and there into the Tiber, murders were being committed day and night and going unpunished."[22] The pope had given up even the pretense of being anything more than a secular ruler, naming his son Cesare (Caesar) and taking the papal moniker Alexander (as in "the Great"). Savonarola's religiosity did not concern him, but the Frate's constant attacks on the authority of the papacy, his claim to speak directly from God, and most of all, his refusal to join Alexander's Holy League to drive the French from Italy did. Alexander first tried to buy Savonarola off with the offer of a cardinal's hat. "Better one red with blood," the friar retorted. The pope then warned him to tone down his sermons. Savonarola continued to preach fire and brimstone. Finally, the pope had had enough, and officially excommunicated Florence's leader.

For six months Savonarola remained silent. Then, on Candlemas Day, 1498, he laid down the gauntlet by celebrating High Mass in the Duomo. To Alexander he wrote that he could no longer place any faith in the pope, advising him "to make immediate provisions for your own salvation."[23] On February 27, another bonfire was held. But by now Savonarola's supporters had begun to waver, worn down by bad harvests and the plague that God seemed to have visited on the city. The notion of an excommunicated priest giving Communion also drove some away. "Certainly it seemed a mistake to me, although I had faith in him," Luca Landucci tells us, "but I never wished to endanger myself by going to hear him, since he was excommunicated."[24] Gangs of rowdy anti-Savonarolan boys now began to disrupt the children's processions, snatching crosses from the marchers and throwing them in the river.

They tossed dead cats on the Bonfire of Vanities. Some even broke into the Duomo, smeared the pulpit with manure, and drove nails into it from below in hopes Savonarola might impale his hands when he hammered it, as he often did when in full fury during a sermon.

Finally the Signoria had had enough, and when the pope threatened the entire city with interdiction, the priors ordered Savonarola to stop preaching. After a last sermon in which he lashed the Church as a Satanic power that protected whores and promoted vice, he fell silent. His enemies, however, were not satisfied. They had long derided his claim to a special relationship with God, and now a Franciscan monk, Fra Francesco, issued a direct challenge: an ordeal by fire. Savonarola declined the offer to walk through flames alongside the monk, but he agreed to permit his supporter, Fra Domenico, to do so in his stead. Fra Francesco refused to settle for anyone but Savonarola, so another Franciscan replaced him. All this seemed to the Signoria ridiculously medieval, but the populace was not to be denied.

At ten in the morning on April 7, the two friars arrived at the Piazza della Signoria, Fra Domenico accompanied by Savonarola holding the Host in his excommunicated hands. As crowds of supporters waited, the two sides bickered for hours about whether Fra Domenico could carry a crucifix and the Host with him into the fire. Finally rain began to fall, and the ordeal was called off.

The next day, Palm Sunday, a mob roughed up Savonarolans in the Duomo, then rushed to San Marco, catapulting rocks over the walls and slamming against the church's thick doors to try to force their way inside. The monks held out until early morning, when the mob set fire to the church doors and fought its way in. The Signoria had by then issued an arrest warrant for Savonarola, whom they found praying at a desk in the beautiful library Michelozzo had built for Cosimo de' Medici. Dragging him to the Palazzo della Signoria, they locked him in the Alberghettino, the tiny cell where Cosimo had been incarcerated sixty years earlier.

Put twice to the *strappado*—where the victim's wrists are tied behind the back and he is repeatedly hoisted and dropped by a rope tied to them—Savonarola first confessed to all the charges put to him, then recanted when the torture was over. He was found guilty of heresy, and tortured once more for good measure, on the orders of the pope's commissioners, to confirm the verdict.

On May 22, 1498, Savonarola, along with two of his most devoted disciples, was brought to a high gallows, surrounded by tinder, that

had been erected in the middle of the Piazza della Signoria, where the Bonfire of Vanities had burned a year earlier. The scene is depicted in a tiny, extraordinarily detailed painting done (see front cover) in secret by an anonymous eyewitness, a diehard follower of the Frate. Another eyewitness, Savonarola's erstwhile follower Luca Landucci, offers a terse account of what happened next. The three friars, he wrote,

> were all robed in their vestments, which were taken off one by one, with the appropriate words for the degradation . . . then their faces were shaved, as is customary in this ceremony. . . . [The] first to be executed was Fra Silvestro, who was hanged from the post and one arm of the cross, and there not being much drop, he suffered for some time, repeating "Jesu" many times while he was hanging, for the rope did not draw tight nor run well. The second was Fra Domenico of Pescia, who also kept saying "Jesu"; and the third was the Frate called a heretic, who did not speak aloud, but to himself, and so he was hanged.

The painting shows the three men dangling in a nearly empty plaza, with armed men harassing the few followers brave enough to try approaching.

Savonarola was now a martyr for his followers, and the city's rulers knew it. To prevent any relics from remaining for followers to venerate, they lit their own bonfire for the friar:

> When all three were hanged, Fra Girolamo being in the middle, facing the Palazzo, the scaffold was separated from the ringhiera, and a fire was made on the circular platform around the cross, upon which gunpowder was put and set alight, so that the fire burst out with a noise of rockets and cracking. In a few hours they were burnt, their legs and arms gradually dropping off; part of their bodies remaining hanging to the chains, stones were thrown to make them fall, as it was feared the people might get hold of them; and then the hangman and those whose business it was hacked down the post and burnt it on the ground, bringing a lot of brushwood, and stirring the fire up over the dead bodies, so that the very least piece was consumed. Then they fetched carts, and accompanied by the mace-bearers they carried the last bit of dust to the Arno, by the Ponte Vecchio, in order that no remains should be found. Nevertheless, a few good men had so much faith that they gathered some of the floating ashes together, in fear and secrecy, because it was as much as one's life was worth to say a word, so anxious were the authorities to destroy every relic.[25]

The New Republic

The days immediately following Savonarola's fall were evil ones for Florence. In his diary, Landucci reported grimly that "at night-time one saw halberds or naked swords all over the city, and men gambling by candlelight in the Mercato Nuovo and everywhere without shame. Hell seemed open; and woe to him who should try to reprove vice."[26] During midnight mass on Christmas Eve of 1498, ruffians let loose an old horse in the cathedral, slashing it and leaving it to die on the steps; ink was poured into the holy-water basins and the pulpit was smeared with feces.

This sort of thuggery was gradually brought under control, and, contrary to the hopes of anti-Savonarolan elites, the government, with its democratic Great Council, continued to be controlled by the *popolo*. But the city's economy remained bad. Florence's isolation during the Savonarola period had left the guilds nearly bankrupt, and a long war against Pisa—which the French had failed to return despite promises to the contrary—was bleeding the city treasury dry. Without any executive body, decision-making was haphazard and leadership ineffectual, especially because legislation required a two-thirds vote. In 1502 the government would finally take steps to remedy this problem. They did so by making the office of Standard Bearer of Justice—the head of state and presiding officer of the Signoria—into a lifetime appointment, choosing for the job Piero Soderini, a moderate and a staunch constitutionalist.

A diplomat who had forged close ties to the French king Louis XIII, the independent Soderini was the candidate of choice for the many who wanted neither a Medicean nor a Savonarolan to wield such potentially tyrannical power. Unfortunately, Soderini's cautiousness and circumspection could also be seen as mediocrity, especially by fellow *ottimati* bitter at his failure to restore oligarchic offices and his decision to govern instead with "men of lesser brain and quality." Soderini, they sniped, was a nonentity with "no ideas, no imagination, and no sparkle" of his own.[27] Ideas, imagination, and sparkle, however, were abundantly evident in Soderini's *mannerino*, a sharp-featured and sharp-tongued humanist foreign policy expert serving in the chancellor's office named Niccolò Machiavelli.

Of all the figures that have come down to us as legends from the Florentine Renaissance—Brunelleschi, Alberti, Donatello, Cosimo, Fra Lippo Lippi, Lorenzo the Magnificent, Michelangelo—none has

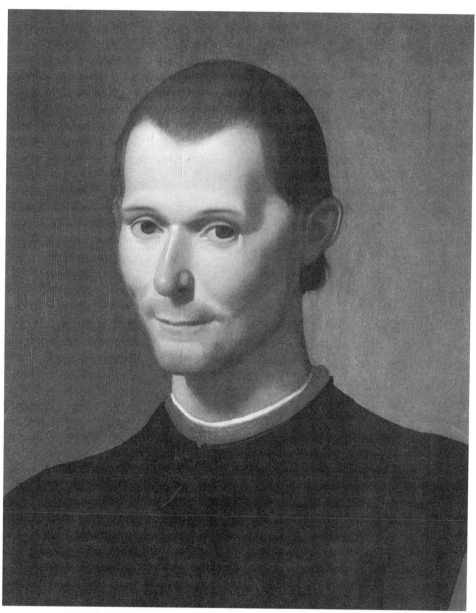

Santi di Tito, *Portrait of Niccolò Machiavelli* (Scala / Art Resource, NY)

been more travestied than Machiavelli. Far from being Machiavellian, Niccolò was in reality a hapless fellow with whom it is easy to sympathize or even identify: an avid professional who ate, drank, and dreamt politics, whose own career in government was hobbled by class prejudice and ruined by forces beyond his control.

Machiavelli's father Bernardo, a poor legal scholar, trained his talented son to fill diplomatic, military, and administrative posts usually reserved for lawyers. Though Bernardo's tax debt probably kept Niccolò out of the lawyers' guild, the Florentine chancellor Bartolomeo Scala recognized Machiavelli's father as a fellow intellectual and befriended him. This probably gave Niccolò a leg up. But unlike his great civic humanist predecessors who worked in the Florentine Chancellery, men like Salutati and Bruni, Machiavelli never was able to break into the inner circle of patrician Florentine republicans (the *ottimati*), and thus never permitted to actually make policy or even serve as lead ambassador on the diplomatic missions he frequently undertook. His lack of status meant that, as the historian J. R. Hale points out, Machiavelli was "as welcome at foreign courts as an employee in his grade could well be," tolerated but disdained as a mere spy rather than embraced as a fellow aristocrat.[28]

Machiavelli's job as a foreign policy advisor was further complicated by dizzying transformations in the international situation faced by the city following the French invasion of Italy in 1494. These changes were quite literally global. A native son of Florence, Amerigo Vespucci, brought back from his journeys the outline of a New World (to which mapmakers would attach his name) that Florentines honored by burning torches for three days and nights. Within the next thirty years, Africa would be circumnavigated by the Portuguese to establish trade between Europe and the East Indies.

Well on the way toward consolidating themselves as absolutist nation-states, Spain, France, and England were poised to take advantage of the emerging world economy. Florence, a small city-state and politically inefficient republic to boot, was not. In fact, the entire Italian peninsula, with its great wealth, lack of unity, and weak military forces, was destined to be a victim of the new imperialism rather than a participant in it, caught in the middle of the confrontation between Habsburg and Valois dynasties.

In this emergent and unprecedented geopolitical order of things, which Machiavelli compared to "unknown lands,"[29] the old rules of statecraft elaborated for republican citizens by civic humanists a cen-

tury earlier no longer held. Roman republicanism was now out of style. As historian Alison Brown notes, by 1501 the leading youths of Florence "had cast off their togas and had adopted a new kind of dress, not the sort worn by their fathers nor in keeping with the style appropriate to citizens but flaunting their grandeur and magnificence."[30]

But civic humanist earnestness had already become passé during Lorenzo's reign, at least within the intellectual cadre of brash "new men" Lorenzo hired as secretaries and envoys. This intelligentsia had been despised as the sons of millers and belt makers by Florence's merchant republican elite, and as toadies by Savonarola's plebeian followers. Like those careerists, though without their often corrupt self-interestedness, the young Machiavelli disdained "the old high rhetorical style of the great humanist chancellors," a manner and attitude which historian John Najemy notes "had no place in the kind of work Machiavelli had to do."[31] Not bothering to learn Greek, he was proud his thinking was free of the ideological blinders of earlier republicanism, with its inflated rhetoric of cultivated dignity and public-spirited virtue. For the realist, such rhetoric was at best a facade, at worst self-deluding. Even Savonarola was dismissed as a manipulator who had made "his lies plausible" for a time. He failed only because as an "unarmed prophet" he had no way "of holding firm those who had believed nor of making the unbelievers believe."[32]

Machiavelli's neo-republicanism would be more canny, more clear-headed, and more suspicious of appearances than the old-school brand of Salutati and Bruni. While cleaving to the republic as an ideal, he would assume that "all men are evil." If they seem good, this must be due to some "hidden cause." Interpreting political behavior, Machiavelli insisted, thus means penetrating behind the veil of appearances to get to "the effectual truth of the thing rather than to the imagination of it."[33] Such confidence in his own interpretative skills annoyed some of his superiors, "who saw him," says Najemy, "as arrogantly usurping the politicians' right to devise and promote policy."[34] But Machiavelli considered himself what Hannah Pitkin describes as "a republican for hard times"[35] merely doing his best to prevent vulnerable Florence from being victimized by the armies both foreign and Italian marauding through the peninsula during the chaotic first decade of the 1500s.

The French had returned in 1499, this time invited by the Venetians. They seized Milan from their erstwhile ally Ludovico il Moro and again fought their way toward Naples. This in turn led the King of Naples to invite the Turks onto Italian soil. That move drew in the Spanish, who

cut off the French and grabbed Naples for themselves. With these great powers duking it out in their territories, the Italian states scrambled for allies and protectors, and foreign mercenaries—Swiss, Germans, Albanians, Gascons, Croatians—swarmed over the country.

Amid all this chaos, Machiavelli's boss Soderini kept Florence steadfastly to a pro-French policy. France's other main Italian ally was Pope Alexander VI, who with his usual corrupt flair had cut a deal in which he permitted Louis XII to set aside his first wife and marry Anne of Brittany, thereby unifying France. In exchange the French agreed to provide troops for the military adventures of one of the pope's sons, the truly Machiavellian Cesare Borgia. Cesare's aim, backed by his father, was to unify the loose confederation of petty tyrannies known as the Papal States into a militarized staging ground from which he could bring all Italy under his control. Cesare went about this with a degree of cold-bloodedness unusual even for this period, murdering his brother and brother-in-law, burning towers filled with women and children, massacring entire towns, and frightening even his father, who was himself busy killing church officials in order to get his hands on their incomes and resell their offices to the highest bidder.

As an ally of France, Cesare should have been a friend to Florence, but in times like these friends were almost worse than enemies. After making his way through Tuscany, "robbing and committing every sort of cruelty,"[36] Cesare showed up at the city gates with a threateningly unruly makeshift army captained by the angry brother of a Florentine commander who had been beheaded by the city for treason the previous year. Appointed "protector" of Florence for thirty-six thousand ducats salary, Cesare then moved on to shake down other victims.

In 1502 Machiavelli was sent on several missions to Cesare, including one where he met fifty-year-old Leonardo da Vinci—prudently identified in the young diplomat's reports only as a "friend" who was "acquainted with Cesare's secrets."[37] After nearly two decades in Milan, Leonardo had been hired by Borgia as a military engineer, an employment the astonishingly inventive polymath had long wished for. Apolitical and oblivious or indifferent to his employer's cruel methods, Leonardo focused his genius on designing self-supporting bridges and creating the first bird's-eye view military maps. Machiavelli, on the other hand, not only noted but was deeply impressed by the duke's cunning, the efficiency of his brutality, and his audacity. Cesare's enterprise, however, ultimately fell to pieces. Meeting him after his downfall, Machiavelli heard from the bitter duke "words full of poison

and anger." Getting away from him seemed, he later recalled, "to take a thousand years." Nonetheless, Machiavelli would later immortalize him as the very model of a modern prince.[38]

As a model of republican heroism, on the other hand, a tyrannical killer whose motto was "Caesar or nothing!" would never do. To stand up to the tough world around it, post-Medicean, post-Savonarolan Florence needed its own tough-guy image. Not unexpectedly, the city looked back to the pre-Medicean period for civic icons to update in the way required to inspire present-day citizens. One plan called for statues of famous Florentine citizens to be sculpted and scattered about the city. It was within this general atmosphere of neo-republicanism that Piero Soderini and others commissioned from a young but already famous Florentine sculptor named Michelangelo what would become the single most potent image of the Florentine Renaissance: the *David*.

David

The cathedral's work yard for sculptural and architectural projects was dominated by a huge marble block, some five and a quarter meters high, known as *il gigante*. Hewn out of the mountainside at Carrara, rolled down the mountain on log castors, and floated up the Arno to the city, the marble had been intended originally for Donatello's chisel. But Michelangelo's great predecessor only got as far as sketching a design which at age eighty he was too frail to carve himself. His follower Agostino di Duccio began roughing in the stone according to his master's directions, but when Donatello died in 1466, work halted. The block then sat unfinished in the yard for more than forty years, waiting for the commune to find another sculptor with the skill—and the chutzpah—to tackle its formidable dimensions.

Twenty-six-year-old Michelangelo Buonarroti was a leading contender for the commission. He had grown up studying the fragments of ancient statuary collected and displayed in Lorenzo the Magnificent's palace garden. And like Botticelli (who along with the young Michelangelo enjoyed the patronage of Lorenzo di Pierfrancesco de' Medici), the sculptor had translated into visual form the Ovidian myths he had heard from the poet Poliziano, creating a writhing tangle of bodies in his early work, *Battle of the Centaurs*. In 1401 he had just returned from Rome, where his *Pietà* had won him acclaim and an international clientele that would within a few years include a French cardinal, Flemish merchants, the sultan, and two popes.

When Michelangelo submitted his proposal promising to carve a statue in one piece from the block without adding any marble accessories, and presented a wax model for the figure of David he had in mind, the directors of the workshop quickly agreed. As a marginal note in the contract tells us, Michelangelo began by summarily stripping the statue of its roughed-in cloak, removing "with one or two strokes of a chisel a knot which the figure had on its chest."[39]

To spur the overcommitted sculptor along, the commissioners paid him only six gold florins in advance. When the statue was half done, in 1502, they were impressed enough to disburse another four hundred florins. Finally, in 1504, Michelangelo announced that the *David* was ready. Originally it was to be placed high on a buttress on the Duomo, to complement a now lost terracotta statue of Joshua by Donatello, but once the sculpture was seen, it was clear that Michelangelo's monumental figure would have to be displayed in a more prominent setting. The committee solicited opinions from a wide range of artists, including Botticelli, Filippino Lippi, and even Michelangelo's archrival Leonardo da Vinci. Leonardo suggested cattily that the statue be hidden deep within the shade of the Loggia dei Signori, a recommendation that was not taken up. It was decided instead to move Donatello's "dangerous" (because female) image of republican virtue, the decapitating *Judith*, into the courtyard of the Palazzo della Signoria to make room for the *David* to be posted just in front of the doorway, where it could stand watch over the city's recovered liberty.

Moving the huge figure to the Piazza was a saga in itself. The journey took four days. First the statue was loaded into a wooden cage and then dragged out of the workshop, after a hole was knocked in the wall above the portal to make room for its head. "It went very slowly," Landucci reported, "being bound in an erect position, and suspended so that it did not touch the ground with its feet . . . moved along by more than forty men."[40] Left standing in the streets one night during its journey, it was stoned by a band of roughnecks, probably Medici supporters. Even after the statue reached the Piazza safely, two more months were required to move it painstakingly along greased beams up onto the Palazzo della Signoria's terrace and, in a nod to conservative sensibilities, to cover the statue's flanks with a girdle of copper leaves.

The small boy who singlehandedly defeated a tyrannical giant, sustained only by God and his own courage, David was, as Donatello's and Verrocchio's earlier versions make clear, a figure long associated

with the republican city-state triumphant over larger foes. In Michelangelo's hands that Florentine self-image was transformed to meet the new circumstances in which the restored republic found itself. The two previous incarnations showed the hero as a delicate boy posed after the victory, his foot resting on or stepping off from Goliath's severed head, sword in hand, pensive or smirking at what he had done. Michelangelo's David, in stark contrast, is a buff boy-giant whose outsized proportion does not quite suffice to make him a grown man. Not having yet fought, he turns to peer southward toward Rome—where the Medici were at that very moment intriguing against the republic—with a look of defiance masking the anxiety in his eyes (Image 16). This David is completely unclothed, swordless, armed only with a slingshot, stripped of any overt civic messages or covert pagan symbolism. Gone too is the fashionable elegance that conveyed the distinctive ways in which the Medici exerted power within the republic in earlier periods. Instead, the human body itself, in its muscular tensing and twisting, its outthrust chest, turned head, and unanchored stance, lends this David a psychological intensity, expressing an internal struggle to live up to the civic ideal in the face of unprecedentedly enormous dangers.

This sort of inner conflict, or even a more straightforwardly Savonarolan view of David as representing God's chosen republic standing naked and alone against tyrants, would have made Machiavelli impatient. David's nakedness, in his view, wasn't a trope for the bared soul, for Christian or republican virtue, or for neo-Platonic desire. The lesson it taught wasn't metaphysical, ethical, or political—it was strategic. David had refused Saul's arms, according to Machiavelli, because "the arms of others either fall off your back [mercenaries] or weigh you down [auxiliaries], or hold you tight [a mixture of both]."[41] To be strong, he insisted, a republic needed to create its own native militia instead of relying on the arms of others.

This kind of thinking about military self-reliance prompted the Soderini government in 1503 to order the Hall of the Five Hundred (the quorum for the more restricted Great Council, reduced from Savonarola's three thousand citizens) in the Signoria to be decorated with two huge murals showing scenes evoking great military victories from Florence's past republican history. Michelangelo, a favorite of Soderini's and far along on the David, was commissioned to paint one of the murals. The commission for the other mural went to the only artist alive whose prestige could match and even exceed Michelangelo's.

The Competition

The sculptor in creating his work does so by the strength of his arm by which he consumes the marble, or other obdurate material in which his subject is enclosed: and this is done by most mechanical exercise, often accompanied by great sweat which mixes with the marble dust and forms a kind of mud daubed all over his face. The marble dust flours him all over so that he looks like a baker; his back is covered with a snowstorm of chips, and his house is made filthy by the flakes and the dust of stone. The exact reverse is true of the painter . . . [who] sits before his work, perfectly at his ease and well dressed, and moves a very light brush dipped in delicate color; and he adorns himself with whatever clothes he pleases. His house is clean and filled with charming pictures, and often he is accompanied by music or by the reading of various and beautiful works which, since they are not mixed with the sound of the hammer or other noises, are heard with the greatest pleasure.

—Leonardo da Vinci, *Treatise on Painting*[42]

When Michelangelo returned from Rome to Florence in 1501, he found the artistic community enthralled by Leonardo da Vinci, who had arrived just months earlier, after nearly two decades in Milan. The genius had been forced to flee with his close friend, the mathematician Luca Pacioli, when Leonardo's patron, the tyrant Ludovico il Moro, was overthrown. It was for Pacioli's book showing the application of the golden ratio to art that Leonardo had drawn his famous illustration of a perfectly proportioned "Vitruvian man" in a perfect circle. Now, comfortably ensconced with his entourage at the church of Santissima Annunziata, Leonardo was so distracted from painting by mathematical experiments, one observer wrote, that "he cannot abide the paintbrush."[43]

Even so, before leaving for his brief stint as Cesare Borgia's military engineer, Leonardo created a major sensation in the city with a beautiful cartoon of the Madonna with Saint John and Saint Anne. (Vasari tells us that when it was finished, it brought men, women, young and old to see it for two days as if they were going to a solemn festival.[44]) On his return, around the time he sat down with Machiavelli to sign the contract for the Signoria's mural, Leonardo began working on a small panel painting on the side. He would continue to add ultrathin layers of paint to it until he died sixteen years later. It was a portrait (with a misty Dolomite landscape in the background probably added

later when the artist left Florence for Milan) of the unostentatiously attired wife of a middle-class silk-merchant client and family friend of his father's, a young mother named Lisa.

Any two such great artists facing off would likely fuel artistic rivalry. But as we saw with the competition between Ghiberti and Brunelleschi a century earlier, artistic differences for Michelangelo and Leonardo reflected not just aesthetic values but also differences of personality, social identity, and even politics. Leonardo was older, handsome, dandyish, an illegitimate child (as indicated by his surname, "da Vinci") born to a Florentine notary by a peasant woman. He couldn't have been more different from the young, intense Michelangelo, who favored the black *lucco*, the cloak worn by the patrician republican class to which his ancient Florentine family, though not wealthy, belonged by descent.

Both artists were exploring the equivalent of a New World in painting, leaving behind the harmonious spatial alignment of shapes within a rationalized perspectival space, the aesthetic of Florentine artists from Masaccio to Botticelli. Instead, Leonardo and Michelangelo began to explore ways to present mutually interacting, twisting bodies (and parts of bodies) in what art historian Frederick Hartt describes as "dynamic interweaving."[45] But this spatial flexing was expressed in utterly diverse new styles, reflecting the temperamental differences between the two men. Leonardo won praise for his elegant *gratia* (grace), Michelangelo for his display of musculature. Their techniques differed accordingly. Obsessed with penetrating scientifically into the depths of the body and nature, and convinced that an "infinite gradation"[46] between light and darkness is the basis of visual perception, Leonardo developed a technique that dissolved outlines. The images that emerge appear to us "without lines or borders, in the manner of smoke [sfumato] or beyond the focus plane,"[47] figures fused with their mist-filled, mysterious surroundings. Michelangelo, by contrast, was a sculptor at heart, obsessed with finding the neo-Platonic essences locked within volumes of marble. In his art this sculptural imperative translates into a technique reliant on cross-hatching and incisions that imbue figures such as those in the *Doni Tondo* (now in the Uffizi) with photo-sharp clarity and rock-hard definiteness beyond nature.

As the double commission required, both artists set to work drawing the enormous cartoons, sixty feet long and twenty-four feet wide, that were needed to fill the vast walls of the Signoria's Hall of the Five Hundred. The resulting images, eagerly received by hordes of artists and connoisseurs who had swarmed to Florence to witness this

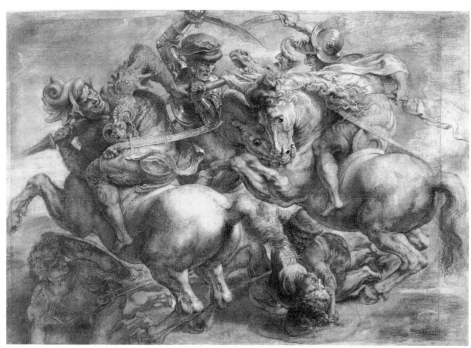

Peter Paul Rubens, after Leonardo da Vinci, *The Battle of Anghiari* (Wikimedia / Public Domain)

clash of artistic titans, changed the course of European art. Leonardo's battle scene, a churning swirl of horses, became instantly famous and was repeatedly copied, setting the agenda for a whole generation of Leonardesque painters. Michelangelo's cartoon was if anything even more influential, even though only one complete copy of his composition survives. The cartoon, a veritable catalog of twisted-body poses depicting nude Florentine soldiers struggling out of the river they had been bathing in when an alarm was sounded during an earlier siege of Pisa, was ultimately torn to pieces by eager artists. Among them was the young Raphael, who while continuing to paint tranquil subjects, began making sketches of nude fighting men and incorporating in his own art some of the serpentine torque seen in Michelangelo's and Leonardo's images.

A Republican Militia

Michelangelo's and Leonardo's murals were never realized. But the enormous artistic popularity of their cartoons depicting military themes, especially the need for military readiness shown in Michelangelo's scene, surely did not hurt Machiavelli's campaign to promote his pet idea: establishing a standing Florentine militia. Once upon a time, in the early days of the republic, native troops led by mercenaries had fought the city's battles. But Florence's ruling class had long since turned to relying solely on mercenaries, despite their often lackluster performance. When Savonarolans had attempted to revive the ancient militia in the 1490s, that initiative was stymied by republican elites, who pointed to the fall of the ancient Roman republic as showing what can happen if the people are armed. That same fear of an uprising drove the opposition to Machiavelli's plan. Soderini backed the proposal, however, and eventually managed to push through a law authorizing a militia.

In a nod to the anxieties of the elite, however, it was to be part-time and manned not by lower-class Florentines but by peasants from the surrounding countryside. To train this new unit, Machiavelli tapped a soldier he had befriended while serving on diplomatic missions to Cesare Borgia: the fearsome Spanish condottiere don Michelotto, Borgia's former enforcer. His hiring raised its own anxieties in turn, which Machiavelli was at pains to calm by instructing don Michelotto he should "never eat in the house of the head of a party, and . . . should never become friendly with banished men."[48]

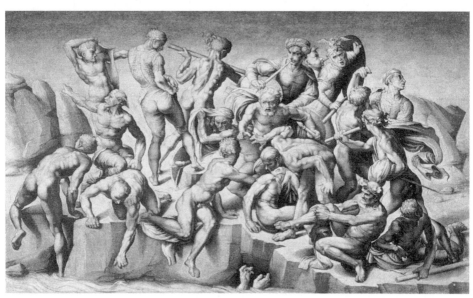

Bastiano da Sangallo, after Michelangelo, *The Battle of Cascina* (Wikimedia / Public Domain)

By 1506 Machiavelli's recruits, having sworn on the Bible to obey regulations and been warned of "all the capital punishments to which they are subject"[49] should they abuse their power, were ready to hold their first parade in the Piazza della Signoria, dressed in the traditional colors of the old commune's *popolo*. Their uniform, Landucci reported admiringly, consisted of

> a white waistcoat, a pair of stockings half red and half white, a white cap, shoes, and an iron breastplate. Most had lances, and some of them muskets. These were called battalions; and they were given a constable who would lead them, and teach them how to use their arms. They were soldiers, but stopped at their own houses, being obliged to appear when needed; and it was ordered that many thousand should be made in this way all through the country, so that we should not need to have any foreigners. This was thought the finest thing that had ever been arranged for Florence.[50]

Well-dressed they may have been, but Machiavelli's militia of amateurs was hardly likely to be a match for the brutal battle-hardened mercenary bands it was likely to face. But it did prevail in its first major test, forcing the long-awaited surrender of Pisa in 1509. Credit for this great victory was given to Machiavelli, who basked in the glory of being compared to one of the great generals of the ancient Roman republic. But that triumph was soon forgotten in the debacle the Florentine republic would suffer only three years later.

The disaster was instigated by Giuliano della Rovere, who on his accession to the papacy chose to take the name of Julius II. The moniker reflected his admiration for Julius Caesar (as his predecessor had named himself after Alexander the Great). Julius's attitude toward the papacy may be summed up by his instructions to Michelangelo to depict him "with a sword in my hand, not a book." As Machiavelli's more hardheaded diplomat friend, the aristocrat Francesco Guicciardini, noted, Julius was "a Prince of inestimable spirit and resolution" for whom "no concept of any kind, no matter how vast and measureless, was inconceivable."[51]

Julius wasted no time. He first subdued the rebels within his own Papal States, then appealed successfully to France, Germany, and Spain to join a league to help the pope militant strip Venice of the Lombard territories seized from the Holy See. Once the Venetians had been routed, Julius turned on a dime and issued a call for the Italian city-states to drive out the French.

Now forced to choose between Julius and France, Florence refused to participate, standing pat with their leader Soderini's pro-French alliance and promising nothing more than neutrality. This position led the furious pope to try unsuccessfully to foment a conspiracy to topple Soderini and restore the Medici—a failure that only made Julius more determined to change Florence's government. In April 1512 the French crushed Julius's league near Ravenna in one of the bloodiest battles of that era. The defeat seemed to put an end to the pope's threat to the republic. But the league regrouped and within a few months Louis XII yanked his army back to France.

Julius's Holy League now pivoted toward Tuscany, urged on by the papal representative, none other than cardinal Giovanni de' Medici, Lorenzo the Magnificent's son. Giovanni had been waiting for this moment since 1494, when at the age of nineteen he and the Medici had been expelled from the city they had ruled for six decades. After his hapless brother Piero drowned in battle in 1503, the corpulent Giovanni had taken over as head of the family. For the last nine years he had carefully cultivated the confidence of the pope while building bridges to other aristocratic Florentine clans, including even their once-exiled rivals the Strozzi (to whom he married off his sister Clarice in 1508). Now the moment had come to force the city to accept his family's return.

From inside Florence, however, where it was reported that the Spanish troops up in the hills were starving, the Holy League seemed far from invincible. "On the contrary," Luca Landucci noted hopefully in his diary, "it was rather for the enemy to fear, because if they came down into these plains, they would fare badly. This was the opinion of every intelligent person."[52] They were reassured by Soderini's decision to reinforce Florence itself while leaving a garrison of three thousand of Machiavelli's militiamen in the point city of Prato fifteen miles away, a force thought ample enough to stave off the Spanish.

Or so it seemed, until the Spanish cannon blew a hole no larger than a window in Prato's wall, and Machiavelli's terrified militia ran like rabbits. In their wake followed the Spanish marauders, "more cruel than the devil," slaughtering and pillaging mercilessly for two days. Hundreds, perhaps thousands, were massacred, including those who sought refuge in churches; hundreds of others were kept alive to be raped, tortured, and held for ransom.

As news of Prato's dreadful fate filtered into Florence, a group of armed Medici partisans marched to the Palazzo della Signoria to demand Soderini's resignation. Machiavelli was dispatched through the lines to his friend and fellow diplomat, the aristocrat Francesco Vettori,

to arrange safe passage for the ousted chief executive, who was permitted to go into banishment in Dalmatia. On the same day, September 1, 1512, the pope's brother Giuliano entered Florence. As he was meeting with the priors, Guicciardini tells us, "suddenly soldiers assaulted the gate and then climbed the stairs and occupied the palace, pillaging the silver which was kept there for the use of the Signoria. The Signori, together with the Standard Bearer (the head of state), were forced to yield to the will of those who could do more with weapons than the magistrates could achieve by respect and unarmed authority; and so as Giuliano de' Medici proposed, the Signori immediately summoned the people to a parliament by ringing the great bell."[53] After eighteen years the Medici had returned once more from exile, as they had done in Cosimo's day some eighty years earlier.

Though the Medici were now masters of the city, Giuliano, like his great-grandfather Cosimo before him, went out of his way to show respect for civic protocol. Donning a citizen's cloak, he permitted the newly elected Gonfalier of Justice to unfurl from the Signoria's window the old banner inscribed with the word "Liberty." Giuliano then formally requested (though "not without some people laughing"[54]) that the Signoria rescind the decree exiling the Medici, and accepted the Signoria's edict declaring that the Medici must live as citizens obedient to the republic.[55] Such submissive gestures disconcerted the elites who had welcomed the Medici's return. They had expected the family to restore the type of regime Lorenzo the Magnificent had established. Now Giuliano was naively permitting the anti-Medicean Savonarolan faction to dominate the newly forming government.

It only became clear to the Medici that a coup was needed when Cardinal Giovanni entered the city in mid-September to join Giuliano and heard how lukewarm were the cries of "Palle!" ("balls," referring to the symbols on the Medici's coat of arms) that greeted him. The next day Giuliano showed up at the Signoria along with Rucellai, Tornabuoni, and other aristocrats backed by the Spanish viceroy's troops. They demanded the priors ring the bell to call the traditional *parlamento* authorizing emergency rule—but this time with power to renew itself indefinitely. The aged ex-Savonarolan pharmacist Luca Landucci described the ensuing farce with grim resignation:

> The piazza was full of armed men, and all the streets and outlets from it were barred with men-at-arms, crying perpetually *Palle*. The palace itself was also filled with armed men, even up to the belfry; but some of the people who had entered the piazza voted that they were content with the

parlamento and the new government. God be praised! Everyone ought to
be content with what Divine Providence permits because all states and
forms of government are of the Lord, and if in these changes the people
suffer some hardship, loss, costs, or discomfort, we must consider that
it is on account of our sins and with the object of some greater good.[56]

"Florence burns, the whole city"

Six months later, the greater good piously hoped for by Landucci and
other average Florentines suddenly seemed realized, when Giovanni
de' Medici was elected pope, taking the name Leo. In Florence the
news was greeted with wild celebrations. Not only did a Florentine
pope mean great honor for the city, but as Machiavelli's friend the
aristocrat Francesco Vettori noted, "everybody thought to profit from
this pontificate."[57] For four days, "crazy with happiness," Florentines
partied spontaneously in the streets. "There was much bell-ringing, and
bonfires were lit in many parts of the city," Landucci reported. "The
people ran all over Florence to pull down the wooden roofs above the
shops and everywhere, burning up everything."[58] Firecrackers and can-
nons were fired continuously for hours.

Understanding the dangers inherent in such an uncontrolled revel,
even if held in honor of one of their own, the Medici locked the fam-
ily palace the instant they heard the news of Leo's election. From the
safety of their windows, they and their allies the Rucellai threw ten
thousand ducats worth of coins and gold goblets to the mob below,
while their servants distributed food and clothing and served endless
tankards of wine from giant casks rolled out in front of the palace.

To symbolize the beginning of this new era, Landucci noted, "they
made several triumphal cars, and every evening set light to one in front
of the house of the Medici in their honor; one was of discord, war, and
fear, whilst another was of peace, and this latter they did not burn, as
if to express that there was an end of all passions, and peace remained
triumphant."[59] Another float, painted by Pontormo and carved by Bac-
cio Bandinelli, showed a dead warrior wearing rusty armor and lying on
the globe. At the climax of the procession, the armor was cleft, and out
leapt a naked child gilded all over, to represent the age of gold reviving
from the corpse of that of iron.

It was an unintended irony that a few days later the child would die
from the effects of gilding.[60] The republic would take a few decades
longer to succumb to the golden peace of Medici rule. But it was now
sick unto death, and the pathos of its last years lay ahead.

CHAPTER SIX

~

The Twilight of the Republic

After 1512, Machiavelli would say in retrospect, "Everything was totally wrecked." But it took some time for this recognition to sink in. Florentine republicans struggled to make sense of the commune's subordination to Medici power during the long twilight struggle of the 1510s and 1520s. The effort to come to grips symbolically with the contradictory reality that there was now a "prince in the republic" gave rise to two of the most poignant cultural achievements of the Florentine Renaissance: Machiavelli's political thought and Michelangelo's Medici Chapel. With the sack of Rome in 1526, Florentines seized the chance to make one last heroic effort to throw off the yoke of the Medici before the final destruction of the republic in 1530. For three years the civic ideal would burn more intensely than ever, until it was finally snuffed out by plague, famine, and the combined forces of the Spanish and the pope.

New Orders

As Florentines thronged the streets celebrating the election of the first Medici pope, a stunned Niccolò Machiavelli looked on, he writes to Vettori, "as if in a dream," having just been released from the Bargello prison as part of a general amnesty. He was an old acquaintance of Lorenzo's son Giuliano, and had expressed fawning hope early on that Florence "would not live less honored with the aid [of the Medici] than she had lived in earlier times, when Lorenzo the Magnificent of happy memory governed."[1] Nevertheless, Machiavelli had been dismissed soon after the

Medici returned, in the general purge of Soderini followers. Then the regime uncovered an assassination plot against Giuliano a few months later, with Machiavelli's name on a list of possible supporters of the plan. He vociferously protested both his ignorance and his innocence, and it was clear he had never even been contacted. But the Medici security police were in no mood to take chances and arrested him anyway.

To make sure he really knew nothing, the hapless diplomat was clapped into the Bargello, described by him with black humor as "my so dainty inn." There he was perfunctorily tortured with several shoulder-wrenching drops on "the rope," the *strappado*. From his cell, whose "walls exude lice . . . that are as big as butterflies," Machiavelli penned desperate sonnets to Giuliano describing the horror around him: "One man is being chained and the other shackled / with a clatter of keyholes, keys, and latches; / another shouts that he is too high off the ground! . . . I have, Giuliano, a pair of shackles on my legs / with six hoists of the rope on my shoulders: / my other miseries I do not want to talk about, / as this is the way poets are to be treated."[2]

Being released should have been a relief. But for a political junkie like Machiavelli, being shut out of political life was a worse torture than anything he had experienced in prison. He wrote bitterly that having been "loyal and good for 43 years," he found himself rewarded for his "good service" by "prison, exile, slander, and death."[3] Jobless and restricted from traveling outside Florentine territory, the former diplomat was forced to spend most of his time bored to death on his small farm outside Florence. ("Give my regards to the chickens," a friend teased him.[4]) Just how frustrating this was for Machiavelli comes through in letters written to his ex-colleague, the aristocrat Francesco Vettori, who had managed to survive the purges and now served the Medici as ambassador to Pope Leo. "I am trained no longer to wish for anything with passion," Machiavelli declares resignedly in a letter of April 9, 1513. Within a few sentences, however, he admits that "if I could speak to you, I couldn't keep from filling your head with castles in Spain, because . . . I have to talk about the government, and I must either make a vow of silence or discuss that."[5]

In the most famous of these letters, Machiavelli conveys with extraordinary vividness the excruciating dullness of his daily routine deprived of the chance to talk politics:

> I get up in the morning with the sun and go into a grove I am having cut down, where I remain two hours to look over the work of the past

day and kill some time with the cutters, who have always some bad-luck story ready, about either themselves or their neighbors. . . . Leaving the grove, I go to a spring, and thence to my aviary. I have a book in my pocket, either Dante or Petrarch, or one of the lesser poets, such as Tibullus, Ovid, or the like. I read of their tender passions and their loves, remember mine, enjoy myself a while in that sort of dreaming. Then I move along the road to the inn; I speak with those who pass, ask news of their villages, learn various things, and note the various tastes and different fancies of men. In the course of these things comes the hour for dinner, where with my family I eat such food as this poor farm of mine and my tiny property allow. Having eaten, I go back to the inn; there is the host, usually a butcher, a miller, two furnace tenders. With these I sink into vulgarity for the whole day, playing at *cricca* and at trich-trach, and then these games bring on a thousand disputes and countless insults with offensive words, and usually we are fighting over a penny, and nevertheless we are heard shouting as far as San Casciano.[6]

Pathetic as it is, this sad situation contained a huge silver lining— not for Machiavelli, but for posterity. As Machiavelli goes on to tell us, his isolation drove the exiled policy wonk to renew his acquaintance, at least in imagination, with the classical sources that had spawned the Florentine Renaissance more than a century earlier:

On the coming of evening I return to my house and enter my study; and at the door I take off the day's clothing, covered with mud and dust, and put on garments regal and courtly; and reclothed appropriately, I enter the ancient courts of ancient men, where, received by them with affection, I feed on that food which only is mine and which I was born for, where I am not ashamed to speak with them and to ask them the reason for their actions; and they in their kindness answer me; and for four hours of time I do not feel boredom, I forget every trouble, I do not dread poverty, I am not frightened by death; entirely I give myself over to them.[7]

The many queries Machiavelli put to the ancients during these evenings concerned the reasons for their political actions, of course, and in imagining himself conversing with them about civic life he was following the practice of his civic humanist predecessors Bruni, Salutati, and Alberti. They had asked Roman and Greek thinkers how virtue and reason could buttress and guide the republic of their time. Machiavelli's situation forced him to pose a very different question: How could classical thought even make sense of the political madness

unfolding around him? As Machiavelli's *ottimati* friend Francesco Vettori wrote to him, things were now happening that "seemed impossible to imagine" beforehand could turn out as they did. Machiavelli agreed that present-day politics were beyond understanding, at least if one tried to do so using "the arguments and concepts" inherited from the republican political tradition.[8]

The exiled diplomat was not the only one scratching his head about what the return of the Medici meant for the future of the republic. The election of a native son as pope had made Florentines giddy, but also a bit anxious. Indeed, it seemed as if the republic itself was being symbolically smothered. As one stunned anti-Medicean, Giovanni Cambi, noted at the time, the pope's coat of arms had been plastered everywhere for the celebration "to such an extent that no one paid any attention to the arms of the commune at all!"[9] What attention was paid republican imagery was outright hostile. For centuries festive processional floats of castles had celebrated the commune's triumph over rural barons. These were now burned, their place taken by a Ship of Fools containing a "violent mob" representing Florence's republican life.[10]

Certainly the break with the previous broadly based Soderini government was unequivocal: the Medici dismissed the legislative Great Council and turned its vast hall into a barracks complete with a tavern and brothel. But even while promoting Medici magnificence and taking antidemocratic measures, Leo was far too canny to underestimate the need to soothe republican sensibilities about symbolic matters of legitimacy and sovereignty. When he visited the city in 1515, carried in by Florentine youths on a litter that passed under twelve temporary triumphal arches erected for the occasion, Luca Landucci groused that "for more than a month we had more than an estimated two thousand men at work—woodworkers, masons, painters, wagons, porters, sawers, and diverse trades—such that one figured a cost of 70,000 florins or more on these perishable things that pass like shadows, which could have built a most beautiful temple to honor God and [given] glory to the city."[11] Yet the pope willingly submitted to the Signoria's protocols of sovereignty. These included tearing down an entry gate to avoid giving him the keys to the city, and the refusal by priors to tip their hats to cardinals. Leo even went out of his way to give the city a ceremonial sword, presented, he said pointedly, "as to his fellow citizens."[12]

The problem was that as pope, Leo was spending most of his time not in Florence but in Rome. There, it must have rankled Machiavelli

to know, he entertained, among many others, Machiavelli's ex-boss Soderini, whose return from exile in Dalmatia to Rome (though not to Florence itself) had been the price for getting the votes Leo needed to win the papal election. To wield Medici power in Florence, Leo assigned his twenty-year-old nephew Lorenzo, son of Piero. Like his late father, whose peremptory actions had gotten the Medici drummed out of the city back in 1494, Lorenzo was an arrogant princeling. He had been raised in Rome and came to Florence, said one republican observer, "not used to civility, and thus aspiring to arms and dominion."[13] Attired in black and sporting a beard in the Spanish fashion, surrounded by courtiers who addressed him as *padrone*, Lorenzo lorded about the countryside with a retinue that included jesters and hundreds of hunting dogs.

Most Florentines would much have preferred to be ruled by Lorenzo di Piero's rival, Pope Leo's brother (and like Leo the son of the Magnificent Lorenzo) Giuliano. Relatively relaxed, free of aristocratic pretensions, and highly cultured, Giuliano counted among his acquaintances not only Machiavelli, but also Raphael and Leonardo. His breeding was so cultivated that his friend Castiglione depicted him in his handbook of manners, the *Courtier*, as a paragon of courtesy. But Leo wanted Giuliano in Rome.

For both brother and nephew Leo had grand plans. Giuliano was to marry into the French royal family and be created a French duke, perhaps to be handed the Kingdom of Naples if the pope could succeed in driving out the Spaniards. For the more ambitious Lorenzo, Leo dreamt of installing him as ruler of a single, unified, central Italian state. It was the same future his papal predecessors Sixtus and Alexander had planned for *their* relatives Girolamo Riario and Cesare Borgia, and a version of the dream of Italian state-builders going back at least to Giangaleazzo Visconti of Milan (whose threat to engulf the republic, we have seen, spurred the civic humanist resistance that sparked the Florentine Renaissance).

Long before the pope's intentions became explicit, Machiavelli understood that Lorenzo was Leo's Cesare, a would-be princeling hungry for a dominion of his own. Machiavelli's republicanism did not prevent him from accepting the reality of this state-building ambition, or from seeking to claw his way back into Florentine politics by serving such a goal. In his darkest work, *The Prince*, written with the desperation of an exile and dedicated to Giuliano and Lorenzo, Machiavelli did just that, offering the two Medicis blood-curdling advice on how to go about securing oneself as tyrant in a new state.

Lorenzo's first task would be to take full control of Florence. The question was how. This was no new state, but a long-established republic bristling with civic institutions and traditions designed to resist precisely the usurpation through force and guile that Machiavelli had strategized. Moreover, the city's political culture of anti-Medicean elites and Savonarolans (known as *frateschi*) continued to hope that the new French king who invaded Italy in 1515 would oust the Medici again. If Lorenzo wished to become outright master of the city, Leo counseled him, he would have to move carefully.

Ironically, it was to Machiavelli's citizen-militia that Lorenzo first turned in his quest for power over the republic. After the Medici's return in 1512, the militia had been suppressed along with the old neighborhood battalions. "Everything was done to take away from the people the opportunity of being able any longer to meet together under those ancient and popular insignia," mourned one republican.[14] But in 1514 Lorenzo reinstituted the militia law, and in 1515, when the pope appointed Giuliano captain of the papal armies being mustered against the French invasion, Lorenzo insisted on equal treatment, demanding he be appointed captain of all Florentine troops, including not just foreign mercenaries paid by the city but also Florence's own militia.

The republic's leaders were alarmed. Not only was Lorenzo taking charge of forces within the city itself, but in assuming the position of supreme military commander he was doing something no citizen had been permitted to do since the beginnings of the republic. To prevent precisely the sort of usurpation Lorenzo clearly had in mind, Florentines had long stipulated that the captaincy could only be held by foreigners, professional condottieri like the Englishman John Hawkwood or Niccolò da Tolentino. As we have seen, these fighting men were prohibited from making private contact with individual Florentine citizens and were even forbidden to have monuments erected to them during their lifetimes. (Posthumous trompe l'oeil statues like those of Hawkwood and Tolentino in the Duomo were the best a captain could hope for under the republic's rules.) Even the ceremony bestowing the office, in which the captain took an oath and received from the city the symbol of authority, the military baton, was designed with exquisite strictness to emphasize that the power to command stemmed from the Signoria.

Lorenzo wanted authority to flow the other way, of course, and when the day of his appointment arrived, he did his best to short-circuit the ceremony in the Piazza della Signoria on the terrace fronting the

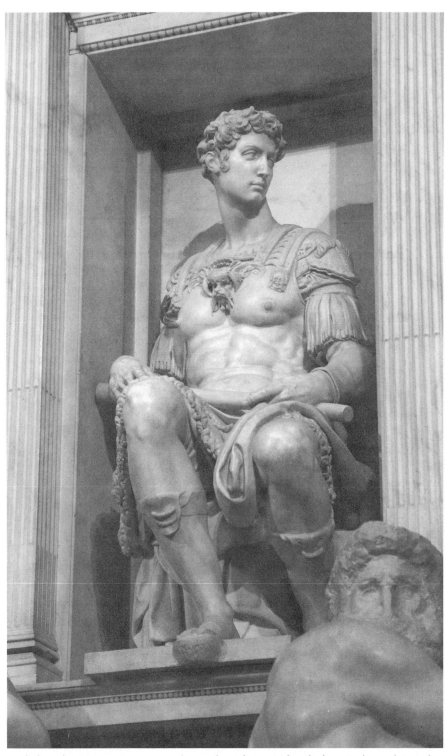

Michelangelo Buonarroti, *Lorenzo de' Medici* (often misidentified as *Giuliano de' Medici*) with baton (Wikimedia/Rufus46)

Palazzo Vecchio. Ignoring the citizens who were supposed to escort him to the platform according to protocol, he rode directly up to it with a squadron of armed Florentine knights. When the moment came for Lorenzo to accept the baton from the priors, one of his pages jumped between them to grab it and hand it, in turn, to his master. Nevertheless the newly dubbed captain did show enough respect for the sovereignty of the city to stand hat in hand while being harangued from the *ringhiera* by the Standard Bearer, and to accept the baton "thanking the excellent Signoria and the whole *popolo* for such an honor, promising to fulfill his duty with the greatest care and sincere love."[15]

In the end, as historian Richard Trexler says, "despite the real power the *bastone* gave him, its limitations were to withstand all his efforts to establish a lordship in Florence. The baton strengthened, and bound, its holder."[16] Within three years, Lorenzo would abandon his project of becoming prince of Florence, marching off to conquer Urbino, marry the French king's cousin, and father a child.

His daughter, Catherine de' Medici, would grow up to become the most powerful woman in sixteenth-century Europe as queen of France. But Lorenzo was never to see this triumph of Medici ambition. During the fighting to hold Urbino, he was badly wounded by an arquebus's bullet, then came down with tuberculosis and syphilis, wasting away and dying in 1519 at the age of only twenty-five. His competitor Giuliano had also succumbed to tuberculosis three years earlier. Their vexed legacies to the Florentine Republic were two bastards, Ippolito and Alessandro, who within the next two decades would become infamous figures in the city's history.

"Prince of the Republic": A Puzzle for Michelangelo and Machiavelli

In death, however, the two Medici captains Lorenzo and Giuliano were to pose a problem of symbolism almost as difficult as any they had created during their lifetimes. For now Leo, together with his cousin Giulio, proposed to create a memorial chapel in the Medici family church of San Lorenzo, where Leo's father, Lorenzo the Magnificent, and Giulio's father, the Magnificent's murdered brother Giuliano, had been laid to rest together in the family's sacristy. These two older and venerated Medici were to be reinterred in a new sacristy together with the two dead captains, thus lending prestige to their less well-thought-of namesakes. It was an accident of history

that the commission for this Medici chapel was given to the sculptor Michelangelo, who had been raised in Lorenzo the Magnificent's circle, but who also harbored republican sympathies.

In designing the joint tomb, Michelangelo and his patrons faced several problems at the outset. How were the depictions of Lorenzo and Giuliano to be balanced, given that one was to be honored as a captain of the city and the other as a captain of the church? With a Medici pope still controlling Florence from Rome, how should the power of the papacy be symbolized for a Florentine audience? As for Lorenzo, how should his quite fraught relation to the city be represented? Finally, what sort of link should be established between these captains and their hallowed Medici ancestors bearing the same names? The era of Lorenzo the Magnificent and his brother Giuliano half a century earlier was now fondly remembered by the increasingly disempowered republican *ottimati* as happier republican days in contrast to the present. The Medici themselves, of course, saw the earlier Medici as precursors. How could the conflict between these opposed perspectives be managed?

For other sculptors, these issues might not have arisen with the same intensity. But Michelangelo's own republicanism, and his personal connection to Lorenzo the Magnificent's circle, lent such questions a heightened importance. Michelangelo's answer, the sculptural ensemble of Medici tombs in the New Sacristy, was a brilliant stretch, one that enabled him to straddle republican past and problematic present in a work of unparalleled historical and philosophical complexity.

As Richard Trexler has shown, the two captains, Lorenzo and Giuliano, are portrayed as heroic military leaders bearing the symbols of their respective public offices—for Lorenzo, the baton of the Florentine militia, and for Giuliano, the traditional insignia of Roman consuls, a small pouch called a *mappa*. But Michelangelo went to great pains to make clear that the achievements of these honored men are not those of gods or Caesars; they like all men are subject to time, whose anguished figures (Night and Day, Dawn and Dusk) lie below the two captains mourning their passing. Only by looking beyond themselves can Lorenzo and Giuliano find a guiding light beyond the earthly cycle of time. That light is to be found not by looking up to Platonic clouds (as Botticelli's Graces were directed to do by Hermes in the *Primavera*) but by turning, as the two captains do, to the head of the chapel. There their Magnificent ancestors lie, and the even greater spirit of the Medici *pater patriae*, Cosimo, is represented by his patron saints Cosmas and Damian.

But Michelangelo goes further, to show the family as a whole participating in the eternal. Moreover, he presents them doing so in a way that reflects honor not on the family alone, but also on the city they are supposed to humbly serve as citizens. Since Cosimo's time, as we have seen, the Medici had sought to do this by associating themselves with the Magi, marching in the mock Adoration processions that the republic used to hold, and commissioning paintings from the likes of Benozzo Gozzoli and Botticelli depicting themselves as Magi. Michelangelo himself had been present in the good old days at the Feast of the Magi held by Lorenzo the Magnificent's Company of the Magi in the family's chapel in the Medici palace. He had been present, too, when that confraternity carried Lorenzo's body to San Marco. More recently he had seen the coin issued by Leo showing the Medici pope's own image on one side, the Magi on the other.

Reaching back to this tradition, Michelangelo created in effect an *Adoration of the Magi* in the round like Gozzoli's *Procession of the Magi* in the Medici palace—though tellingly without the crowd of Florentine citizens Gozzoli had been at pains to make place for in Cosimo's procession (as Cosimo had been at pains to include them in his patronage network). Michelangelo's two captains, though they had to be depicted larger than life and in military dress with all its threatening military and anti-civic associations, were in his rendering also to be recognized not as tyrants but as adoring kings. Each humbly bears gifts of gold (in Lorenzo's hand) and frankincense (in Giuliano's box) offered in tribute to the Madonna and Child, surmounting what were intended to serve as the tombs of their ancestral namesakes—but also, if the echo of earlier uses of the Magi by the Medici were heard, offered in tribute to the republic itself.

Like Michelangelo, Machiavelli had found himself searching for some way to reconcile his republicanism to the reality of Medici power over the republic. In the first desperate months of exile when he scribbled out *The Prince* (dedicated to Giuliano and then, following his death, to Lorenzo), he had imagined the post-republican political world as hell and fantasized that the Medici might save the Italy he loved by driving out the foreign armies—an achievement that, he warned, demanded leaders who would reject the old politics of civic humanist virtue for a political ethic that recognized the need to be "able not to be good and to use this and not use it according to necessity."[17]

Any such hope was crushed by Giuliano's early death and the heavy-handed rule of Lorenzo (who, in a development that must have rubbed salt in the wound, ignored the author of *The Prince* but took on his old

friend, the aristocrat Francesco Vettori, as an advisor). Machiavelli was left warning the next generation of Medici obliquely not to go baton-grabbing as had Lorenzo: "If you wish to live in security," he has Cosimo the Elder's father counsel in *Florentine Histories*, "take only as much political power as is given you by the laws and by men. This will not bring on you either envy or danger, because what a man takes for himself, not what is given to him, makes him hated."[18] Let would-be tyrants look back to the time of the Caesars and see the terrible results of outright domination:

> He will see Rome burnt, its Capitol demolished by its own citizens, ancient temples lying desolate, religious rites grown corrupt, adultery rampant throughout the city. He will find the sea full of exiles and the cliffs splattered with blood. In Rome he will see countless atrocities perpetrated; nobility, wealth, ancient honors and above all, virtue, counted as capital crimes. He will find liars rewarded and slaves rebellious against their masters. . . . Then he will understand very well what Rome, Italy, and the whole world owes to Caesar.[19]

The creeping Medici Caesarism of post-1512 Florence was also registered in Michelangelo's tombs in the New Sacristy. The sculptor, as we have seen, dealt with it by hearkening back to the symbolism of an era when, in memory at least, the Medici family had coexisted relatively happily with the republic. As a former secretary of the republic interested in the cause of the present political impasse, Machiavelli was naturally more practically oriented. Yet he too found himself seeking help in Florence's past—not the past of Medicean Magi iconology, however, but that of the Florentine republic's political culture.

Where *The Prince* focused on leadership and the conflict between virtue and political *virtù*, Machiavelli's later works emphasized institutions ("orders") and ideological conflicts. His analysis turned civic humanism's republican optimism on its head, so much so that at first he denied that Florence had ever "had a state for which it could truly be called a republic."[20] Leonardo Bruni's celebratory history of the city's progress and his warnings against discord, Machiavelli noted, took no account of the way in which, paradoxically, "those very tumults which many so inconsiderately condemn . . . led to laws and institutions whereby the liberties of the public benefited."[21] The civic humanist view of history also overlooked the ways in which the republic's "great equality" was in turn always in danger of corruption by wealthy and ambitious elites.

Machiavelli concluded sadly that republicanism was fine in theory, but in practice was bound to degenerate: "For, if in a republic there appears some respected young man, who possesses in himself extraordinary *virtù*, the eyes of all citizens will begin to turn towards him, and they will honor him without reservation; so that if such a person has any ambition, the combination of his natural gifts with his growing popularity will place him in such a position that when the citizens realize their error, there will be little they can do about it, and should they attempt what little they can, they will only increase more quickly his power." It is only a matter of time before this will lead to that painful anomaly peculiar to Florence: the ascension of a "prince of the republic."[22]

The virtuous citizen corrupts the republic, almost inevitably: "Virtue gives birth to quiet, quiet to leisure, leisure to disorder, disorder to ruin."[23] This is the ultimate Machiavellian irony, inverting the civic humanism of Bruni and Salutati, with its assumption of the seamlessness of virtue and civic life, and presenting a modern vision of politics as a process larger than, and largely independent of, the qualities and even the will of individuals. Governing begins to be grasped as a matter not of justice arrived at by civic deliberation, nor of prudent statecraft by a wise ruler, nor even (as in *The Prince*) of individual *virtù* mastering fortune. It is instead a game of power, of conflict rippling uncertainly through social groups and institutions, flowing around and through even the heroes lauded by the republic. The Medici themselves, despite their hold on power, are in reality like everyone prisoners of this system of factions, rivalries, liberality, and favors, and caught up willy-nilly in the larger sociohistorical process that unfolds through it.

For the corrupt republic to reform itself, Machiavelli now understood, would take more than a single great man. Their only hope lay in the collective *virtù* of Florentines, their ability to learn from their own tragic history to put their faith not in authoritarians like the Medici, but in themselves. Machiavelli was darkly optimistic that this would happen, since history showed that though states come by these means to ruin, they then renew themselves: "When they have arrived there and men have become wise from their afflictions, they return, as was said, to order [*ordine*, legitimate rule]." He added, however, that this was provided that they do not "remain suffocated by an extraordinary force."[24] The Florentines felt just such a death grip on their throats, and when Machiavelli died in June 1527 they were trying, one final time, to break the Medici chokehold and breathe free.

"The true prince": The Last Florentine Republic

The year 1527 will be full of atrocities and events unheard of for many centuries: overthrow of governments, wickedness of princes, most frightful sacks of cities, great famines, a most terrible plague almost everywhere in Italy; everything full of death, flight and rapine.

—Guicciardini, *History of Italy*[25]

With a reputation for being "heavy-handed and hateful . . ., avaricious, faithless and not given naturally to benefit mankind,"[26] Giulio de' Medici (Image 17), who had succeeded Leo as head of the family in 1521, was not well-liked in Florence. Even before he was elected pope in 1523, taking the name Clement, republicans had tried to assassinate him. He soon alienated Medici-supporting elites as well by seizing formal control of Florence's foreign policy, reducing ambassadors from honored figures wielding influence to givers of advice that was ignored. And when he left the city in charge of Lorenzo's and Giuliano's underage bastard sons Alessandro and Ippolito, superintended by a cardinal who was not only not Florentine but also a foreigner hailing from one of Florence's subject-cities, all Florentines felt snubbed.

But Clement had his hands full in Rome. He had won election in part by vowing to continue his cousin Leo X's policy of supporting the young emperor Charles V of Spain, who was trying to drive the French out of northern Italy. (In a quid pro quo for the Papacy's backing Spain against France, Charles was supposed to capture, try, and execute Martin Luther as a heretic.) Within a year, however, Clement had changed his mind and thrown the Papacy's support to France—just in time to put himself on the losing side.

It spelled disaster for both Clement and Rome. Vowing to "teach the Pope a lesson he would never forget,"[27] Charles dispatched a strong army north from Naples. At the same time, a huge force of brutal, pike-bearing Lutheran *Landsknechte* from Germany came pouring down from the north, joined up with a freebooting Spanish army in Milan, and pushed inexorably southward toward Tuscany on their way to Rome.

To pay for the armies needed to defend the Holy City from this onslaught, Clement drained the Florentine treasury dry. Between April 1526 and May 1527, Florentines spent an astonishing eight hundred thousand ducats on war, a sum equivalent to the entire annual income of the republic. Yet with the bulk of this money going to pay for Rome's protection, the commune found itself nearly defenseless against the

approaching marauders. Clement's man in charge in Florence, Cardinal Passerini, responded by dithering—he "spends the whole day in idle chatter and neglects important things," fumed his advisor, the Florentine aristocrat diplomat Francesco Guicciardini—while his charges, the Medici bastards Alessandro and Ippolito, lolled at their villas.[28] Finally a contingent of younger Florentines stormed into the Signoria demanding that steps be taken to protect the city. The proto-rebellion was quelled only after pro-Medicean troops attacked the Signoria. During the battle, the David's arm was broken by a stone hurled from the roof.

As it turned out, Florence was spared at the last minute when papal troops arrived, and the disorderly German and Spanish horde swerved past them to the richer and now undefended prize that lay to the south. Three weeks later, having slogged through terrible snowstorms and torrential rains, ragged and near starvation after being unpaid for months, they burst into Rome. The sack of Rome—perhaps the most terrible in European history—lasted eight days. It devastated the city, left the pope a virtual prisoner in the Castel Sant' Angelo, and destroyed what remained of loyalty to the Medici among Florentine elites, whose Rome-based merchants lost a million florins to the pillagers.

The Medici bastards, abandoned by their Spanish protectors, were now publicly excoriated by many, including Lorenzo the Magnificent's spunky granddaughter, Clarice Strozzi (whose banker husband Filippo, a Medici supporter, had turned against them after Clement sent him as hostage for a treaty and then abandoned him). Within days they were gone.

Then once again, for the last time, the intoxicating dream of a virtuous republic gripped the city. The wax statues of eminent Medici were smashed and pissed on. That of Clement was ground to dust in what one onlooker described as the "murder of the pope," noting that "having slaughtered him in wax, they would have all the more readily killed him in fact."[29] Everywhere the Medici emblems were ordered removed; even old Cosimo's epitaph in San Lorenzo was re-chiseled yet again to read not "Pater Patriae" but "Tyrannus."

For a brief time, the oligarchs vainly imagined they could finally institute an aristocratic republic modeled on that of Venice. But it quickly became clear that this time around, the old republican slogan "Liberty and the People" would be taken seriously: the people themselves, driven by Savonarolan ideals, would rule.

The Palazzo Vecchio's Hall of the Five Hundred, the former meeting place for republican deliberations, had been partitioned by the Medici

into barracks for their mercenaries. Now, it was first purged in a single day by enthusiastic young citizens working side by side with ordinary laborers, then sanctified by priests sprinkling holy water. The following day the great bell tolled, summoning all eligible citizens to the first Great Council meeting in fifteen years, the largest ever assembled in Florence and the first to include among its numbers the militant young men who had led the revolutionary charge. The council, now identified in law as "the true prince,"[30] quickly elected the 1,360th and last Standard Bearer of the new republic, Niccolò Capponi, son of the famous republican who in 1494 had saved the city by standing up to Charles VIII.

The day after Capponi's election, a solemn procession of all the religious companies and orders took place. It bore the head of the commune's patron saint, Zenobius, from the Duomo to the Signoria. There the crowd joined the Standard Bearer and government officials in marching to the church of Santissima Annunziata to adore the miraculous Annunciation, a fresco purportedly painted by Saint Luke. The procession finished back at the Duomo, where the Bishop of Fiesole blessed the new government in a solemn High Mass.

Stern Savonarolan laws soon followed. Carnival was again suppressed, Palio races forbidden, and laws against gambling tightened; extravagant dress and entertaining were forbidden, books censored, and the Jews banished.

And then the plague exploded, striking Italy with a virulence unseen since the Black Death of 1348. It quickly carried off most of the Spanish troops who had sacked Rome, as superstitious Florentines noted with grim satisfaction, but soon it struck with equal wrath within Florence itself. By midsummer of 1527 hundreds a day were being tossed into the burial carts to be dumped in mass graves without ceremony, having made their confessions and dictated wills from their rooftops (notaries being unwilling to enter plague-ridden houses). The quorum for meetings of the Great Council was cut in half, and even preaching was suspended as a prophylactic measure. By the time the epidemic abated the following winter, one quarter of the population had been killed, including Michelangelo's brother, who died in the sculptor's arms. Summing up the city's woes before the decimated Great Council, Standard Bearer Capponi ended on his knees, crying "Mercy!" and calling for Jesus Christ to be elected as King of Florence. The motion was instantly passed by a vote of 1,100 to 18, and an inscription to that effect—*Iesus Christus Rex Florentini Populi S. P. Decreto Electus*—placed over the doors to the Palazzo della Signoria.

Despite its devastations, the plague, by striking so severely the armies of both the emperor and the French, actually gave the infant republic badly needed time to organize itself. Oddly enough, so did Pope Clement's escape from Rome in December of 1527. Holed up in Orvieto, Clement, indecisive as always, spent the next year alternating between cajoling Florence to readmit the Medici and threatening to join forces with the emperor to take the city by force. Finally, at the beginning of 1529, he struck a deal that sent shock waves through the commune. The emperor's Italian gains would be recognized by the Papacy, and Charles himself crowned by the pope. In return Charles would agree to provide the troops behind which the Medici could return to Florence. The final confrontation was at hand.

Besieged

The pious say that faith can do great things, and, as the gospel tells us, even move mountains. The reason is that faith breeds obstinacy. To have faith means simply to believe firmly—to deem almost a certainty—things that are not reasonable; or, if they are reasonable, to believe them more firmly than reason warrants. A man of faith is stubborn in his beliefs; he goes his way, undaunted and resolute, disdaining hardship and danger, ready to suffer any extremity. . . . In our own day, the Florentines offer an excellent example of such obstinacy. Contrary to all human reason, they prepared for an attack by the pope and the emperor, even though they had no hope of help from any quarter, were disunited, and burdened with thousands of other difficulties. And they have fought off these armies from their walls for seven months, though no one would have believed they could do it for seven days. Indeed, the Florentines have managed things in such a manner that, were they to win, no one would be surprised; whereas earlier, everyone had considered them lost. And this obstinacy is largely due to the faith that they cannot perish, according to the prediction of Brother Jerome [Savonarola] of Ferrara.

—Francesco Guicciardini, *Maxims and Reflections*[31]

As it became clear that the pope intended to seek rapprochement with the Spanish, anti-Medicean feelings in Florence again began to run high. Rumors—many of them substantiated—swept through the city: reports of messages written in invisible ink, of Medici forces rallying in

nearby villages, of leading citizens secretly negotiating surrender in advance. Followers of the Medici were told to get out of town, sentenced to have their tongues pierced for "words against the present pacific state," and subjected to attempted assassinations.[32] Within the convent of Le Murate, pro-Medici nuns clashed with supporters of the *popolo* over the fate of ten-year-old Catherine de' Medici, held in protective custody there. Some extremists called for her to be killed, chained naked to the city's battlements exposed to enemy fire, or sent to a brothel. To protect her the government had the girl who would later become queen of France moved to a more secure nunnery.

Even the city's leader Niccolò Capponi found himself under suspicion, forced to agree to the formation of an armed guard of younger republicans that patrolled the Palazzo della Signoria and kept continuous watch over him. He finally was ousted after the *arrabiati* (the non-Savonarolan angry young men who formed the most radical anti-Medici party) accused him of treason for undertaking secret negotiations with the pope. With him went the last hope of compromise.

In preparing for the now inevitable attack, Florence's new government set the city on a war footing more complete than any it had ever seen. Two of the pope's most implacable foes were hired as mercenaries; all buildings outside the city walls that might have been used by the enemy as cover were razed to the ground, mills destroyed, orchards uprooted, gardens burned. (The only exception was the refectory of the monastery of San Salvi, where Andrea del Sarto's elegiac *Last Supper* awed the workmen into sparing the building.) To reinforce the bastions, every male over fourteen was set to work. It continued day and night, "and while the men worked," writes the historian Cecil Roth, "the women prayed."[33] Finally, in a move Machiavelli would have cheered, for the first time in Florentine history a militia was created made up of youthful citizens. Pontormo memorialized one such young republican halberdier (Image 18) posing defiantly in the style of Donatello's early marble *David*. Instead of the Palio races traditionally held on John the Baptist's birthday, the civic holiday was celebrated with a review of the new militia.

To prevent the Medici from setting up house to wait out the siege at Lorenzo il Magnifico's villa at Careggi, the Signoria had it torched. Michelangelo proposed going even further and razing the Medici palace to give them nothing to return to if the city did fall. Though this suggestion was not taken up, the government did charge him to shelve

plans to sculpt a *Samson Smiting the Philistines* (which would have com-memorated Florence's recovered liberty) as a companion to the *David*; instead he was to oversee the strengthening of the city's fortifications.

By this time, Michelangelo had already all but stopped work on the Medici tombs, after toying with the idea of replacing Lorenzo's baton, symbolic of his captaincy, with a sword (the baton now appearing intolerably to suggest Medici rule over the city). In the basement under the chapel he grabbed some chalk, turned to the wall, and tried sketching Lorenzo's figure with a sword where the baton would be. But the hands had already been chiseled, making this alteration impossible, he quickly realized, and the frustrated sculptor ultimately let the baton and statues remain unchanged.

Early in the fall of 1529 the dreaded imperial/papal force appeared on the hills above Florence, pitched camp, and settled in to await the republic's starvation. Both groups immediately sent into action their companies of "ribalds," scalawags whose duties included pillaging, wall-scaling, portering, gambling, prostitution, and perhaps most important, insulting the enemy. Spanish ribalds ostentatiously buried the Mar-zocco stone lion, symbol of the commune, while Florentine children stood on ramparts next to a papal flag and mooned the enemy. In sharp contrast to such rowdiness, the citizens' militia showed an impressive degree of discipline, members even cropping their shoulder-length hair to look more like soldiers. In front of an altar erected facing the Baptis-tery, they passed a Bible from rank to rank, each young man swearing to use his arms for the glory of God, the common good, and the defense of liberty. Pontormo's *The Ten Thousand Martyrs* (now in the Uffizi), painted during the siege around 1529, memorializes this pious milita-rism in the face of evil. It depicts ten thousand pagan soldiers who win a battle after being converted to Christianity by an angel, but who are then crucified by the emperor Hadrian after refusing to recant.

In spite of such brave appearances, no one expected the Florentines to hold out long. After all, as the Venetian envoy noted, they were mere merchants and craftsmen. Michelangelo himself had fled just before the arrival of the Spanish, crediting rumors that a secret deal was being cut to permit the Medici to return. But this was a stubborn city that had survived a 1402 siege by the viper of Milan, Giangaleazzo Visconti; warred with Pope Sixtus in Lorenzo il Magnifico's time; and outfaced French crusader Charles VIII in 1494. "I contemplate in these our fellow-citizens," Battista della Palle, the world's first art dealer, wrote to Michelangelo, urging the sculptor's return, "a noble spirit of

Michelangelo Buonarroti, *Study of Legs for the Tomb of Lorenzo de' Medici* (often misidentified as *Giuliano de' Medici*) (Scala / Art Resource, NY)

Giorgio Vasari, *The Siege of Florence* (Wikimedia / Public Domain)

disdain for all their losses and the bygone luxuries of villa life; admirable unity and fervor for the preservation of liberty; fear of God alone, confidence in Him and in the justice of our cause."[34]

God would not let the republic down, so long as Florentines showed their faith. Accordingly, the Signoria ordered that whenever the great bell sounded the battle signal, "all persons not adapted and fitted for arms, such as priests, friars, monks, nuns, children and women of whatever age . . . shall be obliged to kneel . . . and to make continual oration while the battle aforementioned shall continue, and to pray the Omnipotent God to give strength and courage to the arms of the Florentine soldiers and militia, and to give them victory."[35]

For ten months this fervor helped the Florentines hold out. Morale was buoyed by the daring exploits of their commander, Francesco Ferrucci, who periodically led guerrilla raiding parties out to keep the city's meager supply routes open. Within the city, everyone did their best to act as if it were business as usual: merchants wearing helmets and carrying arquebuses checked their inventories, children continued going to school, and the Great Council met regularly. At the height of the siege, the carnival game of *calcio* was staged in the Piazza Santa Croce, within sight and range of the Spanish cannon.

But slowly, inexorably, the noose tightened. To pay the city's mercenaries, the government seized property from the Church, the guilds, even the hospitals. Valuables from relics, including the jewels from Leo X's miter, were stripped from churches and convents. The government ordered citizens to turn in all silver and gold plate, which was melted down to coin ducats stamped with the words "Jesus Our King and God."

Not all Florentines went along willingly with such confiscations, some emptying the bones of ancestors from family crypts to hide their silver there. One exile's wife, Vasari tells us, rebuffed officials when they came to collect panels from a bedroom set painted by del Sarto and Pontormo which the French king coveted: blocking the doorway, she refused them entry, declaring she would "defend the honor of her marriage bed with her blood and even her life."[36]

As the siege wore on, plague and starvation began to take their toll. Almost a third of the populace ultimately perished from disease, famine, and battle, including (just after the siege ended) the last great painter of the Florentine Renaissance, Andrea del Sarto, who had wishfully depicted the many Florentine deserters as hanged criminals. The ranks of the militia were so depleted that in the last months the

city did something that had been anathema since the revolt of the Ciompi back in the 1380s: it permitted the artisans to be armed.

The republic's last days were now near. Forced to attempt more and more desperate raids, the intrepid Ferrucci was at last cornered by Spanish troops during one of his sorties, captured, and hacked to pieces. Although a preacher insisted that angels would appear at the bastion to save the city from its imminent demise, everyone now recognized there was no possibility of salvation. By the bitter end, there was only three days' food left in the city. "Everyone was beside himself with fright and bewilderment," the historian Benedetto Varchi later recalled; "no one knew what to say anymore, what to do or where to go. Some tried to escape, some to hide, some to seek refuge in the Palazzo della Signoria or in the churches. Most of them merely entrusted themselves to God and awaited resignedly, from one hour to the next, not just death but death amidst the most horrid cruelties imaginable."[37]

The expected sack, however, was averted when the mercenary in charge of Florence's garrison made a secret last-minute agreement with the Spaniards and turned his artillery around to face the city he had been hired to protect. In accepting the city's surrender, the pope made the usual vague promises to show clemency and respect the city's liberty. But the terms were hard. Florence was to pay a huge tribute and turn over fifty leading citizens as hostages. Clement also tapped as interim ruler Francesco Guicciardini, as willing to look political evil in the face as his old friend Machiavelli but a pro-Medicean aristocrat with an axe to grind, his family's property having been confiscated during the siege.

Guicciardini was authorized to exact fierce retribution against the rebels. The leader of the republicans, Francesco Carducci, was tortured and executed along with six others; many prominent citizens were exiled or went into hiding, including Michelangelo (who spent three months in the basement under the New Sacristy, covering the walls with sketches). To make clear Medici long-term intentions toward the republic, the great bell which had been used to call the people to assemble was smashed to pieces in the Piazza della Signoria. Its fragments were then melted down and recast as Medici medallions.

~

Coda

With the pope's blessing, Alessandro de' Medici was installed by his Spanish backers as "Duke of the Republic" in 1532. He promptly tore up the constitution and ordered up a portrait of himself from Vasari (Image 19), modeled on Michelangelo's statue of Alessandro's captain-father Lorenzo, complete with the military commander's baton that in Alessandro's case conspicuously symbolized his power over Florence (shown in the painting's background). As another such symbol, the duke had Bandinelli's thuggish *Hercules and Cacus* set up in front of the Signoria next to the *David*; sonnetteers who dared make fun of this muscle-bound lout were imprisoned. A more directly threatening symbol of Alessandro's power was the newly built Fortezza da Basso, an intimidating citadel whose ramparts were hung with the standards of the Medici and the emperor, and whose guns were trained not on the enemy but on the city. Not that there was much threat of revolt: Alessandro had ordered the citizenry disarmed, confiscating even weapons left hanging as votive offerings in churches.

Florence's aristocrats despised Alessandro, but had no stomach for another siege. Nor could they hope to rally the Florentine public after having betrayed it so thoroughly: as Guicciardini, writing to Clement VII, put it bluntly but accurately, "We [aristocrats] have as our enemy an entire people."[1] The elite opted to close ranks with Medici, abandon republicanism, and become courtiers. Within a year of Alessandro's accession, the venerable citizenly custom of wearing the hooded *lucco* was

completely abandoned, caps or hats being worn instead, and beards as well as slashed stockings came into vogue.

Michelangelo's statues in the Medici Chapel now began to be talked of not as "captains" but "dukes," part of what Trexler calls "the phony apotheosis which so infected post-republican Florence."[2] As commentators celebrated his figures' charisma while conveniently forgetting the republican symbolism connected to the Magi and the baton, Michelangelo maintained a stony silence in Rome. He refused to come back to Florence to finish his chapel, or to explain its program, even when the baton-bearing figure of Lorenzo was misidentified as that of Giuliano. His only comment was a grim one: chided that his statues did not resemble the two Medici, he retorted that no one would know what they had looked like anyway in a thousand years.

It seemed that it would take at least that long for Florentines to forget the Medici, so heavy-handed was Alessandro's rule, which contemporary chronicler Giuliano Ughi lamented for having confused and tossed out all the *"antiqui ordini e buoni instituti del popolo Fiorentino"* ("ancient orders and good institutions of the Florentine people").[3] Within a few years, however, the dissolute and autocratic duke, "hated and feared for his disordered lust"[4] by the Florentine people and hated by the exiles for trampling on Florence's liberty, would be dead. Ironically, so would the last faint hopes for the republic.

One of Alessandro's favored companions in debauchery was his kinsman Lorenzino, degenerate grandson of the aesthete who had commissioned Botticelli's *Primavera*. A drunk who had been kicked out of Rome for lopping the heads off statues, Lorenzino was often seen together with Alessandro, riding two on a horse, whoring, even cross-dressing. But the moody Lorenzino resented playing the courtier, resented being passed over by a bastard three years younger than himself, and even, perhaps, resented Alessandro's tyranny. When a pamphlet detailing his perversions began circulating, he began brooding over his public disgrace. Finally he hatched a plan that he believed would at one stroke restore his reputation and make up for all the slights he had suffered.

Lorenzino told Alessandro that a beautiful married woman had asked him to act as a go-between to arrange a secret love-tryst with the duke at his house. At the appointed hour, on a festival Saturday when Alessandro would be less likely to be noticed among the crowds, the randy duke arrived at Lorenzino's house, told his guards to wait outside, stripped, jumped into bed, and waited, eventually dozing off.

He awoke to find Lorenzino and a hired assassin lunging at him. As the assassin repeatedly stabbed Alessandro, the duke began screaming, and when Lorenzino clamped a hand over his mouth, he bit several fingers to the bone. Pulling a glove over his bloody hand and locking the bedroom door behind him, Lorenzino jumped on his horse and rode off to Bologna, having neglected to let the city's republicans or exiled citizens in on his plan or its success. As a result, the moment for action was missed. The Mediceans, backed by their Spanish troops, would not let it come again.

Alessandro remained wrapped in cloth in the old sacristy for over two months. Finally, the emperor's agents took it upon themselves to deposit the tyrant's body in the Medici Chapel, notwithstanding all the preexisting associations with republicanism with which Michelangelo had imbued its statues. After a public funeral complete with a replica of the duke dressed in his finest clothing, the Spanish opened the Medici Chapel the next day for the first time. The populace was "invited" to honor the remains of their late hated duke, placed under what must have seemed now the skeptical gaze of Michelangelo's two captains. Smoke from the thousands of candles Florentines were forced to light in front of the coffin turned it soot-black, though a diarist later attributed the blackness to Alessandro's soul.

In hiding abroad after the assassination, Lorenzino wrote an apologia comparing himself in traditional republican terms to Brutus slaying Caesar. (Years later he would be tracked down in Venice by Medici agents and stabbed to death with a poisoned dagger.) The Florentine republicans exiled in Rome celebrated the tyrannicide, and Michelangelo was induced to sculpt a bust of Brutus (now in the Bargello), presumably as a tribute to Lorenzino.

But by then the last of the active Florentine resistance to Medici absolutism had been wiped out, after being cornered and captured near Prato. The forces were led by eighteen-year-old Cosimo de' Medici, son of the Florentine military hero Giovanni delle Bande Nere (the only Medici to have fought wars in his own right as a mercenary, and the last of the great Italian condottieri). Unlike his father, who at his age had already been twice banished for murder and the rape of a sixteen-year-old boy, Cosimo was cold and self-controlled, though equally ruthless. He ordered the leader of the resistance, Filippo Strozzi, to be thrown into the Fortezza da Basso and tortured by the Spanish emperor's garrison there. With grim understatement, Luca Landucci's son reported in the family diary that on December 18, 1538, "Filippo Strozzi, who had been

imprisoned in the Citadel for 16 months and 18 days, cut his throat, or had his throat cut, a matter which causes serious reflection."[5] Such serious reflection on the part of potentially rebellious Florentine subjects was also fostered by Cosimo's treatment of the twelve other captured resistance leaders. Every day for three days running, four of them were paraded before him in the Piazza della Signoria and then beheaded.

Cosimo's decisiveness as Florence's new ruler pleased the emperor enough to name him Duke of Tuscany. Cosimo's fierce portrait bust by Cellini (Image 20) presents him in Caesarist breastplate, the antithesis of his namesake Cosimo the Elder, who had had himself depicted riding a mule. As formal head of state, Cosimo moved with his family for a time into the rooms in the Signoria once occupied by Machiavelli's boss Piero Soderini and his family. But a duke required a palace suitable for guests and for court functions, for which the Pitti palace across the river was eventually purchased and greatly enlarged by the painter Giorgio Vasari.

Vasari also oversaw the construction of an aboveground interior corridor running over a cleaned-up Ponte Vecchio that would allow Cosimo to avoid having to risk going among his subjects while walking from his palace to the newly constructed governmental offices, the Uffizi. These were erected next to what now began tellingly to be called the Palazzo Vecchio rather than the Signoria. Here the city would henceforth be administered by bureaucrats, auditors, and secretaries, none of them Florentine. Its wars would be funded from here on in by money borrowed only from foreigners rather than, as had traditionally been the rule under the republic, from Florentines themselves.

To symbolize the triumph of the Medici over the republic, and perhaps also to remind Florentines of the terror he was willing to employ, Cosimo permanently posted Swiss lancers in the loggia next to the Palazzo Vecchio, and commissioned Benvenuto Cellini to cast a bronze statue depicting Perseus with the head of Medusa to stand there, with them looking out onto the piazza. As the art historian John Shearman has noted, the elegant yet violent *Perseus* was placed so that Michelangelo's icon of liberty, the *David*, would seem, by gazing at the Medusa's head, to be turned to stone—republicanism petrified by the duke's power.[6]

Though the meaning of that confrontation has faded from memory, Cellini's *Perseus* and Michelangelo's *David* still face each other on the Piazza della Signoria. Once the epicenter of political struggle, the square has long since become an open-air sculpture gallery gawked

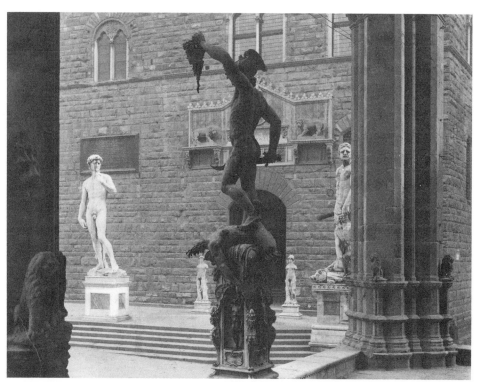

Benvenuto Cellini, *Perseus with the Head of Medusa*, side view with Michelangelo's *David* in the background. Loggia de Lanzi, Florence (Alinari / Art Resource, NY)

at by hordes of tourists oblivious of its turbulent past. Our story ends here—where the Uberti clan's houses were razed after the Guelphs defeated the Ghibellines; where the word *libertas* was inscribed over the doorway to the very seat of power; where ragged wool carders staged the first workers' revolution; where condottieri hired by the commune were harangued about the virtues of republicanism; where crowds of citizens gathered time and again in response to the emergency summons of the great bell, to change the state or defend it; where Cosimo the Elder, looking down from his prison-cell window in the tower of the Signoria, saw his enemies gathering; where the Festival of the Magi erected a mock Jerusalem; where Savonarola burned his bonfire, and where he himself was burned; where the Pazzi conspirators in 1478 and Piero de' Medici in 1494 rushed in desperate but futile efforts to take the seat of government; where Donatello's *Judith* and Michelangelo's *David* were posted as warnings to tyrants and to stand guard against them; where Machiavelli's militia mustered; where Lorenzo di Piero was forced to accept the baton from city leaders rather than seize it; where the young men of the last republic gathered to storm the Signoria in 1427; and where the last remaining republican holdouts were executed by Cosimo I. Here Florence's Renaissance spirit was born, burned fiercely, and finally died.

Itself a rebirth, in its afterlife this spirit would have an incalculably diffusive influence, both politically and culturally, on European civilization. Two centuries later, on another continent, it would be again reincarnated as a republican ethos of civic virtue and adherence to liberty, with very different philosophical justifications but similar travails. As it shaped Florentine art, philosophy, and literature, so it continues to shape our own imagination of the past and our orientation toward the future, our faith in what man's unleashed powers can achieve, and our tragic recognition of how such power may undermine and ultimately destroy the system that enabled it to emerge. Both the dream and the nightmare lived by Renaissance Florentines are recognizably modern. In that respect, they remain our contemporaries.

~

Notes

Chapter 1. Florence Rising

1. Compagni, *Chronicle*, 5–6.
2. Trexler, *Public Life*, 40.
3. Gregorio Dati, quoted in Guasti, *Le feste*, 5.
4. Beccadelli, *Hermaphroditus*, 83.
5. Strocchia, "Learning the Virtues," 8.
6. Vespasiano, *Renaissance Princes*, 165.
7. Sacchetti, *Novelle*, 235.
8. Villani, *Croniche Fiorentine*, 98.
9. Villani, *Croniche Fiorentine*, 121.
10. Pseudo-Latini, *Cronica*, quoted in Schevill, *Medieval and Renaissance Florence*, 106.
11. Villani, *Chroniche Fiorentine*, 122.
12. Villani, *Cronica*, 6:78.
13. Villani, *Cronica*, 8:71.
14. Villani, *Cronica*, 12:84.
15. Villani, *Cronica*, 10:118.
16. Quoted in Brucker, *Florentine Politics and Society*, 110–11.
17. Machiavelli, *Florentine Histories*, 128.
18. Najemy, *History of Florence*, 165.
19. Quoted in Brucker, *Civic World*, 51.
20. Machiavelli, *Florentine Histories*, 130.
21. Goldthwaite, *Private Wealth*, 414.
22. Burckhardt, *Civilization of the Renaissance*, 78.
23. Witt, *Hercules at the Crossroads*, 151.

24. Cavalcanti, *Istorie Fiorentine*, 29–30.
25. Pocock, *Machiavellian Moment*, 51.
26. Quoted in Skinner, *Ambrogio Lorenzetti*, 19.
27. Villani, *Cronica*, 3:129.
28. Dati, *Istoria di Firenze*, 69.

Chapter 2. The Work of Man

1. Brucker, *Florence, the Golden Age*, 15.
2. Franco Sassetti, quoted in Najemy, *History of Florence*, 192.
3. Baron, *Crisis*, 15.
4. Morelli, *Ricordi*, 397.
5. Saviozzo da Siena, quoted in Cronin, *Florentine Renaissance*, 42.
6. Machiavelli, *Florentine Histories*, 145.
7. Quoted in Baron, *Crisis*, 29.
8. Witt, *Coluccio Salutati*, 193.
9. Dominici, *Lucula Noctis*, 252–56.
10. Quoted in Baron, *Crisis*, 21.
11. Hankins, "Exclusivist Republicanism," 474.
12. Quoted in Kohl and Witt, *Earthly Republic*, 150.
13. Bruni, *Laudatio*, quoted in Kohl and Witt, *Earthly Republic*, 151.
14. Holmes, *Florentine Enlightenment*, 234.
15. Salutati, quoted in Baxandall, *Painting and Experience*, 42.
16. Quoted in Holmes, *Florentine Enlightenment*, 90.
17. Quoted in Caesar, *Dante*, 192.
18. Quoted in Cronin, *Florentine Renaissance*, 50.
19. Quoted in Rabil, *Renaissance Humanism*, 147.
20. Quoted in Kohl and Witt, *Earthly Republic*, 173.
21. Quoted in Brucker, *Florence, the Golden Age*, 7.
22. Quoted in Baron, *In Search of Civic Humanism*, 33, 18.
23. Shearman, *Only Connect*, 455.
24. Brucker, *Civic World*, 289n199.
25. Quoted in Baron, *In Search of Civic Humanism*, 7.
26. Quoted in Kohl and Witt, *Earthly Republic*, 155.
27. Bennett and Wilkins, *Donatello*, 66.
28. Vasari, *Lives of the Artists*, 476.
29. Giannozzo Manetti, *On Human Worth*, 66.
30. Vasari, *Lives of the Artists*, 110, 118.
31. Quoted in Vasari, *Lives of Seventy Painters*, 71n14.
32. Alberti, quoted in Garin, *Portraits from the Quattrocento*, 119.
33. Giannozzo Manetti, *On Human Worth*, 138.
34. Alberti, *Family in Renaissance Florence*, 266.
35. Alberti, *Family in Renaissance Florence*, 28, 29, 30.

36. Alberti, *Opere volgari*, 177.
37. Baxandall, *Painting and Experience*, 86.
38. Belting, "Perspective," 190.
39. Quoted in Braider, *Refiguring the Real*, 21.
40. Wittkower, "Brunelleschi and Proportion," 288.

Chapter 3. The Age of Cosimo

1. Alberti, *Family in Renaissance Florence*, 137.
2. Trexler, *Public Life in Renaissance Florence*, 28.
3. Quoted in Hatfield, "Compagnia de' Magi," 110.
4. Trexler, *Public Life in Renaissance Florence*, 228.
5. Machiavelli, *Florentine Histories*, 23.
6. Baron, *In Search of Civic Humanism*, 16.
7. Brucker, *Civic World*, 303n255 (author's translation).
8. Machiavelli, *Florentine Histories*, 137.
9. da Bisticci, *Renaissance Princes*, 213.
10. Machiavelli, *Florentine Histories*, 16.
11. Quoted in Hibbert, *House of Medici*, 30.
12. Machiavelli, *Florentine Histories*, 27.
13. da Bisticci, *Renaissance Princes*, 215.
14. Machiavelli, *Florentine Histories*, 177.
15. Quoted in Kent, *Rise of the Medici*, 1.
16. Cavalcanti, quoted in Kent, *Rise of the Medici*, 105.
17. Quoted in Fabroni, *Magni Cosmi Medicei vita*, 74.
18. Quoted in Trexler, *Public Life in Renaissance Florence*, 421.
19. Trexler, *Public Life in Renaissance Florence*, 309.
20. Machiavelli, *Florentine Histories*, 184.
21. Machiavelli, *Florentine Histories*, 179.
22. Garin, *Portraits from the Quattrocento*, 16; Robin, *Filelfo in Milan*, 17–20.
23. Machiavelli, *Florentine Histories*, 227.
24. Quoted in Hibbert, *House of Medici*, 63.
25. de Roover, *Rise and Decline of the Medici Bank*, 57.
26. da Bisticci, *Renaissance Princes*, 223.
27. Quoted in Hatfield, "Compagnia de' Magi," 111.
28. Quoted in Hatfield, "Compagnia de' Magi," 16.
29. da Bisticci, *Renaissance Princes*, 223.
30. Hale, *Florence and the Medici*, 50.
31. Spina-Barelli, "Note iconografiche in margine," 30–31.
32. Vasari, *Lives of the Artists*, 88.
33. Quoted in da Bisticci, *Renaissance Princes*, 129.
34. Hibbert, *House of Medici*, 65.
35. Palmer, *Reading Lucretius*, 23.

36. Corsi, *Vita di Marsilio Ficino*, 51.
37. da Bisticci, *Renaissance Princes*, 218.
38. Baxandall, *Painting and Experience*, 47; Zardino, quoted in Baxandall, 46.
39. Ruskin, *Stones of Venice*, 378.
40. Quoted in Geanokoplos, *Byzantium*, 181.
41. McCarthy, *Stones of Florence*, 98.
42. Alberti, *On Painting*, 79.
43. Vasari, *Lives of the Artists*, 193.
44. Najemy, *History of Florence*, 292.
45. Quoted in Creighton Gilbert, "Archbishop on the Painters," 76.
46. Pieruzzi, *Opere ben vivere*, 223.
47. Quoted in Young, *Medici*, 130.

Chapter 4. Magnificence

1. Landucci, *Florentine Diary*, 4.
2. Dei, *La cronica*, 22r, 66.
3. Machiavelli, *Florentine Histories*, 296.
4. Quoted in Ross, *Lives of the Early Medici*, 105–7.
5. Quoted in Watkins, *Humanism and Liberty*, 160.
6. Machiavelli, *Florentine Histories*, 303.
7. Quoted in Watkins, *Humanism and Liberty*, 161.
8. Quoted in Martines, *April Blood*, 94.
9. Quoted in Martines, *April Blood*, 105.
10. Quoted in Machiavelli, *Florentine Histories*, 322.
11. Quoted in Watkins, *Humanism and Liberty*, 176.
12. Machiavelli, *Florentine Histories*, 327.
13. Machiavelli, *Florentine Histories*, 327.
14. Landucci, *Florentine Diary*, 19.
15. Quoted in Hibbert, *House of Medici*, 149.
16. Medici, *Selected Poems and Prose*, 169.
17. Landucci, *Florentine Diary*, 26.
18. Quoted in Garin, *Portraits from the Quattrocento*, 181.
19. Medici, *Selected Poems and Prose*, 171.
20. Quoted in Gregory, "Return of the Native," 18.
21. Machiavelli, *Florentine Histories*, 344, 340.
22. Landucci, *Florentine Diary*, 31.
23. Schevill, *Medieval and Renaissance Florence*, 397.
24. de Roover, *Rise and Decline of the Medici Bank*, 373.
25. Landucci, *Florentine Diary*, 9.
26. Quoted in Niccolini, *Vita di Lorenzo de' Medici*, 72.
27. Hankins, "Myth of the Platonic Academy of Florence."
28. Medici, *Selected Poems and Prose*, 46.

29. Quoted in Celenza, *Intellectual World*, 290.
30. Poliziano, *Prose volgari inedite*, 47 (author's translation).
31. Garin, *Portraits from the Quattrocento*, 69.
32. Burckhardt, *Civilization of the Renaissance*, 179.
33. Quoted in Najemy, "Machiavelli and the Medici," 573.
34. Butterfield, *Sculptures of Andrea del Verrocchio*, 31.
35. Landucci, *Florentine Diary*, 42.
36. Quoted in Garin, *Portraits from the Quattrocento*, 160.
37. Ficino, *Letters*, 12.
38. Hale, *Florence and the Medici*, 55.
39. Quoted in Wind, *Pagan Mysteries*, 114.
40. Wind, *Pagan Mysteries*, 118.
41. Wind, *Pagan Mysteries*, 124.
42. Wind, *Pagan Mysteries*, 125.
43. Pico della Mirandola, *Oration*, 117, 135.
44. Pico della Mirandola, *Oration*, 149.
45. Quoted in Hale, *Florence and the Medici*, 57.
46. Quoted in Felix Gilbert, "Bernardo Rucellai," 105.
47. Landucci, *Florentine Diary*, 49.
48. Landucci, *Florentine Diary*, 48.
49. Quoted in Hatfield, "Compagnia de' Magi," 130.
50. Strocchia, "Learning the Virtues," 209.
51. Landucci, *Florentine Diary*, 45.
52. Quoted in Horsburgh, *Girolamo Savonarola*, 45.
53. Quoted in Villari, *Life and Times*, 184.
54. Quoted in Cronin, *Florentine Renaissance*, 248.
55. Quoted in Villari, *Life and Times*, 179–80.
56. Savonarola, *Selected Writings*, 70.
57. Savonarola, *Compendio di rivelazioni*, 140.

Chapter 5. New Jerusalem, New Republic

1. Guicciardini, *History of Italy*, 51.
2. Machiavelli, *The Prince*, 102.
3. Parenti, *Storia fiorentina*, 29.
4. Landucci, *Florentine Diary*, 65.
5. Quoted in Hibbert, *House of Medici*, 188.
6. Landucci, *Florentine Diary*, 66.
7. Landucci, *Florentine Diary*, 68.
8. Quoted in Guicciardini, 65.
9. Landucci, *Florentine Diary*, 73.
10. Quoted in Rubinstein, "Florentina Libertas," 153 (author's translation).
11. Savonarola, *Selected Writings*, 172.

12. Quoted in Erlanger, *Unarmed Prophet*, 118.
13. Quoted in Peter Burke, *Culture and Society*, 141.
14. Quoted in Crum, "Donatello's Bronze *David*," 445.
15. Landucci, *Florentine Diary*, 89.
16. Landucci, *Florentine Diary*, 102.
17. Landucci, *Florentine Diary*, 103.
18. Rocke, *Forbidden Friendships*.
19. Quoted in Peter Burke, *Culture and Society*, 140.
20. Brucker, *Florence, the Golden Age*, 7.
21. Landucci, *Florentine Diary*, 100.
22. Quoted in Garin, *Portraits from the Quattrocento*, 233.
23. Quoted in Hibbert, *House of Medici*, 197.
24. Landucci, *Florentine Diary*, 131.
25. Landucci, *Florentine Diary*, 143.
26. Landucci, *Florentine Diary*, 145.
27. Guicciardini, *Storie fiorentine*, 411–12.
28. Hale, *Machiavelli and Renaissance Italy*, 9.
29. Machiavelli, *Discourses*, 97.
30. Brown, "Lorenzo de' Medici's New Men," 129.
31. Najemy, *Between Friends*, 63.
32. Machiavelli, *Letters*, 88; *The Prince*, 24.
33. Machiavelli, *The Prince*, 61.
34. Najemy, *Between Friends*, 62.
35. Pitkin, *Fortune Is a Woman*, 19.
36. Landucci, *Florentine Diary*, 181.
37. Strathern, *Artist, Philosopher, Warrior*, 163.
38. Najemy, *Between Friends*, 67.
39. Weinberger, *Michelangelo, the Sculptor*, 81.
40. Landucci, *Florentine Diary*, 214.
41. Machiavelli, *The Prince*, 56.
42. Quoted in Hibbard, *Michelangelo*, 74–75.
43. Fra Pietro Novellara, quoted in Nicholl, *Leonardo da Vinci*, 336.
44. Vasari, *Lives of the Artists*, 293.
45. Hartt, "Leonardo and the Second Florentine Republic," 98.
46. da Vinci, *Treatise on Painting*, 64.
47. Earls, *Renaissance Art*, 263.
48. Michelotto, quoted in Machiavelli, *Machiavelli and His Friends*, 162.
49. de Grazia, *Machiavelli in Hell*, 97.
50. Landucci, *Florentine Diary*, 218.
51. Guicciardini, *History of Italy*, 272.
52. Landucci, *Florentine Diary*, 256.
53. Guicciardini, *History of Italy*, 266.
54. Jacopo Pitti, quoted in Trexler, *Public Life*, 493n6.

55. Brown, "De-Masking Renaissance Republicanism," 231.
56. Landucci, *Florentine Diary*, 261.
57. Vettori, *Scritti storici e politici*, 152.
58. Landucci, *Florentine Diary*, 266–67.
59. Landucci, *Florentine Diary*, 268.
60. Vasari, *Lives of the Artists*, 402.

Chapter 6. The Twilight of the Republic

1. Machiavelli, *Lettere*, 227–28 (author's translation).
2. Quoted in de Grazia, *Machiavelli in Hell*, 34.
3. Machiavelli, *Chief Works*, 743.
4. Quoted in de Grazia, *Machiavelli in Hell*, 24.
5. Machiavelli, *Letters*, 104.
6. Machiavelli, *Letters*, 140.
7. Machiavelli, *Letters*, 142.
8. Quoted in Najemy, *Between Friends*, 102.
9. Cambi, *Istorie*, 8.
10. Trexler, *Public Life*, 507.
11. Landucci, *Florentine Diary*, 285.
12. Quoted in Trexler, "Two Captains," 175.
13. Giovanni Cambi, quoted in Trexler, *Public Life*, 501.
14. Filippo de Neri, quoted in F. W. Kent, "Ties of Neighborhood," 90.
15. Filarete and Manfidi, *Libro Cerimoniale*, 119.
16. Trexler, "Two Captains," 181.
17. Machiavelli, *The Prince*, 61.
18. Machiavelli, *Florentine Histories*, 161.
19. Machiavelli, *Discourses*, 138.
20. Machiavelli, *Discourses*, 101.
21. Machiavelli, *Discourses*, 114.
22. Machiavelli, *Discourses*, 531.
23. Machiavelli, *Florentine Histories*, 185.
24. Machiavelli, *Florentine Histories*, 185.
25. Guicciardini, *History of Italy*, 18.
26. Guicciardini, *History of Italy*, 442.
27. Quoted in Hibbert, *House of Medici*, 248.
28. Quoted in Hibbert, *House of Medici*, 248.
29. Benedetto Varchi, quoted in Trexler, *Public Life*, 123.
30. Quoted in Stephens, *Fall of the Florentine Republic*, 210.
31. Guicciardini, *Maxims and Reflections*, 39.
32. Roth, *Last Florentine Republic*, 98.
33. Roth, *Last Florentine Republic*, 189.
34. Quoted in Roth, *Last Florentine Republic*, 200.

35. Quoted in Roth, *Last Florentine Republic*, 204.

36. Quoted in Elam, "Art in the Service of Liberty," 33.

37. Varchi, *Storia, fiorentina*, 361.

Coda

1. Quoted in Ridolfi, *Life of Francesco Guicciardini*, 221.

2. Trexler, "Two Captains," 186.

3. Ughi, *Cronica di Firenze*, 172.

4. Ughi, *Cronica di Firenze*, 181.

5. Landucci, *Florentine Diary*, 297.

6. Shearman, *Only Connect*, 55.

Bibliography

Alberti, Leon Battista. *The Family in Renaissance Florence*. Translated by Renée Neu Watkins. Columbia: University of South Carolina, 1969.

———. *On Painting and on Sculpture*. London: Phaidon, 1972.

———. *Opere volgari*. Vol. 1. Edited by Cecil Grayson. Bari, Italy: G. Laterza, 1960.

Ames-Lewis, Francis. "Art History or *Stilkritik*? Donatello's Bronze *David* Reconsidered." *Art History* 2 (1979): 139–55.

———. "Neo-Platonism and the Visual Arts at the Time of Marsilio Ficino." In *Marsilio Ficino: His Philosophy, His Theology, His Legacy*, edited by Michael Allen and Valery Rees with Martin Davies, 327–38. Leiden: Brill, 2002.

Atkinson, Niall. "The Republic of Sound: Listening to Florence at the Threshold of the Renaissance." *I Tatti Studies in the Italian Renaissance* 16, no. 1/2 (2013): 57–84.

Baker, Nicholas Scott. *The Fruit of Liberty: Political Culture in the Florentine Renaissance, 1480–1550*. Cambridge, MA: Harvard University Press, 2013.

Barofsky, Paul, and William Wallace. "The Myth of Michelangelo and Il Magnifico." *Source* 12, no. 3 (1993): 16–21.

Baron, Hans. *The Crisis of the Early Italian Renaissance*. Princeton, NJ: Princeton University Press, 1966.

———. *In Search of Civic Humanism*. Princeton, NJ: Princeton University Press, 1988.

Baxandall, Michael. *Painting and Experience in Fifteenth Century Italy: A Primer in the Social History of Pictorial Style*. Oxford: Oxford University Press, 1972.

Beccadelli, Antonio. *Hermaphroditus*. Translated by Eugene M. O'Connor. Lanham, MD: Lexington Books, 2001.

Belting, Hans. "Perspective: Arab Mathematics and Renaissance Western Art." *European Review* 16, no. 2 (2008): 183–90.

Bennett, Bonnie, and David G. Wilkins. *Donatello*. Oxford: Phaidon, 1984.

Blanchard, W. Scott. "Patrician Sages and the Humanist Cynic: Francesco Filelfo and the Ethics of World Citizenship." *Renaissance Quarterly* 60, no. 4 (2007): 1107–69.

Braider, Christopher. *Refiguring the Real: Picturing Modernity in Word and Image, 1400–1700*. Princeton, NJ: Princeton University Press, 1993.

Brown, Alison. "De-Masking Renaissance Republicanism." In *Medicean and Savonarolan Florence: The Interplay of Politics, Humanism, and Religion*, edited by Alison Brown, 225–45. Turnhout, Belgium: Brepols, 2011.

———. "Lorenzo and Public Opinion in Florence: The Problem of Opposition." In *Lorenzo il Magnifico ed il suo mondo*, edited by G. C. Garfagnini, 61–85. Florence: Leo S. Olschki, 1994.

———. "Lorenzo de' Medici's New Men and Their Mores: The Changing Lifestyle of Quattrocento Florence." *Renaissance Studies* 16, no. 2 (2002): 113–42.

———. *The Return of Lucretius to Renaissance Florence*. Cambridge, MA: Harvard University Press, 2010.

Brucker, Gene. *The Civic World of Early Renaissance Florence*. Princeton, NJ: Princeton University Press, 1977.

———. *Florence, the Golden Age, 1138–1737*. Berkeley: University of California Press, 1988.

———. *Florentine Politics and Society, 1348–1378*. Princeton, NJ: Princeton University Press, 1962.

Burckhardt, Jacob. *The Civilization of the Renaissance in Italy*. London: Penguin Classics, 1990.

Burke, Jill. "Visualizing Neighborhood in Renaissance Florence: Santo Spirito and Santa Maria del Carmine." *Journal of Modern History* 32, no. 5 (2006): 693–710.

Burke, Peter. *Culture and Society in Renaissance Italy*. New York: Scribner, 1972.

Butterfield, Andrew. *The Sculptures of Andrea del Verrocchio*. New Haven, CT: Yale University Press, 1997.

Caesar, Michael, ed. *Dante: The Critical Heritage*. London: Routledge, 1989.

Cambi, Giovanni. *Istorie di Giovanni Cambi, Cittadino Fiorentino, Pubblicate e di Annotazioni, e di Antichi Munimenti Accresciute, ed Illustrate da Fr. Ildefonso di San Luigi*. Florence: Per G. Cambiagi, 1785.

Cavalcanti, Giovanni. *Istorie Fiorentine*. Florence: All'insegna di Dante, 1838.

Celenza, Christopher. *The Intellectual World of the Italian Renaissance: Language, Philosophy, and the Search for Meaning*. New York: Cambridge University Press, 2018.

Cohn, Samuel. *The Laboring Classes in Renaissance Florence*. New York: Academic Press, 1980.

Compagni, Dino. *Dino Compagni's Chronicle of Florence (Middle Ages)*. Philadelphia: University of Pennsylvania Press, n.d.

Corsi, Giovanni. *Vita di Marsilio Ficino*. Lucca, 1722.

Corsi, Giovanni, and Angelo Bandini. *Comnentarius de platonicae philosophiae post renats litteras apud italos instauratione sive Marsili Ficini Vita*. Pisa: Augustinum Pizzorno, 1771.

Cronin, Vincent. *The Florentine Renaissance*. New York: Dutton, 1967.

Crum, Roger. "Donatello's Bronze *David* and the Question of Foreign versus Domestic Tyranny." *Renaissance Studies* 10, no. 4 (1996): 440–50.

da Bisticci, Vespasiano. *Renaissance Princes, Popes, and Prelates: The Vespasiano Memoirs, Lives of Illustrious Men of the XVth Century*. New York: Harper & Row, 1963.

Dati, Gregorio. *Istoria di Firenze*. Florence: Manni, 1735.

da Vinci, Leonardo. *A Treatise on Painting*. Farmington Hills, MI: Gale Ecco, 2018.

de Grazia, Sebastian. *Machiavelli in Hell*. New York: Vintage, 1994.

Dei, Benedetto. *La cronica: dall'anno 1400 all'anno 1500*. Florence: F. Papafava, 1985.

de Roover, Raymond. *The Rise and Decline of the Medici Bank, 1397–1494*. Cambridge, MA: Harvard University Press, 1963.

Dominici, Iohannis. *Lucula Noctis*. Edited by Edmund Hunt. Notre Dame, IN: Notre Dame University Press, 1940.

Earls, Irene. *Renaissance Art: A Topical Dictionary*. New York: Greenwood Press, 1987.

Elam, Caroline. "Art in the Service of Liberty: Battista della Palla, Art Agent for Francis I." *I Tatti Studies in the Italian Renaissance* 5 (1993): 33–109.

Erlanger, Rachel. *The Unarmed Prophet: Savonarola in Florence*. New York: McGraw-Hill, 1988.

Even, Yael. "Divide and Conquer: The Autocratic Patronage of the Opera del Duomo." *Notes in the History of Art* 8, no. 3 (1989): 1–6.

Fabroni, Angelo. *Magni Cosmi Medicei vita*. Pisa: A. Landi, 1789.

Ficino, Marsilio. *The Letters of Marsilio Ficino*. Preface by Paul O. Kristeller. New York: Gingko Press, 1985.

Field, Arthur. *The Origins of the Platonic Academy of Florence*. Princeton, NJ: Princeton University Press, 2014.

Filarete, Francesco, and Angelo Manfidi. *The Libro Cerimoniale of the Florentine Republic*. Edited by Richard Trexler. Geneva: Droz, 1978.

Fubini, Ricardo. "Renaissance Humanism and Its Development in Florentine Civic Culture." In *Palgrave Advances in Renaissance Historiography*, edited by Jonathan Woolfson, 118–38. New York: Palgrave Macmillan, 2005.

Ganz, Margery A. *Paying the Price for Political Failure: Florentine Women in the Aftermath of 1466.* Florence: L. S. Olschki, 1994.

Garin, Eugenio. *Portraits from the Quattrocento.* New York: Harper & Row, 1972.

Geanakoplos, Deno John. *Byzantium: Church, Society, and Civilization Seen Through Contemporary Eyes.* Chicago: University of Chicago Press, 1984.

Gilbert, Creighton. "The Archbishop on the Painters of Florence." *Art Bulletin* 41, no. 1 (1959): 75–87.

Gilbert, Felix. "Bernardo Rucellai and the Orti Oricellari." *Journal of the Warburg and Courtauld Institutes* 12 (1949): 101–31.

Goldthwaite, Richard. *The Building of Renaissance Florence.* Baltimore, MD: Johns Hopkins University Press, 1980.

———. *Private Wealth in Renaissance Florence: A Study of Four Families.* Princeton, NJ: Princeton University Press, 1968.

Gombrich, E. H. "From the Revival of Letters to the Reform of the Arts: Niccolò Niccoli and Filippo Brunelleschi." In *Essays in the History of Art Presented to Rudolf Wittkower,* edited by Howard Hibbard, Milton J. Lewine, and Douglas Fraser, 71–82. London: Phaedon, 1969.

Gregory, Heather. "The Return of the Native: Filippo Strozzi and Medicean Politics." *Renaissance Quarterly* 38, no. 1 (1985): 1–21.

Guasti, Cesare. *Le feste di S. Giovanni Batista in Firenze: descritte in prosa e in rima.* Florence: Giovanni Cirri, 1884.

Guicciardini, Francesco. *The History of Italy.* Translated by Sidney Alexander. Princeton, NJ: Princeton University Press, 1984.

———. *Maxims and Reflections of a Renaissance Statesman.* New York: Harper & Row, 1965.

———. *Storie fiorentine.* Edited by Alessandro Montevecchi. Milan: Rizzoli, 1998.

Hagerty, Melinda. "Laurentian Patronage in the Palazzo Vecchio: The Frescoes of the Sala Dei Gigli." *Art Bulletin* 78, no. 2 (1996): 264–85.

Hale, John Rigby. *Florence and the Medici.* Florence: Thames and Hudson, 1977.

———. *Machiavelli and Renaissance Italy.* London: English Universities Press, 1964.

Hankins, James. "Civic Knighthood in the Early Renaissance: Leonardo Bruni's De Militia (ca. 1420)." *Noctua* 1, no. 2 (2014): 260–82.

———. "Exclusivist Republicanism and the Non-Monarchical Republic." *Political Theory* 38, no. 4 (2010): 452–82.

———. "The Myth of the Platonic Academy of Florence." *Renaissance Quarterly* 4, no. 3 (1991): 429–75.

———. *Virtue Politics: Soulcraft and Statecraft in Renaissance Italy.* Cambridge, MA: Harvard University Press, 2019.

Hartt, Frederick. "Leonardo and the Second Florentine Republic." *Journal of the Walters Art Gallery* 44 (1986): 95–116.

Hartwig, Otto. *Quellen und Forschungen zür ältesten Geschichte der Stadt Florenz.* Halle, Germany: M. Niemeher, 1880.

Hatfield, Rab. "The Compagnia de' Magi." *Journal of the Warburg and Courtauld Institute* 33 (1970): 107–61.

Herlihy, David, and Christiane Klapisch-Zuber. *Tuscans and Their Families: A Study of the Florentine Catasto of 1427.* New Haven, CT: Yale University Press, 1985.

Herzner, Volker. "Die Kanseln Donatellos in San Lorenzo." *Munchner Jahrbuch der bildenden Kunst* 23 (1972): 101–64.

Hibbard, Howard. *Michelangelo.* New York: Harper & Row, 1974.

Hibbert, Christopher. *The House of Medici: Its Rise and Fall.* New York: Perennial, 2003.

Holmes, George. *The Florentine Enlightenment, 1400–1450.* Oxford: Clarendon Press, 1992.

Horsburgh, Edward Lee Stuart. *Girolamo Savonarola.* Boston: Knight, 1901.

Jacks, Philip, and William Caferro. *The Spinelli of Florence: Fortunes of a Renaissance Family.* University Park: Pennsylvania State University Press, 2001.

Kent, Dale. *The Rise of the Medici.* Oxford: Oxford University Press, 1978.

Kent, Dale V., and F. W. Kent. "Two Vignettes of Florentine Society in the Fifteenth Century." *Rinascimento* 23 (1983): 237–60.

Kent, F. W. "Ties of Neighborhood and Patronage." In *Patronage, Art, and Society in Renaissance Italy,* edited by F. W. Kent and Patricia Simons, 79–98. New York: Oxford University Press, 1987.

Klapisch-Zuber, Christiane. *Women, Family, and Ritual in Renaissance Italy.* Chicago: University of Chicago Press, 1985.

Knecht, R. J. *Catherine de' Medici.* New York: Routledge, 2014.

Kohl, Benjamin, and Ronald G. Witt. *The Earthly Republic: Italian Humanists on Government and Society.* Philadelphia: University of Pennsylvania Press, 1978.

Landucci, Luca. *A Florentine Diary from 1450 to 1516.* Translated by Iodoco del Badia and Alice de Rosen Jervis. London: J. M. Dent; New York: E. P. Dutton, 1927.

Machiavelli, Niccolò. *The Chief Works and Others.* Vol. 2. Translated by Allan Gilbert. Durham, NC: Duke University Press, 1989.

———. *The Discourses.* Translated by Leslie Walker. London: Penguin, 1984.

———. *Florentine Histories.* Translated by Laura E. Banfield and Harvey C. Mansfield Jr. Princeton, NJ: Princeton University Press, 1990.

———. *Lettere.* Edited by Franco Gaeta. Milan: Feltrinelli, 1961.

———. *The Letters of Machiavelli: A Selection.* Translated by Allen H. Gilbert. Chicago: University of Chicago Press, 1988.

———. *Machiavelli and His Friends: Their Personal Correspondence*. Translated and edited by James B. Atkinson and David Sices. DeKalb: Northern Illinois University Press, 1996.

———. *The Prince*. 2nd ed. Translated by Harvey Mansfield. Chicago: University of Chicago Press, 2006.

Manetti, Antonio. *Vita di Filippo Brunelleschi*. Milan: Polifilo, 1976.

Manetti, Giannozzo. *On Human Worth and Excellence*. Edited and translated by Brian P. Copenhaver. Cambridge, MA: Harvard University Press, 2018.

Marks, L. F. "The Financial Oligarchy in Florence under Lorenzo." In *Italian Renaissance Studies*, edited by E. F. Jacob, 123–47. London: Faber & Faber, 1960.

Martines, Lauro. *April Blood: Florence and the Plot against the Medici*. New York: Oxford University Press, 2003.

McCarthy, Mary. *The Stones of Florence*. New York: Harcourt, 1987.

McHam, Sarah Blake. "Donatello's Bronze *David* and *Judith* as Metaphors of Medici Rule in Florence." *Art Bulletin* 83, no. 1 (2001): 32–47.

Medici, Lorenzo de'. *Lorenzo de Medici: Selected Poems and Prose*. Edited and translated by Jon Thiem. University Park: Pennsylvania State University Press, 1991.

Morelli, Giovanni di Paolo. *Ricordi*. Edited by Vittore Branca. Florence: Felice le Monnier, 1969.

Najemy, John. *Between Friends: Discourses of Power and Desire in the Machiavelli-Vettori Letters of 1513–1515*. Princeton, NJ: Princeton University Press, 1993.

———. *A History of Florence, 1200–1575*. Malden, MA: Wiley-Blackwell, 2008.

———. "Machiavelli and the Medici: The Lessons of Florentine History." *Renaissance Quarterly* 35 (1982): 551–76.

Nelson, E. W. "The Origins of Modern Balance-of-Power Politics." *Medievalia et Humanistica* 1 (1943): 124–42.

Niccolini, E., ed. *Vita di Lorenzo de' Medici*. Vicenza: Accademia Olimpica, 1991.

Nicholl, Charles. *Leonardo da Vinci: The Flights of the Mind*. London: Penguin, 2005.

Padgett, John, and Christopher K. Ansell. "Robust Action and the Rise of the Medici, 1400–1434." *American Journal of Sociology* 98 (1993): 1259–319.

Palmer, Ada. *Reading Lucretius in the Renaissance*. Cambridge, MA: Harvard University Press, 2014.

Parenti, Piero. *Storia fiorentina*. Florence: L. S. Olschki, 1994–2018.

Pesman, Roslyn. "Machiavelli, Soderini, and the Republic of 1494–1512." In *The Cambridge Companion to Machiavelli*, edited by John Najemy, 48–63. New York: Cambridge University Press, 2010.

Pico della Mirandola, Giovanni. *Oration on the Dignity of Man: A New Translation and Commentary*. Edited by Francesco Borghese, Michael Papio, and Massimo Riva. New York: Cambridge University Press, 2012.

Picotti, G. B. *La giovinezza di Leone X: il Papa del Rinascimento*. Rome: Multigrafica Editrice, 1981.

Pieruzzi, Antoninus. *Opera ben vivere di Santo Antonino arcivesco di Firenze*. Edited by Francisco Palermo. Florence: M. Cellini, 1858.

Pitkin, Hanna. *Fortune Is a Woman: Gender and Politics in the Thought of Niccolò Machiavelli*. Chicago: University of Chicago Press, 1999.

Pocock, J. G. A. *The Machiavellian Moment: Florentine Political Thought and the Atlantic Republican Tradition*. Princeton, NJ: Princeton University Press, 1975.

Poliziano, Angelo. *Prose volgari inedite e poesie latine e greche edite e inedite di Angelo Ambrogini Poliziano raccolte e illustrate da Isidoro Del Lungo*. Florence: G. Barbera, 1867.

Rabil, Albert. *Renaissance Humanism: Foundations, Forms, and Legacy*. Vol. 1, *Humanism in Italy*. Philadelphia: University of Pennsylvania Press, 1988.

Ridolfi, Roberto. *The Life of Francesco Guicciardini*. London: Routledge & Kegan Paul, 1967.

Robin, Diana. *Filelfo in Milan*. Princeton, NJ: Princeton University Press, 1991.

Rocke, Michael. *Forbidden Friendships: Homosexuality and Male Culture in Renaissance Florence*. New York: Oxford University Press, 1996.

Ross, Janet. *The Lives of the Early Medici as Told in Their Correspondence*. London: Chatto & Windus, 1910.

Roth, Cecil. *The Last Florentine Republic*. London: Methuen & Co., 1925.

Rubinstein, Nicolai. "Florentina Libertas." *Rinascimento* 26 (1986): 3–26.

―――. "Politics and Constitution in Florence at the End of the Fifteenth Century." In *Italian Renaissance Studies*, edited by E. F. Jacob. New York: Barnes & Noble, 1960.

Ruskin, John. *The Stones of Venice*. London: Smith, Elder, 1858.

Sacchetti, Franco. *Novelle di Franco Sacchetti*. Milan: Giovanni Silvestri, 1815.

Savonarola, Girolamo. *Compendio di rivelazioni e Dialogus de veritate prophetica*. Edited by Angela Crucitti. Rome: A. Belardetti, 1974.

―――. *Selected Writings of Girolamo Savonarola: Religion and Politics, 1490–1498*. Translated and edited by Anne Borelli and Maria Pastore Passaro. New Haven: Yale University Press, 2006.

Schevill, Ferdinand. *Medieval and Renaissance Florence*. New York: Harper & Row, 1963.

Servadio, Giaia. *Renaissance Woman*. New York: I. B. Tauris, 2005.

Shearman, John. "Masaccio's Pisa Altar-Piece: An Alternative Reconstruction." *Burlington Magazine* 108, no. 762 (1966): 446–57.

―――. *Only Connect: Art and the Spectator in the Italian Renaissance*. Princeton, NJ: Princeton University Press, 1992.

Skinner, Quentin. *Ambrogio Lorenzetti: The Artist as Political Philosopher*. London: British Academy, 1986.

Spina-Barelli, Emma. "Note iconografiche in margine al Davide in Bronzo di Donatello." *Italian Studies* 29 (1974): 28–44.

Stephens, J. N. *The Fall of the Florentine Republic, 1512–1530*. Oxford: Clarendon Press, 1983.

Strathern, Paul. *The Artist, the Philosopher, and the Warrior: Da Vinci, Machiavelli, and Borgia and the World They Shaped*. New York: Bantam, 2009.

Strocchia, Sharon T. *Death and Ritual in Renaissance Florence*. Baltimore, MD: Johns Hopkins University Press, 1992.

——. "Learning the Virtues: Convent Schools and Female Culture in Renaissance Italy." In *Women's Education in Early Modern Europe: A History, 1500–1800*, edited by Barbara J. Whitehead. New York: Garland, 1999.

Terry, Allie. "A Humanist Reading of Fra Angelico's Frescoes at San Marco." In *Neoplatonic Aesthetics: Music, Literature & the Visual Arts*, edited by John Hendrix and Liana Cheney, 115–31. New York: Peter Lang, 2004.

Trexler, Richard. "Correre la terra: Collective Insults in the late Middle Ages." *Mélanges de l'école française de Rome* 96, no. 2 (1984): 845–902.

——. *Dependency in Context in Renaissance Florence*. Binghamton, NY: Center for Medieval and Early Renaissance Studies, 1994.

——. *Public Life in Renaissance Florence*. New York: Academic Press, 1980.

——. "Two Captains and Three Kings: New Light on the Medici Chapel." In *Church and Community, 1200–1600: Studies in the History of Florence and New Spain*, edited by Richard Trexler, 169–244. Rome: Edizioni di storia e letteratura, 1987.

Trollope, T. Adolphus. *A History of the Commonwealth of Florence, from the Earliest Independence of the Commune to the Fall of the Republic in 1531*. London: Chapman & Hall, 1865.

Ughi, Giuliano. *Cronica di Firenze o compendio storico dall'anno MDI al MDXLVI*. In *Archivio storico italiano*, *Appendice 7*, edited by Francesco Frediani. Florence, 1849.

Varchi, Benedetto. *Storia fiorentina*. Vol. 2. Florence: Le Monnier, 1858.

Vasari, Giorgio. *Lives of Seventy of the Most Eminent Painters, Sculptors, and Architects*. Vol. 1. Edited by Edwin Howland Blashfield, Evangeline Wilbour Blashfield, and Albert A. (Albert Allis) Hopkins. New York: C. Scribner's Sons, 1911.

——. *Lives of the Artists*. Translated by Julia Conaway Bondanella and Peter Bondanella. Oxford: Oxford University Press, 1991.

Vettori, Francesco. *Scritti storici e politici*. Edited by Enrico Niccolini. Bari, Italy: G. Laterza, 1972.

Villani, Giovanni. *Cronica*. Edited by F. Dragomanni. Florence, 1848.

——. *Selections from the First Nine Books of the Croniche Fiorentine of Giovanni Villani*. Translated by Rose E. Selfe. Westminster, UK: Archibald Constable, 1897.

Villari, Pasquale. *Life and Times of Girolamo Savonarola*. Translated by Linda Villari. New York: Charles Scribner's Sons, 1888.

Wallace, William E. *Michelangelo: The Artist, the Man, and his Times*. New York: Cambridge University Press, 2010.

Watkins, Renee Neu. *Humanism and Liberty*. Columbia: University of South Carolina Press, 1978.

Weaver, Elissa. *Convent Theatre in Early Modern Italy: Spiritual Fun and Learning for Women*. Cambridge: Cambridge University Press, 2002.

Weinberger, Martin. *Michelangelo, the Sculptor*. New York: Columbia University Press, 1967.

Wind, Edgar. *Pagan Mysteries in the Renaissance*. New York: W. W. Norton, 1968.

Witt, Ronald. *Coluccio Salutati and His Public Letters*. Geneva: Droz, 1976.

———. *Hercules at the Crossroads: The Life, Works, and Thought of Coluccio Salutati*. Durham, NC: Duke University Press, 1983.

Wittkower, Rudolph. "Brunelleschi and Proportion in Perspective." *Journal of the Warburg and Courtauld Institutes* 16 (1953): 275–91.

Young, G. F. *The Medici*. New York: E. P. Dutton, 1917.

Zorach, Rebecca. "Love, Truth, Orthodoxy, Reticence; or, What Edgar Wind Didn't See in Botticelli's *Primavera*." *Critical Inquiry* 34 (2007): 190–234.

Index

Page numbers in italics refer to illustrations; color illustrations are indicated by image number.